WRITING ABOUT ART

Revised Edition

by Marjorie Munsterberg

www.writingaboutart.org

Designed by Ephraim Gregor, www.ephraimgregor.com

Copyright © 2009 by Marjorie Munsterberg

Available from www.writingaboutart.org

ISBN: 978-1441486240

Table of Contents

PREFACE

I created *Writing About Art* as the text for a course of the same name at The City College of New York. It explains the different approaches college students encounter in undergraduate art history classes. Each chapter outlines the characteristics of one type of visual or historical analysis, and briefly explains its history and development. Passages by well-known art historians provide examples of each method. Four appendices outline the steps involved in researching art historical topics, writing essays about them, and citing sources properly. Appendices III and IV include sample student papers, accompanied by my comments and suggested changes.

I have not included illustrations, in the hope that more attention will be given to the passages quoted. Glancing at a picture and then skimming text about it is not the same as trying to create a mental image from words alone. The absence of illustrations also makes it easier for each reader to decide which words are especially effective in communicating information about visual things. However, complete identification of the images discussed is given so that the reader can find them easily on the Web. Many of them will be familiar from art history surveys.

Writing About Art has been revised repeatedly in response to comments from students and colleagues. It is no exaggeration to say that without the help of my students at CCNY, I never could have – or would have – written this text. I owe them all, especially those who allowed me to use their papers as examples, tremendous thanks. They also forced me into the twenty-first century, making it clear how useful it would be to have this text available as a website as well as a paperback. In appreciation of all they have given me, I dedicate this work to my students in Art 210.

Marjorie Munsterberg
mmunsterberg@gmail.com

The great aim is accurate, precise and definite description. The first thing is to recognise how extraordinarily difficult this is. It is no mere matter of carefulness; you have to use language, and language is by its very nature a communal thing; that is, it expresses never the exact thing but a compromise – that which is common to you, me and everybody. But each man sees a little differently, and to get out clearly and exactly what he does see, he must have a terrific struggle with language . . . [which] has its own special nature, its own conventions and communal ideas. It is only by a concentrated effort of the mind that you can hold it fixed to your own purpose.[1]

The way to breathe life into the description of any object is to apply adjectives to it. A piece of cloth is of little interest for us until we know whether it is starched, handwoven, salmon pink, translucent, knotted, torn, bespangled, or sodden.[2]

1. Introduction

This text is intended to help students improve their ability to write about visual things. I explain the most common types of analysis used by art historians and a little bit about how these methods developed. This is not a history of art history, however, nor is it an introduction to the theory and methods of art history. Major scholars are not mentioned and complicated ideas have been presented only in terms relevant to their practical application. It also is not a guide to learning how to look at art. For that, Joshua Taylor's *Learning to Look* remains unsurpassed.[3]

Almost all of my examples come from texts written in English. Translations change exactly what is of greatest interest here: the words and concepts used by good writers about art. Furthermore, there is a history to the language used in English by art historians. Sometimes this has shaped the meaning of a term, occasionally in significant ways. A few examples will be discussed below. Even in their use of ordinary words, however, these writers can serve as models. Their vocabulary and ideas offer a wealth of contributions to the internal resources upon which we all draw when we write. The more developed these resources are, the more fluent and expressive writing based upon them will be.

Painting, sculpture, and architecture have been considered the major forms of the fine arts during much of the Western tradition. They have attracted many of the most ambitious artists and, consequently, more attention from art historians. Architecture, however, like video and electronic mediums, requires a specialized descriptive and analytical vocabulary. Just as the art historical methods I explain are the ones most commonly used, so the forms of art discussed in the passages I have selected are those most frequently covered in art history courses. For the same reason, most of the art analyzed in the text comes from the West.

I have not included any reproductions, in the hope that more attention will be given to the passages quoted. Glancing at a picture and then skimming text about it is not the same as trying to create a mental image of something from words alone. The absence of illustrations also should make it easier for each reader to decide which words seem particularly effective in communicating information about visual things. However, I have given enough information about each work so that a picture of it can be found without difficulty. Many of them will be familiar from art history surveys.

Another editorial decision I made was to cite the names of the authors quoted within my text. The normal practice of putting that information in the notes makes it easier for the reader, who is given a smoothly flowing argument instead of one constantly interrupted by names and book titles. Here, however, since my subject is writing, identifying the writer with the passage seemed useful. The most important art historians of the past have birth and death dates in parentheses after the first mention of their names.

This is a guide to writing about art, not to writing itself. It is no substitute for a book like *The Elements of Style*, the classic but still inspiring text by William Strunk, Jr. and E.B. White.[4] Nonetheless, I would like to begin with a few fundamental principles. Paragraphs should be the basic organizing unit of any essay. Each one should develop a single idea, introduced at the beginning of the paragraph by a topic sentence. The paragraphs should be organized so that the ideas follow one another in a logical sequence. This means that the topic sentences should form an outline of what the writer intends to express. Sentences should be complete, and grammar and spelling must be correct. Words should convey the writer's meaning as directly as possible.

The choice of which verb tenses to use must be consistent throughout a single piece of writing. My personal choice is to use the present tense for anything that still exists, like a work of art or a book, and the past tense for a completed action. In other words, Michelangelo sculpted *David* (because he did it centuries ago), but *David* shows Michelangelo's interest in the Classical conception of the nude male body (because it still does). This seems to me the most logical approach, although sometimes it leads to awkward phrasing. Many people use the present tense for both cases. In other words, Michelangelo uses the Classical conception of the nude male body in his sculpture *David*. Whatever the choice, it must be adhered to throughout any particular essay.

To be effective, a paper must be directed toward a single goal. The purpose matters to the writer and it matters to the reader, who will have expectations about what comes next based on what has been promised. Writing intended to evoke a vivid impression of a work of art has to present very different information from an interpretation of the subject that depends upon detailed historical arguments. For this reason, it is important to let the reader know as soon as possible what kind of analysis will follow. Every aspect of the paper should contribute to it.

Success is measured by how well the intended meaning has been communicated to the intended reader. There is no substitute for having someone read a draft, or for putting

a paper aside and returning to revise it later. Even before that, though, a writer should try to assess the clarity and logic of the presentation. Underlining topic sentences to see if they really do outline the argument is helpful. Quickly sketching elements mentioned in a visual description is another revealing exercise. If there is no place in the drawing for a particular detail, it has been introduced at the wrong point in the essay or essential elements have been neglected. Most of all, the writer should be prepared to revise and revise and revise. Good papers never just happen.

2. VISUAL DESCRIPTION

The simplest visual description uses ordinary words to convey what the writer sees. First he or she must look at the subject – slowly, carefully, and repeatedly, if possible – to identify the parts that make the whole. These parts must be sorted into the more and the less important, since no description can include everything, and assumptions must be separated from actual observations. It is easy to confuse what we see with what we think we see, or what we know is there. Then comes the difficult job of finding appropriate words. In effect, writing a visual description consists of two separate acts of translation. The first transforms a visual experience into a verbal one and the second turns a private experience into one that can be communicated to someone else.

Any writer takes some things for granted. It is crucial to understand what these things are and then consider them in terms of both the purpose of the description and the interests of the reader. For example, to describe the sky in a particular 17th-century Dutch landscape painting as cloudy indicates one aspect of the picture in a general way. It leaves entirely unexplained the specific elements that create the visual effect – like the shapes and colors of the clouds, the way they have been arranged, or how they suggest space. These qualities cannot be imagined by a reader who has not been given explicit details. In the same way, identifying something by artist, title, and date might be all a specialist needs to visualize the work. Anyone else, however, will need to be told much more.

Generally speaking, the best place to begin a visual description is with an explanation of the subject and the materials of the work. Together they provide enough information to orient any reader. In most cases, though, neither will be enough by itself. To say that a work of art shows a woman and a child, but not whether the representation is in two or three dimensions, makes it hard to form even the roughest mental image. If, however, the writer says that the work is a life-size sculpture of a woman and child, the reader can begin to imagine what it might look like. He or she also will know enough to have questions. A good written description will anticipate these questions and provide information in an order that answers them.

Additional observations can make the first sentence even more useful. Perhaps the artist is famous, and "a life-size sculpture of a woman and child by Henry Moore" would convey a great deal to the reader. Perhaps the subject is the Virgin Mary and Jesus, an identi-

fication filled with meaning for someone who is knowledgeable about Christianity. Maybe the sculptor is not known and the subject has not been identified. Then describing the relationship between the figures might be helpful. To say that the work is a life-size sculpture of a seated woman holding a small child on her lap gives the reader a beginning. Of course the introductory sentence cannot hold too much information. It must strike a balance between giving the reader a few vague generalities and trying to convey everything at once.

A traditional work of art is, first of all, a physical object. The material or materials used may not be possible to identify by just looking. Perhaps they look like something they are not, or the surface and texture have been obscured by layers of paint. In cases like these, the correct identification can be brought to the attention of the reader, but not as part of what anyone can see. This is an instance of knowing being different from seeing. If information is based on an external source, even a museum label, the source must be cited after it has been verified. Many mistakes get repeated as facts by people who did not bother to check them.

The size of a work is always crucial. The effect made on a viewer by an object that can be held in the hand, compared to a billboard that covers the side of a building, is so different as to make any similarities seem almost inconsequential. The first demands a very intimate relationship, with careful and close looking to see what is there. The other must be seen from a distance and may contain details that are too small to be comprehensible. Scale also influences the design of a work, since the same composition, colors, and methods of making rarely transfer effectively from a small format to a very large one, or vice versa. This is another reason why size must be discussed in a visual description.

Color matters. Even if it is not part of the subject, it influences the way we look at a work. Bright colors catch our eye before dark ones do, and even subtle changes may matter a great deal. The sense of space created within an abstract painting by Wassily Kandinsky comes from the colors he chose as much as the shapes. Often the color of a work has changed over time. Some Greek sculptures, which we are accustomed to see as white marble, were painted with lifelike colors. Our expectations make reconstructions look startlingly incorrect.[5] The controversy that surrounded the cleaning of Michelangelo's paintings in the Sistine Chapel was partly about technical matters, but also about the tremendous change it made to the colors. Those who accepted the results of the cleaning as historically correct had to revise their ideas about Michelangelo as an artist as well as about the history of 16th-century Italian art.[6]

The qualities listed above explain why a reproduction can never substitute for an original. A good copy will convey certain elements of the work, but it cannot convey them all. Even an excellent color photograph of an oil painting, a two-dimensional picture of a two-dimensional picture, will leave out more information than it gives. The same is even more true with reproductions of three-dimensional objects. A single image communicates only one point of view, and it cannot indicate size, shape, surface, or volume. These are the most essential visual qualities of sculpture.

Art historians usually do not write general visual descriptions, because they are intent upon making a specific argument or they are interested in a particular aspect of a work. One exception is James Cahill, whose analyses of Chinese paintings provide exceptionally complete accounts of what the pictures look like. Even without being interested in his scholarly purpose, any reader can appreciate his skill as a writer. Typically, he used ordinary words to make his readers understand size and brush stroke as well as subject and composition. His authorial voice is even and careful and always that of a historian, removed in time and place from the works in question. At the same time, however, he often described what he saw in terms of how it must have been made. In this way, he made a sense of artistic process seem like a vital part of the finished works.

One passage by Cahill about a picture from the Ming period shows how he helped make his readers more attentive viewers. About the ink paintings in an album by the painter Wang Li (Private collection and Shanghai Museum, China), he wrote:

> The surviving leaves [of *Scenes of Hua-shan*] exhibit a remarkable variety in theme and composition [O]ne may question whether the actual landscape offers any such powerfully overhanging formations of strangely twisted and pitted rock as the album does.
>
> In one of the leaves, such a mass occupies almost the whole space of the picture, leaving only narrow ravines at the sides, in which travelers are visible on paths, climbing always upward. . . . He draws in heavy lines that taper at the ends and thicken where they bend; it is the interrelationships of these bent lines, together with sparse texture strokes and a limited use of ink wash, that define the shapes of the rocks and the hollows in and around them. Bushes and trees grow from crevices or on the tops of boulders and ridges. Presenting such a massive escarpment full face to the viewer . . . seems to endow the landscape with an unearthly inner life more than it portrays the effects of natural geological processes.[7]

These few sentences suggest the landscape elements in the picture, the way they are arranged, what kinds of strokes Wang Li used, and the effect of the work on the viewer.

Beginning with a description of the subject of the album as "powerfully overhanging formations of strangely twisted and pitted rock" gives the reader a vivid image to which each word has contributed. "Powerfully" suggests the way in which the rocks are "overhanging" and "formations" suggests the idea of shapes being created over time. This makes better sense after the next phrase, which describes the rocks as "strangely twisted and pitted." All of those words allow "mass," in the next sentence, to suggest a specific visual character. Similarly, "heavy lines that taper at the ends and thicken where they bend" is made up of words that occur in everyday language, but they combine to evoke how Wang Li's brush must have moved to deposit the ink as it did. With the phrase "massive encarpment," the final sentence reiterates the ideas of powerful formations and mass. Then it turns in the unexpected direction of the painted landscape having "an unearthly inner life," which suggests an entirely different dimension from the last phrase, "the effects of natural geological processes." Together, though, they convey a sense of wonder at how the picture presents its subject.

A Western oil painting offers very different qualities to describe from a Chinese ink painting. An exhibition review about Willem de Kooning's work by David Rosand conveys how dramatic the effect of paint and color can be:

> Among the first colors to emerge from de Kooning's monochrome palette of the late 1930s is a flesh pink. Modulated from near neutrality to cosmetic blowsiness, this hue never abandons its significance: throughout his work, it declares flesh. As de Kooning's paint itself acquires an increased substance, which in turn inspires and provokes the aggressiveness of the brush, his visceral equation of impasto and flesh becomes more integral to his art. This phenomenology of paint is most obviously realized in the *Woman* series (from c. 1950 inwards). . . . The series marks a watershed in his career: the return to figuration allowed the artist to acknowledge overtly the physiognomic basis of his painterly style, its source in the gestures of the body. . . . Even as de Kooning moved to an imagery of abstract landscapes, individual strokes, gestures developed in the earlier figures, continue to carry by allusion and recollection their sense of flesh – just as the recurring pink proclaims flesh.[8]

Like Cahill, Rosand saw the physical movements of the painter in the work he described, but they are "gestures of the body" rather than the hand. These gestures provide the "physiognomic basis" for de Kooning's style, and create a direct connection between the figural

subject and the presence of the artist. Color also is important, the crucial "flesh pink" changing from "near neutrality" to "cosmetic blowsiness."

Rosand used the word "impasto" to refer to de Kooning's paint. The term, which comes from the Italian word for dough, refers to accumulations of paint on the surface of a canvas, often textured so they catch the light. The technique first appeared in Venetian paintings made during the Renaissance, by Titian among others. Rembrandt van Rijn and Vincent Van Gogh are two other artists famous for manipulating oil paint in this way. By choosing this word, as well as describing the style as "painterly" (discussed below, pp. 25-6), Rosand connected de Kooning to a specific tradition of Western painting.

EKPHRASIS

One particular kind of visual description is also the oldest type of writing about art in the West. Called ekphrasis, it was created by the Greeks. The goal of this literary form is to make the reader envision the thing described as if it were physically present. In many cases, however, the subject never actually existed, making the ekphrastic description a demonstration of both the creative imagination and the skill of the writer. For most readers of famous Greek and Latin texts, it did not matter whether the subject was actual or imagined. The texts were studied to form habits of thinking and writing, not as art historical evidence.[9]

Homer's description of Achilles' shield in Book 18 of the *Iliad* stands at the beginning of the ekphrastic tradition. Two things about it became central to the genre. First, the passage implicitly compares visual and verbal means of description, most dramatically by weaving elements that could not be part of a shield (like movement and sound) with things that could be (like physical material and visual details). This emphasizes the possibilities of the verbal and the limitations of the visual. Second, the thing being described comes to seem real in the imagination of the reader, despite the fact that it could not exist.

Many writers in subsequent centuries followed Homer's lead and wrote ekphrastic descriptions. During the Italian Renaissance, the rhetorical form became an important literary genre and, in a surprising twist, artists made visual works based on written descriptions of art that had never existed.[10] A famous 19th-century example of ekphrastic poetry is John Keats's "Ode on a Grecian Urn," written in 1819. Like Homer, Keats mixed descriptions of things that could have been visible on a Greek vase with things that could not have been. Unlike Homer, Keats made himself and his own experience of viewing the

vase an important part of the poem. This shift in emphasis reflects a transformation in the genre of ekphrasis, which increasingly came to include the reaction of a particular viewer as part of the description of an object.[11]

In the second half of the 18th century, ekphrastic writing suddenly appeared in a new context. Travelers and would-be travelers provided a growing public eager for vivid descriptions of works of art. Without any way to publish accurate reproductions, appearances had to be conveyed through words alone. William Hazlitt, John Ruskin, and Walter Pater, to name three great 19th-century writers in English, published grand set-pieces of ekphrasis about older as well as contemporary art. For them, the fact that the object existed mattered a great deal. The goal of these Victorian writers was to make the reader feel like a participant in the visual experience. The more convincingly this was done, the more effective the writing was judged to be.

John Ruskin (1819-1900) was the most influential Victorian writer about art, famous for his impassioned defense of the painter J.M.W. Turner and his brilliant ekphrastic passages. In one of them, published in *Modern Painters* in 1843, he described Turner's *Slavers Throwing Overboard the Dead and Dying – Typhoon Coming On*, also known as *The Slave Ship* (Museum of Fine Arts, Boston). Like Homer and Keats, Ruskin mixed specific visual details of the picture with allusions to movement and sound in his description of what the painting looked like. Unlike them, his goal was to persuade readers to believe in his imaginative understanding of an actual work of art.

> It is a sunset on the Atlantic after prolonged storm; but the storm is partially lulled, and the torn and streaming rain clouds are moving in scarlet lines to lose themselves in the hollow of the night. The whole surface of the sea included in the picture is divided into two ridges of enormous swell, not high, nor local, but a low, broad heaving of the whole ocean, like the lifting of its bosom by deep-drawn breath after the torture of the storm. Between these two ridges, the fire of the sunset falls along the trough of the sea, dyeing it with an awful but glorious light, the intense and lurid splendour which burns like gold and bathes like blood. Along this fiery path and valley, the tossing waves by which the swell of the sea is restlessly divided, lift themselves in dark, indefinite, fantastic forms, each casting a faint and ghastly shadow behind it along the illumined foam. They do not rise everywhere, but three or four together in wild groups, fitfully and furiously, as the under strength of the swell compels or permits them; leaving between them treacherous spaces of level and whirling water, now lighted with green and lamp-like fire, now flashing back the gold of the declining

sun, now fearfully dyed from above with the indistinguishable images of the burning clouds, which fall upon them in flakes of crimson and scarlet, and give to the reckless waves the added motion of their own fiery flying. Purple and blue, the lurid shadows of the hollow breakers are cast upon the mist of the night, which gathers cold and low, advancing like the shadow of death upon the guilty* ship as it labors amidst the lightning of the sea, its thin masts written upon the sky in lines of blood, girded with condemnation in that fearful hue which signs the sky with horror, and mixes its flaming flood with the sunlight, – and cast far along the desolate heave of the sepulchral waves, incarnadines the multitudinous sea.

[Ruskin's note] *She is a slaver, throwing her slaves overboard. The near sea is encumbered with corpses.[12]

Ruskin's description is overwhelming. The weather, the light, the movement of the sea, the ship seen against the sky, are made vivid by his rich use of adjectives. Ruskin drew upon an immense vocabulary, using many words that are unfamiliar today. Even his Victorian contemporaries regarded his style of writing as exceptional. It shows the influence of the King James translation of the Bible and, in this particular passage, Shakespeare. These are references that Ruskin assumed his audience would understand, although any modern reader needs a dictionary and specialized knowledge to follow them.[13]

It is hard to imagine that anything important has been left out of Ruskin's description. A review of the painting when it was exhibited in London in 1840, however, written by the novelist William Thackeray, makes clear how much Ruskin ignored:

The slaver throwing its cargo overboard is the most tremendous piece of colour that ever was seen; it sets the corner of the room in which it hangs into flame. . . . Rocks of gamboge are marked down upon the canvas; flakes of white laid on with a trowel; bladders of vermilion madly spirited here and there. Yonder is the slaver rocking in the midst of a flashing foam of white-lead. The sun glares down upon a horrible sea of emerald and purple, into which chocolate-coloured slaves are plunged, and chains that will not sink; and round these are floundering such a race of fishes as never was seen since the saeculum Pyrrhae; gasping dolphins redder than the reddest herrings; horrid spreading polypi, like huge, slimy, poached eggs, in which hapless [black slaves] plunge and disappear. Ye gods, what a 'middle passage'![14]

Thackeray's account is as vivid and detailed as Ruskin's, but sarcastic in the style of some art criticism of the period. The excesses of the language are not only entertaining, but they convey something of what certainly appeared to many like the excesses of Turner's painting. "The sun glares down upon the horrible sea of emerald and purple," for example,

suggests how extraordinary the colors seemed. "Flakes of white laid on with a trowel" combines information about color and surface with a sense of making. In fact, although Ruskin did not mention it, Turner's handling of paint and the colors he used are dramatic, remarkable aspects of the work. Mention of the "Middle Passage," a reference to the Atlantic slave trade, directly relates Turner's picture to a contentious political issue of the time. Ruskin, by contrast, only included a note with the information that the picture showed a slave ship. In these respects, Thackeray's review is more informative than Ruskin's, even if it lacks the extraordinary imaginative reach and literary ambition of the set-piece from *Modern Painters*.

Modern writers about art have neither the number of readers nor the amount of space that Ruskin and Thackeray could assume. Furthermore, the ability to reproduce works of art in sumptuous color plates has reduced the importance of ekphrastic writing. Coffee-table art books, however, have provided a new venue. The writer need not create an image of the work for the viewer because superb illustrations are the point of the publication. Nonetheless, the best writers use the text to guide the reader through the works being discussed and, in the process, they interpret with their emphases and choice of words. A long passage by Robert Rosenblum (1927-2006) about J.A.D. Ingres's *Madame Moitessier* (National Gallery, London), for example, suggests the visual richness of Ingres's picture with the detail and complexity of the prose while leading us through the composition:

> At first, the dense luxury of Second Empire costume and *décor* dazzles the eye, above all in the cornucopian outburst of printed roses that spills across the silk dress, and then in the compounding of this splendor through the tufted damask of the sofa, the amethyst bracelet, the glimpse of a fan and oriental vase on the Rococo console, the gilded ornament of the mirror frame. Yet ultimately this *nouveau riche* opulence is subordinated to a strange silence and calm that completely contradict the portrait's initial assault upon our senses of sight and touch. For one, the mirror image that occupies the upper half of the painting provides a dull and hazy reflection that challenges the vivid clarity of the material world below
>
> Yet this dialogue between a real world and its dreamlike, immaterial reflection is not merely visual; it also involves the personality of the sitter A pampered creature of flesh as plump and cushioned as the sofa beneath her, she nevertheless becomes an enigmatic presence . . . a modern oracle presiding in the padded comfort of a mid-nineteenth-century drawing room. Her right hand, as pliable as a starfish, is posed weightlessly against her cheek and temple, as if enforcing her uncom-

mon powers of wisdom and concentration; and her eyes, compressed forward with the total volume of the head, appear to observe us both directly and obliquely. And to enrich even more this aura of a tangible yet remote being, Ingres has cast her reflection in pure profile, a ghostly sibyl who gazes as sightlessly as a marble statue into an invisible world.[15]

Rosenblum's description is long and complicated. Like the painting itself, this passage demands slow, careful attention to many details. Even with a reproduction of the picture next to it, the text contains so many particulars about costume, setting, and sitter that it takes time to absorb. Only at the end is there an interpretation of the "personality of the sitter," based on visual elements that fit into what the reader already knows. "A pampered creature" makes sense because of the details in the previous paragraph, while the idea of "a tangible yet remote being" has been suggested already in the discussion of the "dull and hazy reflection that challenges the vivid clarity of the material world below."

Rosenblum wrote another description of the same painting, this one included in a history of 19th-century art. The differences between them are revealing. Instead of forming an image of the work in the mind of the reader, the goal of any ekphrastic passage, this text relates the picture to other works made during the same time. The author highlights those aspects of the painting that suit his historical argument as well as his characterization of the artist's style. In addition, the identity of the sitter, part of the history of the work as well as the period, plays an active role in the analysis.

> [V]iewed through the lenses of period style, Ingres's portrait . . . make[s] us wallow in a plum-pudding richness of textures, materials, patterns that aspire to an airless density. Mme. Moitessier, of course, is a model of cool propriety in her wealthy Paris interior, and her posture alludes to classical prototypes; but she and Ingres clearly revel in her sumptuous inventory of possessions: the gilt console, the tufted damask sofa, the Chinese vase, the peacock-feathered fan, the bracelets and brooch with their enormous gems, and above all the full cascade of the rose-patterned silk dress with its embellishments of fringes and ribbons. But Ingres . . . transcends the Second Empire period look through his own genius, which here ennobles the sitter not only with the abstract, yet sensual linear circuits that command the undulant shapes of fingers, shoulders, and arms, but through an adaptation of the common antique pose of contemplative head-on-hand[16]

Like the passages quoted above, these two descriptions by Rosenblum depend upon the experience of many years spent looking and writing. Rich in language and disciplined

in structure, they build sentence by sentence on what came before. The reader is not allowed to wander off the direction the author has set and is not left in doubt about what is being discussed. The details also build upon one another, so the relationships among them are made clear. All of these examples demonstrate what the best art historical writing can achieve.

FORMAL ANALYSIS

Formal analysis is a specific type of visual description. Unlike ekphrasis, it is not meant to evoke the work in the reader's mind. Instead it is an explanation of visual structure, of the ways in which certain visual elements have been arranged and function within a composition. Strictly speaking, subject is not considered and neither is historical or cultural context. The purest formal analysis is limited to what the viewer sees. Because it explains how the eye is led through a work, this kind of description provides a solid foundation for other types of analysis. It is always a useful exercise, even when it is not intended as an end in itself.

The British art critic Roger Fry (1866-1934) played an important role in developing the language of formal analysis we use in English today. Inspired by modern art, Fry set out to escape the interpretative writing of Victorians like Ruskin. He wanted to describe what the viewer saw, independent of the subject of the work or its emotional impact. Relying in part upon late 19th- and early 20th-century studies of visual perception, Fry hoped to bring scientific rigor to the analysis of art. If all viewers responded to visual stimuli in the same way, he reasoned, then the essential features of a viewer's response to a work could be analyzed in absolute – rather than subjective or interpretative – terms. This approach reflected Fry's study of the natural sciences as an undergraduate. Even more important were his studies as a painter, which made him especially aware of the importance of how things had been made.[17]

The idea of analyzing a single work of art, especially a painting, in terms of specific visual components was not new. One of the most influential systems was created by the 17th-century French Academician Roger de Piles (1635-1709). His book, *The Principles of Painting*, became very popular throughout Europe and appeared in many languages. An 18th-century English edition translates de Piles's terms of analysis as: composition (made up of invention and disposition or design), drawing, color, and expression. These ideas and, even more, these words, gained additional fame in the English-speaking world

when the painter and art critic Jonathan Richardson (1665-1745) included a version of de Piles's system in a popular guide to Italy. Intended for travelers, Richardson's book was read by everyone who was interested in art. In this way, de Piles's terms entered into the mainstream of discussions about art in English.[18]

Like de Piles's system, Roger Fry's method of analysis breaks works into component parts, but they are different ones. The key elements are (in Joshua Taylor's explanation):

> Color, both as establishing a general key and as setting up a relationship of parts; line, both as creating a sense of structure and as embodying movement and character; light and dark, which created expressive forms and patterns at the same time as it suggested the character of volumes through light and shade; the sense of volume itself and what might be called mass as contrasted with space; and the concept of plane, which was necessary in discussing the organization of space, both in depth and in a two-dimensional pattern. Towering over all these individual elements was the composition, how part related to part and to whole: composition not as an arbitrary scheme of organization but as a dominant contributor to the expressive content of the painting.[19]

Fry first outlined his analytical approach in 1909, published in an article which was reprinted in 1920 in his book *Vision and Design*.[20]

Some of the most famous examples of Fry's own analyses appear in *Cézanne. A Study of His Development*.[21] Published in 1927, the book was intended to persuade readers that Cézanne was one of the great masters of Western art long before that was a generally accepted point of view. Fry made his argument through careful study of individual paintings, many in private collections and almost all of them unfamiliar to his readers. Although the book included reproductions of the works, they were small black-and-white illustrations, murky in tone and detail, which conveyed only the most approximate idea of the pictures. Furthermore, Fry warned his readers, "it must always be kept in mind that such [written] analysis halts before the ultimate concrete reality of the work of art, and perhaps in proportion to the greatness of the work it must leave untouched a greater part of the objective."[22] In other words, the greater the work, the less it can be explained in writing. Nonetheless, he set out to make his case with words.

One of the key paintings in Fry's book is Cézanne's *Still-life with Compotier* (Private collection, Paris), painted about 1880. The lengthy analysis of the picture begins with a description of the application of paint. This was, Fry felt, the necessary place of beginning because all that we see and feel ultimately comes from paint applied to a surface.

He wrote: "Instead of those brave swashing strokes of the brush or palette knife [that Cézanne had used earlier], we find him here proceeding by the accumulation of small touches of a full brush."[23] This single sentence vividly outlines two ways Cézanne applied paint to his canvas ("brave, swashing strokes" versus "small touches") and the specific tools he used (brush and palette knife). As is often the case in Fry's writing, the words he chose go beyond what the viewer sees to suggest the process of painting, an explanation of the surface in terms of the movement of the painter's hand.

After a digression about how other artists handled paint, Fry returned to *Still-life with Compotier.* He rephrased what he had said before, integrating it with a fuller description of Cézanne's technique:

> [Cézanne] has abandoned altogether the sweep of a broad brush, and builds up his masses by a succession of hatched strokes with a small brush. These strokes are strictly parallel, almost entirely rectilinear, and slant from right to left as they descend. And this direction of the brush strokes is carried through without regard to the contours of the objects.[24]

From these three sentences, the reader gathers enough information to visualize the surface of the work. The size of the strokes, their shape, the direction they take on the canvas, and how they relate to the forms they create are all explained. Already the painting seems very specific. On the other hand, the reader has not been given the most basic facts about what the picture represents. For Fry, that information only came after everything else, if it was mentioned at all.

Then Fry turned to "the organization of the forms and the ordering of the volumes." Three of the objects in the still-life are mentioned, but only as aspects of the composition.

> Each form seems to have a surprising amplitude, to permit of our apprehending it with an ease which surprises us, and yet they admit a free circulation in the surrounding space. It is above all the main directions given by the rectilinear lines of the napkin and the knife that make us feel so vividly this horizontal extension [of space]. And this horizontal [visually] supports the spherical volumes, which enforce, far more than real apples could, the sense of their density and mass.

He continued in a new paragraph:

> One notes how few the forms are. How the sphere is repeated again and again in varied quantities. To this is added the rounded oblong shapes which are repeated in two very distinct quantities in the compotier and the glass. If we add the continually repeated right lines [of

the brush strokes] and the frequently repeated but identical forms of the leaves on the wallpaper, we have exhausted this short catalogue. The variation of quantities of these forms is arranged to give points of clear predominance to the compotier itself to the left, and the larger apples to the right centre. One divines, in fact, that the forms are held together by some strict harmonic principle almost like that of the canon in Greek architecture, and that it is this that gives its extraordinary repose and equilibrium to the whole design.[25]

Finally the objects in the still-life have come into view: a compotier (or fruit dish), a glass, apples, and a knife, arranged on a cloth and set before patterned wallpaper.

In Fry's view of Cézanne, contour, or the edges of forms, are especially important. The Impressionists, Cézanne's peers and exact contemporaries, were preoccupied "by the continuity of the visual welt." For Cézanne, on the other hand, contour

became an obsession. We find the traces of this throughout this still-life. He actually draws the contour with his brush, generally in a bluish grey. Naturally the curvature of this line is sharply contrasted with his parallel hatchings, and arrests the eye too much. He then returns upon it incessantly by repeated hatchings which gradually heap up round the contour to a great thickness. The contour is continually being lost and then recovered . . . [which] naturally lends a certain heaviness, almost clumsiness, to the effect; but it ends by giving to the forms that impressive solidity and weight which we have noticed.[26]

Fry ended his analysis with the shapes, conceived in three dimensions ("volumes") and in two dimensions ("contours"):

At first sight the volumes and contours declare themselves boldly to the eye. They are of a surprising simplicity, and are clearly apprehended. But the more one looks the more they elude any precise definition. The apparent continuity of the contour is illusory, for it changes in quality throughout each particle of its length. There is no uniformity in the tracing of the smallest curve. . . . We thus get at once the notion of extreme simplicity in the general result and of infinite variety in every part. It is this infinitely changing quality of the very stuff of painting which communicates so vivid a sense of life. In spite of the austerity of the forms, all is vibration and movement.[27]

Fry wrote with a missionary fervor, intent upon persuading readers of his point of view. In this respect, his writing resembles Ruskin's, although Fry replaced Ruskin's rich and complicated language with clear, spare words about paint and composition. A text by Fry like the one above provides the reader with tangible details about the way a specific picture looks, whereas Ruskin's text supplies an interpretation of its subject. Of course,

different approaches may be inspired by the works themselves. Ignoring the subject is much easier if the picture represents a grouping of ordinary objects than if it shows a dramatic scene of storm and death at sea. The fact that Fry believed in Cézanne's art so deeply says something about what he believed was important in art. It also says something about the taste of the modern period, just as Ruskin's values and style of writing reveal things about the Victorian period. Nonetheless, anyone can learn a great deal from reading either of them.

Ellen Johnson, an art historian and art critic who wrote extensively about modern art, often used formal analysis. One example is a long description of Richard Diebenkorn's *Woman by a Large Window* (Allen Art Museum, Oberlin), which covers the arrangement of shapes into a composition, the application of paint, the colors, and finally the mood of the work. Although organized in a different order from Fry's analysis of Cézanne's still-life, her discussion defines the painting in similar terms.

> [Diebenkorn's] particular way of forming the picture . . . is captivating, . . . organizing the picture plane into large, relatively open areas interrupted by a greater concentration of activity, a spilling of shapes and colors asymmetrically placed on one side of the picture. In *Woman by a Large Window* the asymmetry of the painting is further enhanced by having the figure not only placed at the left of the picture but, more daringly, facing directly out of the picture. This leftward direction and placement is brought into a precarious and exciting but beautifully controlled balance by the mirror on the right which . . . creates a fascinating ambiguity and enrichment of the picture space.
>
> . . . The interior of the room and the woman in it are painted in subdued, desert-sand colors, roughly and vigorously applied with much of the drawing achieved by leaving exposed an earlier layer of paint. The edges of the window, table and chair, and the contours of the figure, not to mention the purple eye, were drawn in this way. In other areas, the top layer, roughly applied as though with a scrub brush, is sufficiently thin to permit the under-color to show through and vary the surface hue. . . . [T]he landscape is more positive in hue and value contrasts and the paint more thick and rich. The bright apple-green of the fields and the very dark green of the trees are enlivened by smaller areas of orange, yellow and purple; the sky is intensely blue. The glowing landscape takes on added sparkle by contrast with the muted interior Pictorially, however, [the woman] is anchored to the landscape by the dark of her hair forming one value and shape with the trees behind her. This union of in and out, of near and far, repeated in the mirror image, emphasizes the plane of the picture, the two-dimensional char-

acter of which is further asserted by the planar organization into four
horizontal divisions: floor, ledge, landscape and sky. Thus, while the
distance of the landscape is firmly stated, it is just as firmly denied

While the mood of the picture is conveyed most obviously through
the position and attitude of the figure, still the entire painting func-
tions in evoking this response . . . Lonely but composed, withdrawn
from but related to her environment, the woman reminds one of the
self-contained, quiet and melancholy figures on Greek funerary reliefs.
Like them, relaxed and still, she seems to have sat for centuries.[28]

Johnson's description touches on all aspects of what the viewer sees before ending
with a final paragraph about mood. Firmly situated in our understanding of specific
physical and visual aspects of Diebenkorn's painting, her analogy to the seated women
on Greek funerary reliefs enhances our ability to envision the position and spirit of this
woman. It makes the picture seem vivid by referring to something entirely other. The
image also is unexpected, so the description ends with an idea that catches our attention
because it is new, while simultaneously summarizing an important part of her analysis.
An allusion must work perfectly to be useful, however. Otherwise it becomes a distrac-
tion, a red herring that leads the reader away from the subject at hand.

The formal analysis of works other than paintings needs different words. In *Learning
to Look*, Joshua Taylor identified three key elements that determine much of our response
to works of sculpture. The artist "creates not only an object of a certain size and weight
but also a space that we experience in a specific way." A comparison between an Egyptian
seated figure (Louvre, Paris) and Giovanni da Bologna's *Mercury* (National Gallery of
Art, Washington, DC) reveals two very different treatments of form and space:

The Egyptian sculptor, cutting into a block of stone, has shaped and or-
ganized the parts of his work so that they produce a particular sense of
order, a unique and expressive total form. The individual parts have been
conceived of as planes which define the figure by creating a movement
from one part to another, a movement that depends on our responding
to each new change in direction. . . . In this process our sense of the third-
dimensional aspect of the work is enforced and we become conscious of
the work as a whole. The movement within the figure is very slight, and
our impression is one of solidity, compactness, and immobility.

In *Mercury*, on the other hand, "the movement is active and rapid:"

The sculptor's medium has encouraged him to create a free movement
around the figure and out into the space in which the figure is seen. This
space becomes an active part of the composition. We are conscious not
only of the actual space displaced by the figure, as in the former piece,

but also of the space seeming to emanate from the figure of Mercury. The importance of this expanding space for the statue may be illustrated if we imagine this figure placed in a narrow niche. Although it might fit physically, its rhythms would seem truncated, and it would suffer considerably as a work of art. The Egyptian sculpture might not demand so particular a space setting, but it would clearly suffer in assuming Mercury's place as the center piece of a splashing fountain.[29]

Rudolf Arnheim (1904-2007) also used formal analysis, but as it relates to the process of perception and psychology, specifically Gestalt psychology, which he studied in Berlin during the 1920s. Less concerned with aesthetic qualities than the authors quoted above, he was more rigorous in his study of shapes, volumes, and composition. In his best-known book, *Art and Visual Perception. A Psychology of the Creative Eye*, first published in 1954, Arnheim analyzed, in order: balance, shape, form, growth, space, light, color, movement, tension, and expression.[30] Many of the examples given in the text are works of art, but he made it clear that the basic principles relate to any kind of visual experience. In other books, notably *Visual Thinking and the Power of the Center: A Study of Composition in the Visual Arts*, Arnheim developed the idea that visual perception is itself a kind of thought.[31] Seeing and comprehending what has been seen are two different aspects of the same mental process. This was not a new idea, but he explored it in relation to many specific visual examples.

Arnheim began with the assumption that any work of art is a composition before it is anything else:

> When the eyes meet a particular picture for the first time, they are faced with the challenge of the new situation: they have to orient themselves, they have to find a structure that will lead the mind to the picture's meaning. If the picture is representational, the first task is to understand the subject matter. But the subject matter is dependent on the form, the arrangement of the shapes and colors, which appears in its pure state in "abstract," non-mimetic works.[32]

To explain how different uses of a central axis alter compositional structure, for example, Arnheim compared El Greco's *Expulsion from the Temple* (Frick Collection, New York) to Fra Angelico's *Annunciation* (San Marco, Florence). About the first, Arnheim wrote:

> The central object reposes in stillness even when within itself it expresses strong action. The Christ . . . is a typical *figura serpentinata* [spiral figure]. He chastises the merchant with a decisive swing of the right arm, which forces the entire body into a twist. The figure as a whole, however, is firmly anchored in the center of the painting, which

raises the event beyond the level of a passing episode. Although entangled with the temple crowd, Christ is a stable axis around which the noisy happening churns.[33]

Although his discussion identifies the forms in terms of subject, Arnheim's only concern is the way the composition works around its center. The same is true in his discussion of Fra Angelico's fresco:

> As soon as we split the compositional space down the middle, its structure changes. It now consists of two halves, each organized around its own center. . . . Appropriate compositional features must bridge the boundary. Fra Angelico's *Annunciation* at San Marco, for example, is subdivided by a prominent frontal column, which distinguishes the celestial realm of the angel from the earthly realm of the Virgin. But the division is countered by the continuity of the space behind the column. The space is momentarily covered but not interrupted by the vertical in the foreground. The lively interaction between the messenger and recipient also helps bridge the separation.[34]

All formal analysis identifies specific visual elements and discusses how they work together. If the goal of a writer is to explain how parts combine to create a whole, and what effect that whole has on the viewer, then this type of analysis is essential. It also can be used to define visual characteristics shared by a number of objects. When the similarities seem strong enough to set a group of objects apart from others, they can be said to define a "style." Stylistic analysis can be applied to everything from works made during a single period by a single individual to a survey of objects made over centuries. All art historians use it.

3. STYLISTIC ANALYSIS

The term "style" refers to the resemblance works of art have to one another. Enough visual elements must be shared by enough works to make their combination distinctive and recognizable to a number of people. A single cathedral cannot define the Gothic style any more than a single sculpture can define the style of its artist. Furthermore, the idea must convey meaning to enough people to become widely used. Art history is filled with stylistic definitions that were proposed but never adopted, or did not survive for long. This is not surprising. Ideas and tastes change, different things seem important at different times, and there always are major works that do not fit into a particular definition of a style. These exceptions offer constant challenge to any accepted order.

Many people have tried to define the idea of style in theoretical terms, hoping to make its use in art history more consistent. One of the most interesting attempts is by the philosopher Berel Lang. At the end of an essay about style, he wrote that "not only [is style] not a science but [it is] a version of fiction – a narrative form – tied to the literary trope of synecdoche in which one feature is an ingredient in all the others."[35] The last part of the sentence restates what everyone agrees is fundamental to the definition of any style, that some quality must be shared by every member of the group. The beginning of the sentence, that style is not a science, not something that can be measured and duplicated in experiments, is also assumed by most people.

It is the middle of Lang's sentence, the description of style as a kind of fiction, even a form of narrative or story-telling, that suggests something new. First, it emphasizes the degree to which style is an idea that has been created by someone rather than a quality that belongs to the objects. Like a work of fiction, it is an imaginative, interpretative accounting. Second, if it is a kind of story, it must come with a storyline. In other words, inherent in the idea of a particular style is some kind of meaning or significance. Decisions about what to look for, and what to include or exclude, have been made with a goal in mind. Even if that goal is not formed consciously, it is expressed through choices. Lang's concept is a useful reminder of how any particular definition of a style represents only one possibility among a nearly infinite number of alternatives.

PERSONAL STYLE

The idea of a personal style, which in the Western tradition goes back to the Greeks, seems to apply easily to the work of many artists.[36] All art historians rely upon it. Countless lectures, books, and exhibitions define the style found in art made by a single person. Inevitably, however, any definition of style puts as much outside as remains inside its boundaries. The usual way to minimize this problem is to create more divisions, perhaps a chronological ordering into early, middle, and late. The late or "old age" style has come to be valued as an especially interesting phenomenon, sometimes even as the culmination of an entire career. Other methods of organization may group the works of an artist by subject or medium.

Personal style is limited to the production of one artist, a specific historical individual. Works by others that look similar can be considered part of a school, or described as "in the style of." For some art historians, style can be found in the "touch," the viewer's sense of the hand of the artist working the material. Roger Fry, for example, argued that Cézanne's genius began with the way he applied paint. A late 19th-century art historian named Giovanni Morelli (1816-1891) found signs of individuality in details too insignificant for the artist to have considered consciously, such as the shape of ears.[37] There are many ways to conceptualize the relationship, and most art historians use a mix of qualities to define a personal style.

The traditional approach to deciding whether a particular artist painted a particular work, in the absence of documents that link them explicitly, is called connoisseurship. After careful looking and using many other relevant examples as the basis for comparisons, the art historian making an attribution comes to a decision based not so much on research as on intuition. The work "feels" right, meaning that it seems to resemble other works that can be identified conclusively as being by the artist. Sometimes another connoisseur challenges that judgment, "feeling" something else entirely and redefining the personal style. The history of art is filled with such changes in attribution. Usually the person who undertakes the job of gathering all of the works associated with one particular person decides what to include and what to leave out. This collection, often called by its French name of catalogue raisonné, reflects and, over time, shapes a general consensus. Since attribution influences the value a work has on the art market, it may matter a great deal.[38]

Attribution is, for the most part, a scholarly activity. Nonetheless, just knowing the

name of the artist can transform what a work looks like. This is an important example of seeing based on expectations. A very famous instance of false attribution happened with the 17th-century Dutch artist Jan Vermeer. Previously unknown paintings appeared in Holland during the 1930s and were attributed to him. At least one senior scholar proclaimed one work to be by Vermeer, which led to others being associated with the one that had been declared authentic. After World War II, they were revealed to be forgeries by an unsuccessful artist named Han van Meegeren. He painted a new fake in the courtroom during his trial to prove that he was, in fact, the one who had made the pictures. It is hard to imagine today how anyone ever associated them with Vermeer. The change in taste that inevitably comes with the passage of time has made them seem awkward and even ugly.[39]

An understanding of personal style also influences how historians relate an artist to his or her contemporaries. In 1979, Robert Herbert described Claude Monet's style in a lengthy and extremely detailed analysis. He began his article:

> The belief that Monet's art was one of improvisation is so firmly established that it dominates the 20th-century view of Impressionism. Monet planted his easel in front of his motif, we are told, and devised a method of instant response to nature, despite rain or winter frost. He was so determined to seize a special moment of color-light that he abandoned his canvas when conditions altered, and turned to another, only later going back to the first when the same moment was again available.[40]

Furthermore, according to this belief, Monet's interest in color-light overwhelmed all other considerations, including choice of subject. Herbert set out to prove the contrary – that Monet's art was the result of as much calculation and study as a landscape by a Renaissance master, or one by Paul Cézanne. "If it could be proved that Monet's art was not spontaneous, if it could be proved that it involved a long process," Herbert wrote, then the conventional opposition of Monet's technique to Cézanne's, and of Impressionism to Post-Impressionism, in fact the "whole edifice of Impressionist criticism would come tumbling down."[41]

Herbert analyzed the whole of Monet's career with immensely close readings of important paintings. In this respect, his study resembles Roger Fry's of Cézanne's art, but Herbert did not use the categories of formal analysis, and subject was very important to him. On the important question of the speed with which Monet worked, for example, he wrote:

> In the mid-1870s at Argenteuil, some [of Monet's] paintings were done very quickly, in large buttery strokes, but more numerous are canvases like the famous *Bridge at Argenteuil* [Musée d'Orsay, Paris], which were

worked on repeatedly, with drying time between the sessions. Their brushwork is varied to suit the imagery: smooth for sky, choppy for foliage, horizontal with lapping curves and diagonals for water, and directional strokes for boats and bridges. In each successive session Monet applied his paint quite frankly in strokes of one color, but frequently he wanted to change or enrich the color while retaining the underlying texture of "spontaneity." He therefore added thin surface colors. In the canvas [*Bridge at Argenteuil*], separate surface hues can be detected easily along the furled sail and, in the water, among the reflections of the toll house. The most remarkable spot is just ahead of the bowsprit of the farthest sailboat. There one stroke was allowed to dry, and then was artfully colored over (reading from left to right) in pale blue, peach, medium blue, orange-tan and then medium blue again.

These complexities of technique became greater and more prominent as Monet's career went on, so that by the early 1880s, "paintings that were really done very quickly were very rare."[42] Based on these and many other similar analyses, Herbert created a new understanding of Monet's art. He also changed the way historians view the art of Monet's contemporaries and the style of painting called Impressionism.

PERIOD STYLE

The concept of period style first appeared in the writings of the German scholar Johann Joachim Winckelmann (1717-1768). Often called the father of art history, Winckelmann developed a historical framework for Greek sculpture that was based on the way the objects looked. The Greeks and the Romans also had written about the works, but their histories and guides primarily discussed specific masterpieces or great artists. Winckelmann, on the other hand, created a structure that relied upon visual characteristics, which he defined with beautiful ekphrastic passages about individual sculptures.[43] This meant that it was possible to relate anonymous works about which little was known to the most famous art of the Ancient world. It also meant that an individual object could be considered, for example, a late example of a style. Date of making no longer determined the group in which a work was placed.

At least as important as Winckelmann's definition of style was his adoption of a biological model for its structure. Every style has to have boundaries, places where it begins and ends, and Winckelmann conceived of these in terms of the sequence of natural growth. Each style began with its birth (the early stage), progressed to maturity (the middle or classic phase), a decline (the late) and, finally, disappearance. Using this scheme

arranges works into a very specific order and it is an order that implies value judgments. Early or late examples, which in Winckelmann's view stand at the beginning or end of a style, are necessarily incomplete and thus imperfect. The mature, often called the classic, represents the fullest, the best, definition of the style.[44] This order is so common in modern art history that it is hard to conceive of it as the result of choices. Lang's definition of style, however, explained above (pp. 22-3), reminds us how much this scheme too depends upon interpretation.

Using variations of Winckelmann's model, historians and critics have created definitions of period style for many other kinds of art. One of the most important was developed by Heinrich Wölfflin (1864-1945) in *Principles of Art History*, published in German in 1915 and still read in English translation today. Two aspects of his book have been particularly influential. First is the way Wölfflin defined period style. He believed that analysis of particular works of art would "reveal the connection of the part to the whole"[45] and he decisively rejected the "analogy of bud, bloom, decay."[46] He created groups, not sequences, and defined their boundaries by opposing different uses of the same formal elements. This method of analyzing by opposition and comparison is still the way many art historical lectures are organized. Wölfflin took for granted that his groups were ultimately arbitrary, and discussed how many other ways the same material could be divided.[47]

The specific concepts used by Wölfflin to define certain period styles have been very influential. The idea of "linear" versus "painterly," linked to a fundamental change in the way European art from the 15th and 16th centuries looks compared to that from the 17th century, still appears in survey texts today. Historians also continue to use the word "painterly."[48] The other pairs Wölfflin explained in *Principles* have been less influential: plane/recession, closed/open form, multiplicity/unity, and clearness/unclearness.[49]

Even in translation, Wölfflin's analyses of particular works of art are exceptional. Like Winckelmann, he wrote about what he saw masterfully. His application of the concept of the painterly to sculpture, for example, results in a beautiful and vivid description of Gian Lorenzo Bernini's bust of Cardinal Borghese (Borghese Gallery, Rome):

> The surfaces and folds of the garment are not only of their very nature restless, but are fundamentally envisaged with an eye to the plastically indeterminate. There is a flicker over the surfaces and the form eludes the exploring hand. The highlights of the folds flash away like lizards, just like the highlights, heightened with white, which Rubens introduces into his drawings. The total form is no longer seen with a view

to the silhouette. . . . [The shoulders have] a contour which, restless in itself, at all points leads the eye beyond the edge [of the sculpture]. The same play is continued in the head. Everything is arranged with a view to the impression of change. It is not the open mouth which makes the bust baroque, but the fact that the shadow between the lips is regarded as something plastically indeterminate. . . . [I]t is fundamentally the same design that we found in [paintings by] Frans Hals and Lievens. For the transformation of the substantial into the unsubstantial which has only a visual reality, hair and eyes are in this case always especially characteristic. The "look" is here obtained by three holes in each eye.

Wölfflin summed up the alternative, the linear style, in one sentence about a portrait bust of Pietro Mellini by Benedetto da Majano (Museo Nazionale, Florence): "The essential point is that the form is enclosed in a firm silhouette, and that each separate form – mouth, eyes, the separate wrinkles – has been given an appearance of determinateness and immobility based on the notion of permanence."[50]

Through this and many other comparisons, Wölfflin argued for a division between the two periods, based on a fundamental change in the artistic style. "The whole notion of the pictorial has shifted. The tactile picture has become the visual picture – the most decisive revolution which art history knows."[51] Although he found the linear and the painterly in other places and periods – Impressionist painting, for example, was painterly – it was the movement from what we still call the Renaissance to the Baroque that interested him most deeply.

"REALISTIC"

One very distinctive visual style is sometimes treated as if it did not exist, because the work of art so directly represents the subject that they seem to be the same thing. This style is called "realistic" or, its near twin, "photographic." These terms are so widely used and misused that they should be avoided whenever possible. Of the two, "photographic" is the less informative because photographs can look like anything. There is no style inherent in the products of a camera. If a certain kind of photograph has been assumed by the writer, then which kind it is must be explained. Since the analogy requires its own explanation, the term "photographic style" creates more problems than it solves.

If "realistic" is used to mean a strong likeness to the appearance of things as we see them in the world, then the reader needs to know the particular ways in which the particular work resembles which aspects of the world. Social conventions play a part, since different people and different cultures define the world differently. For all of these reasons,

the most useful definition of this style – like that of any other – depends upon noting very specific visual features which are defined very specifically.

Certainly it is tempting to call paintings by Northern Renaissance artists such as Jan van Eyck "realistic." The pictures present an extraordinary amount of visual information about the surfaces of physical things. Texture, color, reflections, all appear in detail so fine that many of the individual brush stokes are invisible. In addition, the pictures convey a sense of three-dimensional light-filled space. A moment's thought, however, is all it takes to realize that what we call "realistic" is actually an illusion created by colored paint applied to a flat surface. Exactly how this illusion has been created is what needs to be explained. Using the term "realistic" does not help in this task.

4. The Biography

Although visual and stylistic analyses are fundamental to the practice of art history, the most familiar way of grouping art is by artist. The relationship is so close that common English usage drops the "by" in "a painting by Manet," so that it becomes "a Manet painting" or even "a Manet." In the last, only the small word "a" indicates that the "Manet" being discussed is an object rather than a person. This assumption of an intimate and important connection between the maker and the made has very practical implications. It rests on the belief that the actual historical person matters, the person who was born on a certain day and died on another. Exactly how and why the person matters is what determines how and why the life is important. This, in turn, will determine the questions considered in a biography. Like all assumptions of critical analysis, biographical ones should be examined closely.

The identity of the artist has been regarded as one of the most important facts about a work of art for centuries in the West. Beginning with the Greeks, names of great artists have seemed to be worth recording, and stories about them exist even when their works do not. Pliny the Elder and Pausanias, two Romans whose writings are among the richest sources of information about Greek art, approached their subjects as today's art historians do – from the distance of centuries, gathering what was said in older sources without necessarily having seen the original works.[52] The first history of art in the post-Classical world, Giorgio Vasari's *Lives of the Artists*, published in Italy in the mid-16th century, also organizes the art in terms of the biographies of its makers. Since Vasari was a contemporary or near-contemporary of the artists, his vivid anecdotes suggest the authority of personal knowledge.[53]

Even assuming that the identity of the artist is an essential part of understanding a work of art, however, different artists suggest different questions, and different historians write very different kinds of studies. For one scholar, the artist's life consists of an orderly succession of opportunities and achievements, with his or her relationship to the works determined by conscious choices made in response to external events. For another, perhaps even writing about the same person, every scrap of work reveals the genius of the artist, and obstacles that have been surmounted demonstrate the power of the person's talent. Unfinished works may seem more important than finished ones, because they suggest a

more immediate access to the creative process. In a psychoanalytical biography, all of the work is thought to reveal the unconscious, just as dreams do.

The same artist always can be studied from different points of view, but some present the historian with especially dramatic choices. The life and work of Vincent van Gogh have seemed to many to be especially close, his art an expression of the deepest truths about his innermost self. Most historians have presented Van Gogh as the quintessential troubled genius, beset by mental illness and constantly undermined by loneliness and financial difficulties. Individual works are seen as illustrations of the artist's emotional distress, with space that recedes too rapidly or tilts unexpectedly indicating mental imbalance, while twisted trees and dark foreboding cypresses reveal his melancholy. Furthermore, because the most famous works look so different from those by his contemporaries, the pictures seem to be without debt to a conventional artistic education or established masters.[54]

In *Ways of Seeing*, John Berger pointed out how profoundly our knowledge of Van Gogh's death from a self-inflicted gunshot wound influences the way we see his art. On one page of his book, above a small black-and-white reproduction of *Crows over Wheat Fields* (Van Gogh Museum, Amsterdam), Berger wrote "This is a landscape of a cornfield with birds flying out of it. Look at it for a moment. Then turn the page." The reader turns the page to find the same reproduction, but with an italicized, apparently handwritten caption beneath it: "*This is the last picture that Van Gogh painted before he killed himself.*" Then, in a new paragraph, the text continues in the typeface used throughout the book: "It is hard to define exactly how the words have changed the image but undoubtedly they have. The image now illustrates the sentence."[55] In fact, the belief that Van Gogh was working on this painting when he shot himself has become the basis of almost everyone's response to it, influencing explanations of the subject as well as the technique.

In her monograph about Van Gogh, Judy Sund tried to understand *Crows over Wheat Fields* as a work of art rather than as a revelation of inner life. She built her interpretation on Van Gogh's own words, taken from the many letters by him that survive. In early July of 1890, writing about tensions that made him feel as if his life were "threatened at the very root," he began to paint "vast fields of wheat under troubled skies." Sund discussed these pictures:

> The artist wrote . . . of painting two 'big canvases' in this vein, and it is generally agreed that [*Wheat Field under Clouded Sky* (Van Gogh Museum, Amsterdam) is one of them and] the famed *Crows over Wheat Fields* is the other. Often romanticized as Van Gogh's last painting (which it almost certainly was not), *Crows* has been read as a

virtual suicide note – its blackening sky and flock of dark birds taken for portents of his imminent death. Though Van Gogh would, in fact, shoot himself in a wheat field at the end of July, he probably had no plan to do so when he painted *Crows*, a vibrantly hued and lushly textured picture. Indeed, the artist felt that, despite their sad and lonely tenor, his vistas of wheat under heavy skies were visually expressive of something he had trouble describing verbally: a sense of 'the health and fortifying forces I see in the country.'

After this linking of the artist's own words with his painting, Sund considered other letters by Van Gogh to situate the picture in the larger context of his work:

> Despite *Crows*'s turbulent weather and low-flying birds, [it represents] the spectacle of a mature crop . . . Enraptured by the allusive connotations of the rural work cycle, [Van Gogh] . . . took comfort in the glimpses of a grand schema ('the infinite') that nature's cycles afforded. . . . It is also probable that Van Gogh related the swooping birds . . . to the sinister forces that undermine the efforts of the [Biblical] parable's sower . . . *Crows* would seem to proclaim the defeat of those agents of evil, since birds cannot harm a crop that stands ready to be reaped.[56]

In other words, separated from biographical legend and fit to Van Gogh's own sense of landscape, *Crows* becomes an affirmation of life in its subject as much as in its composition, colors, and brush strokes.

Artemisia Gentileschi is another artist who offers historians a dramatic choice about how to connect her life to her art. Gentileschi learned to paint in the studio of her father. In May of 1612, when Gentileschi was 19, her father sued an assistant named Agostino Tassi for raping his daughter. Tassi had been hired to teach her perspective and, according to court documents, had raped her in May of the previous year. After a lengthy trial, during the course of which Gentileschi was tortured to discover whether the allegation was true, Tassi fled from Rome while Gentileschi married someone else and moved to Florence. She went on to have a successful career as a painter in Italy and England.[57]

Mary Garrard wrote a monograph about Gentileschi in which she considered the artist in terms of issues raised by her gender. She argued that Gentileschi's major figure paintings of Biblical and Classical heroines should be read, at least in part, as expressions of the personal feelings of the artist. For example, Gentileschi's *Susannah and the Elders* (Collection Graf von Schoenborn, Pommersfelden), which depicts a subject popular among artists at the time, presents:

> a reflection, not of the rape itself, but rather of how one young woman

felt about her own sexual vulnerability in the year 1610. . . . *Susannah* does not express the violence of rape, but the intimidating pressure of the threat of rape. Artemisia's response to the rape itself is more probably reflected in her earliest interpretation of the Judith theme, the dark and bloody *Judith Slaying Holofernes* [(Uffizi, Florence)] . . . Once we acknowledge, as we must, that Artemisia Gentileschi's early pictures are vehicles of personal expression to an extraordinary degree, we can trace the progress of her experience, as the victim first of sexual intimidation, and then rape – two phases of a continuous sequence that find their pictorial counterparts in . . . *Susannah* and . . . *Judith* respectively.[58]

Griselda Pollock argued against Garrard's interpretation of Gentileschi's *Susannah and the Elders* as a form of autobiography:

[Garrard's] reading of *Susannah and the Elders*, of the awkwardly twisting, and distressingly exposed body, surmounted by the anguished face in the painting that places us so close to the vulnerability of the naked woman with the men so menacingly near, is true to what we now see. But how do we understand what we are seeing, historically?

Just as Sund placed Van Gogh's *Crows* in the context of the artist's own words, so Pollock tried to understand what *Susannah* might have meant to a viewer in Italy in 1610:

There is an excess in the nude body, in its sharp body-creasing twist, the flung-out hands, the taut neck and the downcast head. The face of Susannah is also disturbing. Its expressive tenor is pitched almost too high and its position draws it away from the body, creating distinct registers of representation. . . . These elements of pose, gesture and facial expression, the grammar of historical painting bequeathed by the High Renaissance Academy, endow the female body that is the luminous centre of the painting with an energy, a pathos and a subjectivity that does indeed run counter to the figuration of the female nude on display . . . That shift in effect is not, I would suggest, the result of Artemisia Gentileschi's knowing intention or her experience. The painting might suggest the tentative beginning of a possible grammar, arising out of inexperience as an artist, resulting from difficulties in resolving the integration of elements and of managing space as a narrative device.[59]

In Pollock's view, then, the painting describes a popular subject, depicted by an artist who was not yet able to manipulate all of the pictorial elements needed for a large figural composition. The awkwardness and twisting of Susannah's body is connected to Gentilischi's life, but by representing a stage in her artistic development, not her personal experience.

The examples of Van Gogh and Gentileschi may seem too extreme to be very revealing for ordinary art historical writing, never mind student papers. Nonetheless, they demonstrate how assumptions about the relationship between the life of the artist and his or her art can change the way the art is interpreted. Even a decision as simple as studying only one period in an artist's career has consequences. Whether intended or not, it separates some of the work from the rest, and does so using the artist's life to define the group. That such choices are made by art historians all the time is unavoidable, but they must be understood as choices. Objects do not come labeled this way.

5. ICONOGRAPHIC ANALYSIS

Considering a work in terms of the life of the person who made it creates one kind of historical context. There are many other ways to relate a work to history, though, involving different elements of the period from which it came. One of them is an iconographic analysis, which establishes the meaning a work of art had at the time it was made. This may or may not include what the maker of the work intended or, usually a more important factor, what the person who paid for the work wanted. Any particular time or place provides different possible audiences, each of which will demand specific kinds of information and make certain assumptions. The iconographic argument always depends upon assembling historical evidence to reconstruct these things.

Like all types of art historical analysis, an iconographic analysis must begin with what can be seen in the object or objects being considered. On the basis of these observations, the objects are related to other visual images and, probably, texts. This process may involve considerable historical research in primary sources and many languages, or a single reference to an authoritative secondary source. The result may be more than one interpretation. If they are mutually exclusive, the historian and the reader must decide which one seems most convincing. More often, though, different interpretations address different aspects of the work, so all of them can be historically accurate.

In the easiest case, a work of art depicts a subject that can be identified by anyone who knows what to look for. A handful of scenes from the life of Jesus, for example, appear again and again in Christian art. Just a few details are all it takes to turn a picture of a woman and an angel into an Annunciation, or a mother and a baby in a stable into a Nativity scene. Images like these were meant to be understood by many people, and they use well-established traditions that lasted for centuries. Research is needed to understand how a particular example differs from others and why that matters, or who created it and who paid for it, but the basic subject is clear. Something for which there is no known context, on the other hand, or that describes private feelings of the artist or patron, may be very hard to interpret.

Any iconographic analysis must explain as many visual elements in a work as possible. This is not as easy as it sounds, because people tend to see what they "know" is there. Leo Steinberg remarked about Michelangelo's *Last Judgment* (Sistine Chapel, Vatican, Rome):

The fresco's critical history is a classic instance of how an interpretative tradition feeds on itself, and how rarely the object interpreted is permitted to interfere. Through four centuries of continuous exposure, the Last Judgment ranked with the world's best-known monuments, incessantly reproduced and described, praised and denounced, scanned and scrutinized daily by thousands, with detail photographs available for the past hundred years. Yet it was not until 1925 that the face in the flayed skin held by Saint Bartholomew (to the right below Christ) was identified as the artist's self-portrait. Why this delayed recognition? What inhibited th[is] perception, which now seems so overwhelmingly obvious . . .?[60]

Sometimes, Steinberg observed, copies provide a new view of a familiar work:

Where a copy is manifestly at odds with its model, it not only leads me to see what the copyist missed but what I hadn't noticed. Ours is by nature a pejorative eye, better adapted to registering a mismatch than agreement. The discrepancies that lead to the eye in comparing replicas with their ostensible models are jolts to one's visual sloth.[61]

The art historian most closely associated with iconographic analysis is Erwin Panofsky (1892-1968). Panofsky brought his immense learning to the study of many subjects, but most of all to the study of Renaissance art. In *Early Netherlandish Painting*, he argued for a very particular way of understanding pictures made in Northern Europe during the 15th century. He suggested that many apparently ordinary objects actually symbolize religious ideas, with the result being a total "sanctification of the visible world." The problem, however, is that if "all forms meant to convey a symbolical idea could appear as ordinary plants, architectural details, implements, or pieces of furniture: how are we to decide where . . . symbolism begins?" Panofsky answered his own question:

We have to ask ourselves whether or not the symbolical significance of a given motif is a matter of established representational tradition . . .; whether or not a symbolical interpretation can be justified by definite texts or agrees with ideas demonstrably alive in the period [the work was made] and presumably familiar to its artists . . .; and to what extent such a symbolical interpretation is in keeping with the historical position and personal tendencies of the individual master.

Beyond these tests of historical plausibility lies the ultimate test of what Panofsky called the restraint of "common sense."[62]

An early example of "disguised symbolism" discussed in Panofsky's book is Robert Campin's *Mérode Altarpiece* (Cloisters, Metropolitan Museum of Art, New York), which shows the Annunciation in the central panel and the couple who commissioned the paint-

ing and Joseph in the left and right wings respectively. "The pot of lilies is perfectly at ease upon its table," Panofsky wrote, "and if we did not know its symbolical implications from hundreds of other Annunciations we could not possibly infer from this one picture that it is more than a nice still-life feature." Because of the many other times lilies appear with Mary in the same scene, however, "we are safe in assuming that the pot of lilies has retained its significance as a symbol of chastity; but we have no way of knowing to what extent the other objects in the picture, also looking like nice still-life features, may be symbols as well." He went on to suggest that several more were symbols, citing extensive visual and textual evidence as support:

> The laver and basin . . . [are] an indoors substitute for the 'fountain of gardens' and 'well of living waters,' one of the most frequent symbols of the Virgin's purity. The lions on the armrest of her bench bring to mind the Throne of Solomon . . . [a] time-honored simile of the Madonna. . . . And the candlestick, supporting the candle, . . . was also a familiar symbol of Our Lady . . . [although] the Marian symbolism of the candle itself seems to be superseded by the radiance of the Light Divine: the candle on the table has gone out, emitting a wisp of smoke, at the approach of the angel.[63]

Panofsky's understanding of the *Mérode Altarpiece* transforms a detailed depiction of Mary and a splendidly winged angel Gabriel in a 15th-century room into a description of the Virgin Mary in her many roles. For the informed viewer, this includes not only a reminder of all the events that are to come, but also their ultimate significance. These dimensions change the painting from one that tells a single story, a narrative painting, to one that alludes to the most profound truths of Christianity. The kneeling donors shown in the left panel offer a model of response for the viewer, as reverent witnesses to the founding event of the religion.

Panofsky used the same method to interpret Northern Renaissance paintings that did not have religious subjects. His discussion of Jan van Eyck's *Arnolfini Wedding* (National Gallery, London) begins with a full description of the "comfortably furnished interior, suffused with warm, dim light, [in which] Giovanni Arnolfini and his wife are represented in full length."[64] Taking into account the positions of the two figures, their gestures, and their facial expressions, as well as the symmetry of the composition and the signature of the artist displayed so prominently on the back wall, Panofsky concluded that the picture shows a marriage ceremony. If this is the meaning of the scene, then many individual details take on new meaning:

We begin to see that what looks like nothing but a well-appointed upper-middle-class interior is in reality a nuptial chamber, hallowed by sacramental associations and often sanctified It is not by chance that the scene takes place in a bedroom instead of a sitting room, for the matrimonial bed was so sacred that a married couple in bed could be shown and visited by the Trinity The crystal beads and the 'spotless mirror' . . . are well-known symbols of Marian purity. The fruit on the window sill recalls . . . the state of innocence before the Fall of Man. The little statue of St. Margaret, surmounting the back of the chair near the bed, invokes the patron saint of childbirth. The dog, as seen on so many tombs of ladies, was an accepted emblem of marital faith.[65]

Although subsequent scholars have disagreed with many of the details of Panofsky's account, many have accepted his interpretation of the scene as one related to the marriage of these two people.[66]

Iconographic analysis must be used differently for those works of art that seem not to have a single meaning. Sandro Botticelli's *Primavera* (Uffizi, Florence), painted in Italy just a few decades after Van Eyck's *Arnolfini Wedding*, has attracted the attention of many writers without one interpretation of it being accepted. "Are we dealing," wrote Martin Kemp, "with a high-flown form of painted philosophy or a delightful piece of secular invention which works a playful theme on mythological characters, with a particular emphasis on scantily dressed women?" He concluded that no one key to meaning could be found in the historical evidence, especially when different points of view and points in time were considered:

We may regard the immediate genesis of the picture as the devising of a delightful ensemble on the theme of the spring months over which Venus and Mercury preside. We may even make the more specific proposal that the ensemble was devised as a gift to celebrate the politically motivated wedding in 1483 of Lorenzo with Semiramide Appiani . . . We may imagine its assembly, much in the manner of a secular *Sacra conversazione*, with Venus [instead of Mary] and her [equivalent of Mary's] attendant saints and angels, not as a narrative or mythology, but as an assemblage evoking the realm of the goddess – an orange grove in the Garden of the Hesperides – and symbolising the specific season which is uniquely conducive to the flowering of young love. . . . [Renaissance texts] can be regarded as providing a vital underlying sanction for the commissioning of this *type* of picture and give an insight into the set of knowledge and attitudes through which some privileged viewers may have been able to endow it with high significance[67]

In this analysis, multiple interpretations are not just possible, but they are historically defensible and exist simultaneously. Even if the painting is, like Van Eyck's *Arnolfini Wedding*, about a particular marriage, it does not represent the people involved or the ceremony. Only "privileged viewers," those who possessed special "knowledge and attitudes," would be able to understand the subject. In this reading of *Primavera*, allusiveness and indirect references to things the painting does not show are as much a part of the intended meaning as the elements that actually appear in the composition.

Iconographic analysis also can be used to explain the meaning of a group of related works. In *The Image on the Edge. The Margins of Medieval Art*, Michael Camille considered what seems to be a puzzling, even shocking, kind of image. Around the most solemn prayers and sacred texts in many Gothic manuscripts, scribes introduced "lascivious apes, autophagic dragons, pot-bellied heads, harp-playing asses, arse-kissing priests and somersaulting jungleurs," among many other things.[68] The problem for the art historian is to understand how a reader of the words "Deus in audiutor" (O Lord hear my prayer) at the beginning of a 14th-century *Book of Hours* (British Museum, London, and J. Pierpont Morgan Library, New York) could possibly maintain a mood of devotion and concentration when the page also shows: "three monkeys [who] ape the gestures of the wise men seen above," "a spiky-winged ape-angel [who] grasps the tail of the 'D' [of 'Deus'], as if he is about to pull the string that will unravel it all," "a marvellous monster, known as a sciapod because of his one enormous foot, who proffers a golden crown," "a glaring gryllus," and more.[69] These images, equivalents of which exist in Gothic sculpture, seem inconceivable in a sacred context to a modern viewer. Thus an analysis of them has to consider not only what they meant, but how they could exist at all.

Camille tried to find evidence of a way of thinking in which these images would have made sense to their medieval viewers. Like Kemp, he looked for a "set of knowledge and attitudes" they might reflect. First he considered how 19th- and 20th-century writers had described them, but dismissed their concepts as inappropriate:

> The butterfly juxtaposed with a cooking-pot in the right margin of the opposite page [of the *Book of Hours*] might remind modern observers of the Surrealists' pleasure in the 'fortuitous meeting of a sewing machine and an umbrella on an operating table'. But . . . the exquisite incongruity of medieval marginal art refuses us the illusion of a dream. . . . Other words that, like 'surreal', are inappropriate for describing these creatures include the Romantic term 'fantastic' . . . and, most important of all, the negatively loaded term 'grotesque'.

Then Camille looked at words used by medieval writers, hoping to find a category to which the images might belong. Among the terms that seemed useful were the Latin "fibula" or "curiositates" (a fable; an elaboration, an extravagance) or a variant of "babuini" (monkey-business), or "fatrasies" from "fatras" (trash or rubbish), a genre of humorous poetry found in the Franco-Flemish region from which the *Book of Hours* came. The only problem with likening these types of writing to the Gothic works he was analyzing is that they did not exist in sacred contexts. A crucial aspect of the visual imagery is that the "systematic incoherence of marginal art is placed within, perhaps even against, . . . the Word of God."[70]

Camille concluded two things. One is that the modern sense of an absolute separation between the sacred and the secular does not correspond to medieval attitudes. All kinds of manuscripts, lives of saints as well as bawdy tales, could be bound together in a single volume. This mixing of very different things seems typical of the period:

> The concoction of hybrids, mingling different registers and genres, seems to have been both a verbal and a visual fashion for elite audiences. . . . But this still does not answer the question of what it was that such elevated patrons wanted in this garbage-world, this apish, reeling and drunken discourse that filled the margins of their otherwise scrupulously organized lives.[71]

To answer the question of what might be meant by such mixing, Camille looked again at the *Book of Hours* with which he had begun his inquiry:

> Every element springs into disordered life: line-endings lurch, rabbits run out from behind pen squiggles, hands emerge from holes in the vellum to play catch across the page. . . . Cooking-pots boil and pour water of their own accord, while other household objects dance Alongside the solemn text of the Office of the Dead, skeletons grin and cavort in playful putrefaction. . . .
>
> These images would not have shocked the Franco-Flemish lady who used this book, precisely because they articulated her world. . . . The people of the Middle Ages saw themselves at the edge, the last ageing dregs of a falling-off of humanity, the dissipated end of a Golden Age eagerly awaiting the Last Judgement.[72]

In other words, the prayer book came from a world that viewed itself as near its end. This idea informed every aspect of life and, in Camille's view, provides the context needed to understand the images.

Historians of 19th- and 20th-century art often face another kind of problem. The subject of a work seems so immediate as to need no interpretation at all. Many Impressionist paintings create a sense of just this ease of access. In fact, it forms an important part

of their appeal. John House discussed this question at the beginning of his book about Pierre-Auguste Renoir's *La Promenade* (J. Paul Getty Museum, Los Angeles):

> At first sight, *La Promenade* is one of the most engaging and approachable of all Impressionist paintings. Dappled sunlight plays across a woodland glade; a young man pulls the foliage aside from a narrow path to allow his female companion to pass; she turns her head aside, perhaps momentarily hesitant to go farther into the woods. The [painting] technique – ebullient, variegated, informal – complements this scene of relaxed companionship and courtship. To late-twentieth-century eyes the work raises few questions and poses few problems

After assessing the usefulness of a variety of historical sources of information about the painting, House stated the goal of his analysis: "How did Renoir's choice of this theme and the ways in which he treated it relate to the art of his contemporaries and to contemporary debates about the purpose of fine art and its role in society?"[73] In other words, what was the world like in which *La Promenade* was made, and how does that knowledge contribute to our understanding of this particular picture.

The analytical methods used by House are the same as those used by Panofsky, Kemp, and Camille. Despite the fact that *La Promenade* has no hidden symbolism or reference to mythology or religion, it too was created in a visual context that can be reconstructed by looking at similar pictures from the same period and texts written about similar subjects. The most important difference is that what the artist said about the work might survive, along with responses from contemporaries. So the first question the historian must consider is what importance should be given to which sources and, second, whether the artist has a privileged place in determining the meaning of a work. What if the artist's stated intention makes no sense of what viewers see? What if, instead of seeming like different aspects of the same meaning, the two seem incompatible? Who matters more, the artist or the viewer?

House decided that evidence from the 1860s and 1870s, the time when Renoir painted *La Promenade*, was more revealing than statements the artist made late in his life. "Many of the stories about Renoir and most of the accounts about his views come from his old age. . . . His accounts of his early career were viewed through the filter of . . . later concerns."[74] By contrast, the

> figures and setting [in *La Promenade*] linked it closely to contemporary social and moral debates, and the action itself is not seamless: the viewer is invited to interpret the play of gestures, although no clear

outcome to the action is indicated. On the borderline between popular illustration and fine art painting, its imagery would have resonated with familiar narratives of courtship and seduction, while its status as a fine art painting and its "artistic" technique would have marked it as an object of high culture, appealing to an enlightened elite.[75]

In other words, *La Promenade* represents not only a story suggested by the two figures, but also a very curious picture in 19th-century terms. The subject and the method of painting seemed to be at odds. The first was compatible with images that were popular at exhibitions and appeared by the thousands in contemporary publications. The second was new and distinctively modern, thus identifying the work as one of great artistic ambition.

This sense of contradiction between subject and technique, and recognition of deliberate choices dictated by an artistic purpose, are dimensions of *La Promenade* that modern viewers do not see. Separating the subject from the way it was painted creates a new way of looking at the picture, and suggests a method that can be applied to other works. House concluded: "In a sense this paradoxical combination sums up the early history of Impressionism – an utter rejection of the idealist world of academic art, coupled with an appeal to a new elite that placed the highest value on the virtuoso transformation of the individual's *sensations* into fine art."[76]

6. Historical Analysis

Iconographic analysis is used to establish the meaning of a particular work at a particular time. To identify the subject of an altarpiece as a Madonna and Child, however, explains nothing about the use of the altarpiece, how it fit into the surrounding culture, its economic import, or what it may reveal about social and political issues of the period. These questions apply most naturally to the study of objects from the past, but the same methods can be applied to contemporary art. What matters is the way the context is described and what kinds of relationships are established between it and the work or works being studied. This type of analysis is richest when it creates a web of very specific connections. To juxtapose a few generalizations about a historical context with a work from the period without suggesting any particular relationships between the two does not reveal very much.

Like so many kinds of writing about art, historical analysis became the subject of sustained investigation during the 19th century by scholars writing in German. Jacob Burckhardt (1818-1897) wrote the first major studies of art as an aspect of culture in his books about the Italian Renaissance, published during the 1860s. The idea that art should be considered primarily in terms of the economic structure that produced it rather than aesthetics was explored by Karl Marx (1818-1883). The influence on art of culture in its broadest definition, including politics, religion, and social conventions, as well as popular imagery and magical or irrational beliefs, became the subject of systematic study by Aby Warburg (1866-1929) in the late 19th and early 20th centuries. Different sorts of questions have been asked in the past few decades, as art historians have considered feminism, gender studies, and the impact of colonialism.[77]

In practice, art historians usually mix the types of analysis they use. The topic being studied may suggest certain questions and preclude others, or the writer may have very specific interests. One person might consider only those issues that are directly relevant to works of art. Another might use art as one type of evidence among many to investigate larger historical questions. The point of view chosen determines the shape of the analysis. For this reason, it is very important for the writer to be clear about his or her objective and then consider the best ways to achieve it. Not all questions and not all sources will be equally useful.

Sometimes contemporary events overwhelm a society, affecting every aspect of life. In *Painting in Florence and Siena after the Black Death. The Arts, Religion and Society in the Mid-Fourteenth Century*, Millard Meiss (1904-1975) argued that this happened at a moment central to the history of Italian Renaissance art. The book begins with a statement of his purpose:

> The present book deals with Florentine and Sienese painting from around 1350 to 1375 [T]hose aspects of reality and those problems of form that had occupied the leading masters of the first half of the century, and that were soon again to occupy the artists of the early Renaissance, were suddenly opposed by other values. The painters became engrossed with qualities which do not easily find a place in the evolution leading from Giotto to Masaccio, or from Simone [Martini] and the Lorenzetti [brothers] to Sassetta. The first part of the book endeavors to show that these qualities, however foreign to this evolution and to classical taste, are coherent and purposeful, and that the more important paintings of the time present a unique range of meaning and form. The subsequent chapters confront the problem of the emergence of this art, and they attempt to interpret it in the light of contemporary religious sentiment, contemporary literary thought, and a state of mind that was affected by a series of unusual events.[78]

After a number of political and economic disruptions, "unimaginable catastrophe struck both towns. Suddenly during the summer months of 1348 more than half of the inhabitants of Florence and Siena died of the bubonic plague. . . . Those fortunate few who were able to escape those horrible scenes of [death and dying] were . . . overwhelmed by the loss of family and friends."[79]

Life for survivors of the plague was changed in every respect. Economic disruption had brought great prosperity and political power to some. These new patrons of the arts, Meiss argued, "adhered to more traditional patterns of thought and feeling" which were better expressed by religious art of the late 13th century than by the new styles of the first half of the 14th century.[80] Religious piety became particularly intense, and new subjects entered art while old ones were represented in new ways. "The writing of the period, like the painting, was pervaded by a profound pessimism and sometimes a renunciation of life. . . . [T]he brevity of life and the certainty of death . . . was preached from the pulpits . . . and set forth in paintings, both altarpieces and murals."[81] Finally, religious institutions were flooded with donations from people who were dying or who expected to die. These resources permitted the beginning of ambitious projects of building and decoration.[82]

Painting and Experience in Fifteenth-Century Italy. A Primer in the Social History of Pictorial Style by Michael Baxandall (1933-2008), about art made just half a century later than that discussed by Meiss, is not about the extraordinary but about the ordinary. He too studied the "institutions and conventions – commercial, religious, perceptual, in the widest sense social – that were different from ours and influenced the forms of what they together made."[83] Baxandall tried to recover the assumptions of painters and viewers, the things they would have thought important and the things they would have taken for granted. He considered all sorts of historical information to construct an image of a "Quattrocento cognitive style as it relates to Quattrocento pictorial style."[84] Religious texts and the nature of the commission determined important aspects of the way religious pictures looked.[85] All images, religious and secular, used conventional ways to represent the human figure, especially in its movements. In Botticelli's *Primavera*, "the central figure of Venus is not beating time to the dance of the Graces but inviting us with hand and glance into her kingdom. We miss the point of the picture if we mistake the gesture."[86] Baxandall also identified ways of describing the world visually that were found in business as well as specialized professions such as medicine, preaching, and dance.[87] Finally, he analyzed the words in a Florentine text about art to establish the vocabulary used by 15th-century viewers of the pictures.[88]

The historical context Baxandall constructed depends upon extensive and inventive archival research, beyond the reach of all but a few scholars. The method he used, however, can be taken as a model:

> A society develops its distinctive skills and habits, which have a visual aspect, since the visual sense is the main organ of experience, and these visual skills and habits become part of the medium of the painter: correspondingly, a pictorial style gives access to the visual skills and habits and, through these, to the distinctive social experience. An old picture is a record of a visual activity. One has to learn to read it, just as one has to learn to read a text from a different culture, even when one knows, in a limited sense, the language: both language and pictorial representation are conventional activities.[89]

Thinking of a work of art as the product of a conventional activity is useful for any writer.

John Barrell analyzed a different kind of image and a different world in *The Dark Side of the Landscape. The Rural Poor in English Painting, 1730-1840*. He argued that the vision of rural life described by Thomas Gainsborough and John Constable, among others, "can

be understood only by understanding the constraints . . . that determined how the poor could, or rather how they could *not* be represented."[90] These pictures of rural life offer "the image of a stable, unified, almost egalitarian society." Only by considering this "mythical unity" in terms of what is shown, how it is organized within the composition, and how this relates to the social realities of the time can the ways in which the painters construct-ed this "artifice" be understood. Furthermore, Barrell suggested, these "constraints still operate in subtle ways today." "We should ask ourselves whether we do not still, in the ways we admire Gainsborough, Stubbs, and Constable, identify with the interests of their customers [who purchased these pictures] and against the poor they portray."[91] In other words, Barrell's analysis also may explain ways in which modern viewers respond to these pictures.

Even a single work can reveal a great deal about the society that produced it. Simon Schama and Svetlana Alpers both wrote about Jan Vermeer's *Allegory of Painting* (Kunsthistorisches Museum, Vienna). A major work by Vermeer, it is of great interest for what it suggests, or might suggest, about the artist's conception of painting.

> [Vermeer] portrayed [the artist] from behind, dressed in a fanciful cos-tume from a past era. The importance of the artist's work is evident in the elegant room in which he paints, with its chandelier, lush curtain, and chairs. Most significantly, the artist is portraying an allegorical figure, Clio, the muse of History.
> Clio is posed as described by Cesare Ripa [in his book of symbols], as a girl with a crown of laurel, symbolizing Fame, and holding a trum-pet and a volume of Thucydides, symbolizing History.[92]

Schama and Alpers, however, were not interested in any of those aspects of the painting so much as in the large map that hangs behind the figures on the wall of the studio. For both historians, that one detail offers important information about contemporary attitudes.

For Schama, the map in Vermeer's *Allegory of Painting* reveals the complexity of the Dutch sense of identity at the time:

> It had taken almost a century . . . before "the Fatherland" became ex-clusively associated in Dutch minds with the seven provinces and their directly governed territories in Flanders, Brabant, and Limburg. Even then, there remained some groups in the population, by no means all Calvinist, who yearned for a "reunion" across the river barriers. Dutch Catholics, who constituted over a third of the population, stood to gain the most . . . It may be that Vermeer . . . expressed such a nostalgic view of the old Netherlands and its art in his *Allegory of Painting* . . . In the map that appears so prominently above the figure of the painter

(once thought to be a self-portrait) the Fatherland is represented, not in its new guise, as the seven provinces of the Republic, but the seventeen of the humanist Renaissance.[93]

In this way, Vermeer's picture both illustrates and seems to prove Schama's thesis about the development of a national identity. Furthermore, it combines two crucial factors – the physical definition of the country and the role religion played in how people felt. Although Schama's purpose was not a general discussion of Vermeer, in fact his analysis gives the artist a place and a context that is very relevant to an art historical understanding of the painting and its maker.

Svetlana Alpers wrote about the culture of the period. In *The Art of Describing. Dutch Art in the Seventeenth Century*, she argued for a new way of understanding the art by placing it within contemporary "visual culture" (a term she credited to Baxandall).[94] One characteristic of this culture and of its art, she suggested, is "the mapping impulse," which she defined with a lengthy analysis of Vermeer's *Allegory of Painting*. Like Schama, she found the map hanging on the wall to be filled with meaning. Unlike him, Alpers built her interpretation on the visual role the map plays in the picture. First, it is a "powerful pictorial presence" which catches the viewer's attention in many ways. The details are so specific that the particular map can be identified. It is large, with many visual components, including lettering, pictures, and the lines of the map itself. Finally, Vermeer placed his signature on it. In all these ways, Vermeer likened the painting to the map and, by extension, the act of painting to the act of map-making. For Alpers, this similarity reveals something essential about the Dutch idea of painting:

> The aim of Dutch painters was to capture on a surface a great range of knowledge and information about the world. They too employed words with their images. Like the mappers, they made additive works that could not be taken in from a single viewing point. Theirs was not a window on the Italian model of art but rather, like a map, a surface on which is laid out an assemblage of the world.[95]

Both authors drew upon tremendous knowledge of the period in their analyses of Vermeer's painting. Both also used the painting as evidence of larger attitudes. Schama's book is about the historical period though, and the visual character of this particular picture is not relevant. The things at the core of Alpers's discussion – especially the importance of the map in the composition and the extraordinary amount of detail that can be seen in it – illustrate an idea that is not directly related to the meaning of the painting. For

Alpers though, the painting is of interest in all its aspects. The things shown in it as well as their arrangement identify fundamental qualities in Dutch art of the period.

In many ways, the argument made by Alpers about Vermeer's painting is closer to a stylistic analysis than to Schama's historical analysis. Although the likeness is real, the differences are important. Like Wölfflin, Alpers identified characteristics in many particular works and used them to form a notion of a period style. The characteristics belong to the culture of the period, however, defined by activities such as map-making and optics, not the appearance of the art. Presenting a particular work as part of the surrounding culture makes a conceptual likeness to maps more revealing and more useful than a visual likeness to other pictures by Vermeer or his contemporaries. Like Baxandall, she looked at other visual activities of the time to help understand the pictures in their original context.

A more complicated problem of cultural analysis arises when the same work of art plays an important role in very different societies. Sub-Saharan African sculpture, for example, profoundly influenced modern Western artists. Yet, as Frank Willett explained, people from each society would see the works very differently: "A great deal of satisfaction can indeed be found in looking at African sculpture without background information, . . . but one is not necessarily sharing in the sculptor's experience or enjoying the sensation he intended to convey."[96] Not only is the original meaning lost, but mood and expression, qualities that deeply interested modern artists, are very likely to be misread. Furthermore, the constraints of the original context are completely unknown to the modern viewer. In fact, "there were two forces at work in the creation of traditional African sculpture: the established artistic style appropriate to the type of the object being made, and the individual vision of the carver himself."[97] These are not things that can be understood by looking at a single work, or generalizing from one work to others.

To understand how tribal objects appeared and functioned in the time and place of their making requires an imaginative recreation of an entire world. This involves more than an anthropological study of the society. It also concerns the words and concepts used to describe visual things. Robert Thompson put together a list of nineteen visual criteria Yoruba people mentioned repeatedly when talking about their sculpture. The qualities include: "jijora, or the moderate resemblance to the subject," "ifarahon, visibility," or clarity in the massing of the forms, "didon, luminosity, or shining smoothness of surface," and "gigun, a straight upright posture and symmetrical arrangement of the parts of the

sculpture."[98] With this list, Thompson created something like Baxandall's definition of the 15th-century Italian Renaissance "period eye."

Roger Fry wrote about and collected African art, one of many modern critics and artists to do so. In his last lectures, given at the Slade School in London during the mid-1930s, Fry argued that modern art owed more to African art than to any other tradition.[99] Using the vivid and eloquent language for which he had become famous, Fry described a number of works to indicate the great range of form and style that could be found in African sculpted heads:

> [In one head, t]he artist has seized on the dome-like dominance of the forehead, and he has found how to support it by increasing immensely the bulging salience of the eyes and, with slight variations, the promi-nence of the nose; and against these he has played the straight line of the base of the nose and the terrible horizontal prominence of mouth and teeth. But, as often as not, an African sculptor will suppress the mouth altogether, or reduce it to a slit, and build on the hollow of the eye-orbit, in exact contradiction to the treatment of this head, which eliminates the orbit almost entirely. . . .
>
> [Another work shows] an utterly different choice The mouth is almost suppressed, and the ridge of the nose becomes a support to the almost plant-like exfoliation of the eyes. These are deeply undercut beneath the eyelids, . . . [creating] deep shadows beneath the weight of the prominent lids . . . The hair treated with extraordinary delicacy and precision picks up again the almost vegetable regularity of the features. This chevelure folds like a calyx round the forehead. And here again, what delicate sensibility the curvature of the brow shows; how right, we feel, the bold flattening of the cheeks and what a rare discovery is the sharp but delicate salience of the chin, which seems to close and hold this strangely beautiful plastic sequence.[100]

In an article about abstract art published just a few years later, in 1937, Meyer Schapiro (1904-1996) suggested how complicated the relationship was between Western artists and "primitive" art:

> A whole complex of longings, moral values and broad conceptions of life were fulfilled in [this new responsiveness to primitive art]. If co-lonial imperialism made these primitive objects physically accessible, they could have little aesthetic interest until the new formal concep-tions arose. But these formal conceptions could be relevant to primi-tive art only when charged with the new valuations of the instinctive, the natural, the mythical as the essentially human Time ceased to be an historical dimension; it became an internal psychological mo-ment, and the whole mess of material ties, the nightmare of a deter-

mining world, the disquieting sense of the present as a dense historical point to which the individual was fatefully bound – these were automatically transcended in thought by the conception of an instinctive, elemental art above time. . . . The colonies became places to flee to as well as to exploit.[101]

Schapiro's interpretation gives a different sense to Fry's words. It makes clear the degree to which they are part of Western artistic traditions and Western ways of describing. It also gives them an emotional edge, a sense of discovery that is bound to larger concerns. As Willett suggested, the sculptures Fry saw were not the ones that had been made by particular people in sub-Saharan Africa. Although physically the same objects, they had been transformed in appearance and meaning by historical context.

Gender – of artists, patrons, and viewers, as well as artistic subjects – has become a major area of study in the past few decades. Botticelli's *Primavera* is one painting that looks very different in light of feminist and gender studies. An important older art historical study of the nude is by Kenneth Clark (1903-1983), who created a distinction still used today:

> The English language, with its elaborate generosity, distinguishes between the naked and the nude. To be naked is to be deprived of our clothes, and the word implies some of the embarrassment most of us feel in that condition. The word "nude," on the other hand, carries . . . no uncomfortable overtones. The vague image it projects into the mind is not of a huddled and defenseless body, but of a balanced, prosperous, and confident body: the body re-formed. In fact, the word was forced into our vocabulary by critics of the early eighteenth century to persuade the artless islanders [of Britain] that, in countries where painting and sculpture were practiced and valued as they should be, the naked human body was the central subject of art.[102]

Botticelli's *Primavera* is one of many works discussed by Clark. With the figures of the three Graces, Clark wrote, Botticelli "achieved an extraordinary affinity with Greek figures that he cannot possibly have seen." By presenting them as dancers, he showed their bodies in movement, covered with the flowing lines of near-transparent garments. "So naked beauty reappeared in the Renaissance as it first emerged in Greece, protected and enhanced by *draperie mouillée*" (or "wet drapery").[103] The central figure was an ideal "gentle priestess."[104]

Considering *Primavera* in terms of its historical and cultural context as well as gender studies, rather than the artistic tradition of the representation of the human nude, pro-

duces a radically different understanding. Lilian Zirpolo argued that one way the painting should be seen is "as a model of behavior for the bride," in whose honor the picture had been commissioned:

> Botticelli's Graces . . . represent not only purity and chastity but also the demeanor that befitted the virtuous Renaissance woman. Their measured and elegant gestures and their unemotional facades evoke not only . . . [the] concept of the commendable maiden but also . . . the ideal wife. In the *Primavera*, the Three Graces perform a dance with movements that are as calculated and restrained as the movements . . . recommended for a virtuous wife.[105]

This is close to Baxandall's analysis of the figures in terms of gesture and dance. Zirpolo then turned to the nature of noble marriages in the Renaissance, a subject that adds another aspect to her study. Since such marriages were arranged for political, economic, and dynastic advantage, it was essential that the bride submit to the will of her husband. This is also represented in Botticelli's painting, Zirpolo wrote:

> This vision of marriage for the sake of the families and the emphasis on the bride's submission are expressed by the depicted rape scene showing Chloris pursued by Zephyrus, the West Wind, whose intention is to ravish her. . . . To compensate Chloris for his actions, Zephryus married her and gave her the domain of flowers, changing her name to Flora.
>
> Within the festive atmosphere that permeates the *Primavera*, the brutality of the rape scene can hardly be discerned. Yet, upon close scrutiny it becomes evident that, in contrast to the other female figures in the painting, who are tall, slender, and graceful, Chloris has a beast-like appearance. Her stance resembles that of a frightened and animal defenseless animal, a panic-stricken creature who tries in vain to flee as she is about to fall prey to her hunter.

Zirpolo supported her visual observations by citing several contemporary traditions about marriage that might justify associating it with rape.[106]

Roger Fry also discussed Botticelli's paintings:

> How all these images are charged with emotive power! To begin with, the nude figure, however idealized and etherealized it may be, as it is here, must carry some vague overtones of sexual feeling. . . . [The subject] carries with it a whole mass of suggestions which will vary with the degree of the spectator's knowledge of Classical poetry. . . . But when we pass from the imagery to the mode in which it is presented, . . . we are getting into closer contact with Botticelli's spirit. . . . And at this point we begin to yield ourselves to the rhythmical movements of

Botticelli's linear design, to its mazy interweft of curves leading us on with a charmed motion from one to another with echoes arising from all different parts of the design. . . . But my main purpose has been to make clear to you how complicated a matter a work of art may be and to indicate at how many points two spectators may diverge in their reactions, each starting off, it may be, upon some side track down which their personal make-up or their past experiences may tempt them.[107]

In beautiful and evocative language, Fry suggested the potential richness of any work of art. He did not dictate the response of the spectator or the direction of possible research. He only insisted that investigations be based on very careful looking, and that the conclusions be written as clearly as possible.

NOTES

1. T.E. Hulme, "Romanticism and Classicism," in *Speculations on the Humanism and the Philosophy of Art* (London: Routledge and Kegan Paul, 1958), 132-3.

2. Stephen A. Wainwright, *Axis and Circumference. The Cylindrical Shapes of Plants and Animals* (Cambridge, MA and London: Harvard University Press, 1988), 7.

3. Joshua C. Taylor, *Learning to Look. A Handbook for the Visual Arts*, 2nd ed. (Chicago and London: University of Chicago Press, 1981).

4. William Strunk, Jr. and E.B.White, *The Elements of Style* (New York: Macmillan, 1959). The 4th edition, published in 2000, has a foreword by Roger Angell.

5. Marilyn Stokstad, *Art. A Brief History*, 3rd ed. (Upper Saddle River, NJ: Pearson/ Prentice-Hall, 2007), fig. 26, p. 16, illustrates one such reconstruction of the frieze of the Parthenon.

6. Stokstad, 349.

7. James Cahill, *Parting at the Shore: Chinese Painting of the Early and Middle Ming Dynasty, 1368-1580* (New York and Tokyo: John Weatherhill, 1978), 6-7.

8. David Rosand, "Proclaiming Flesh," *Times Literary Supplement* (17 February 1984), 167.

9. Ruth Webb, "Ekphrasis," in *Grove Art Online. Oxford Art Online*, http://www.oxfordartonline.com (accessed August 22, 2008).

10. One such painting, Sandro Botticelli's *Calumny of Apelles* (Uffizi, Florence), is discussed and illustrated in Webb, "Ekphrasis," Section 4.

11. Robert Langbaum, *The Poetry of Experience. The Dramatic Monologue in Modern Literary Tradition* (New York: W.W. Norton, 1957), 53-4.

12. John Ruskin, *Modern Painters* in *The Complete Works of John Ruskin* (Library Edition), eds. E.T. Cook and Alexander Wedderburn (London: George Allen, 1903-1912), 3:571-2.

13. Elizabeth K. Helsinger, *Ruskin and the Art of the Beholder* (Cambridge, MA: Harvard University Press, 1982), 180-2 and *passim*.

14. William Hazlitt, *Critical Papers in Art* (London: Macmillan and Co., 1904), 124 (rpt., Royal Academy review, orig. publ. *Fraser's Magazine*, June 1840).

15. Robert Rosenblum, *Jean-Auguste-Dominique Ingres* (New York: Harry N. Abrams, 1967), 164.

16. Robert Rosenblum and H.W. Janson, *19th-Century Art*, rev. ed. (Upper Saddle River, NJ: Pearson/Prentice Hall, 2005), 249-50.

17. A full study of this subject can be found in Beverly H. Twitchell, *Cézanne and Formalism in Bloomsbury. Studies in the Fine Arts: Criticism, No. 20* (Ann Arbor, MI: U.M.I. Research Press, 1987).

18. Elizabeth Gilmore Holt, ed., *A Documentary History of Art* (Garden City, NY: Doubleday, 1958), 2:176-7 and 184.

19. Taylor, 63.

20. Roger Fry, "An Essay in Aesthetics," in *Vision and Design* (orig. publ. 1920; rpt. New York: New American Library, 1974),16-38.

21. Roger Fry, *Cézanne. A Study of His Development* (orig. publ. 1927; rpt. New York: Farrar, Straus & Giroux, 1968).

22. Quoted by Alfred Werner, "Introduction," Fry, *Cézanne*, n.p.

23. Fry, *Cézanne*, 42.

24. Fry, *Cézanne*, 45.

25. Fry, *Cézanne*, 47-8.

26. Fry, *Cézanne*, 50-1.

27. Fry, *Cézanne*, 51.

28. Ellen H. Johnson, *Modern Art and the Object. A Century of Changing Attitudes*, rev. ed. (New York: Icon Editions, 1995),133-4.

29. Taylor, 88-90.

30. Rudolf Arnheim, *Art and Visual Perception. Psychology of the Creative Eye* (Berkeley and Los Angeles: University of California Press, 1954).

31. Rudolf Arnheim, *Visual Thinking* (Berkeley and Los Angeles: University of California Press, 1969) and *The Power of the Center. A Study of Composition in the Visual Arts* (Berkeley and Los Angeles: University of California Press, 1982).

32. Arnheim, *Center*, 71.

33. Arnheim, *Center*, 84.

34. Arnheim, *Center*, 87.

35. Berel Lang, "Looking for the Styleme," in *The Concept of Style*, ed. Berel Lang, rev. ed. (Ithaca, NY: Cornell University Press, 1987), 182.

36. J.J. Pollitt, *The Art of Greece, 1400-31 B.C. Sources and Documents in the History of Art Series* (Englewood Cliffs, NJ: Prentice-Hall, 1965), xvi.

37. A fascinating analysis of Morelli's method of analysis in its contemporary context can be found in Carlo Ginzburg, "Morelli, Freud and Sherlock Holmes: Clues and Scientific Method," *History Workshop. A Journal of Socialist Historians* 9 (Spring 1980): 5-36.

38. For a discussion of traditional connoisseurship and some recent changes in the methods used, see Leonard J. Slatkes, "Review of *Rembrandt Research Project. A Corpus of Rembrandt Paintings, 1625-1631*, by J. Bruyn, B. Haak, S.H. Levie, P.J.J. van Thiel, and E. Van der Wettering (The Hague: Martinus Nijhoff Publishers, 1982)," *Art Bulletin* LXXI (1989): 139-44.

39. Arthur K. Wheelock, Jr., *Jan Vermeer*, rev. ed. (New York: Harry N. Abrams, 2004), 45-6. A full account of the forgeries can be found in Jonathan Lopez, *The Man Who Made Vermeers. Unvarnishing the Legend of Master Forger Han van Meegeren* (New York: Harcourt, Inc., 2008).

40. Robert L. Herbert, "Method and Meaning in Monet," *Art in America* 67 (September 1979): 90.

41. Herbert, 92.

42. Herbert, 97.

43. David Irwin, ed., *Winckelmann. Writings on Art* (New York: Phaidon Press, 1972), 4-5 and 53-4.

44. Alex Potts, "Winckelmann, Johann Joachim," in *Grove Art Online. Oxford Art Online*, http://www.oxfordartonline.com (accessed August 22, 2008).

45. Heinrich Wölfflin, *Principles of Art History. The Problem of the Development of Style in Later Art*, trans. M.D. Hottinger (orig. publ. 1915; New York: Dover Publications, 1960), 6.

46. Wölfflin, 13.

47. Wölfflin, 14.

48. See, for example, "painterly" listed as a term of stylistic analysis in Stokstad, xxviii.

49. Wölfflin, 15-6.

50. Wölfflin, 56-8.

51. Wölfflin, 21.

52. Pollitt, ix-xii.

53. Julian Kliemann and Antonio Manno, "Vasari. III," in *Grove Art Online. Oxford Art Online,* http://www.oxfordartonline.com (accessed August 22, 2008).

54. See, for example, Stokstad, 515.

55. John Berger, *Ways of Seeing* (New York: Penguin Books, 1972), 27-8.

56. Judy Sund, *Van Gogh. Art & Ideas Series* (New York: Phaidon Press, 2002), 295-7.

57. Ann Sutherland Harris and Judith W. Mann, "Artemisia Gentileschi," in *Grove Art Online. Oxford Art Online,* http://www.oxfordartonline.com (accessed August 22, 2008).

58. Mary D. Garrard, *Artemisia Gentileschi: the Image of the Female Hero in Italian Baroque Art* (Princeton, NJ: Princeton University Press, 1989), quoted in Griselda Pollock, *Differencing the Canon. Feminist Desire and the Writing of Art's Histories* (London and New York: Routledge, 1999), 106.

59. Pollock, 114.

60. Leo Steinberg, "The Line of Fate in Michelangelo's Painting," in *The Language of Images*, ed. W.J.T. Mitchell (Chicago and London: University of Chicago Press, 1980), 96-7.

61. Steinberg, 85-6.

62. Erwin Panofsky, *Early Netherlandish Painting. Its Origin and Character* (Cambridge, MA: Harvard University Press, 1953), 1:142-3.

63. Panofsky, 1:143. For a summary of the recent scholarship about the *Mérode Altarpiece*, especially as it relates to Panofsky's interpretation of it, see Bernhard Ridderbos, "Objects and Questions" in Bernhard Ridderbos, Anne van Buren, and Henk van Veen, eds., *Early Netherlandish Paintings. Rediscovery, Reception, and Research*, tr. Andrew McCormick and Anne van Buren (Los Angeles: Getty Publications, 2005), 16-23.

64. Panofsky, 1:201.

65. Panofsky, 1:203.

66. For a discussion of the painting and interpretations of it, see Ridderbos, 59-77.

67. Martin Kemp, *Behind the Picture. Art and Evidence in the Italian Renaissance* (New Haven and London: Yale University Press, 1997), 222-3.

68. Michael Camille, *Image on the Edge. The Margins of Medieval Art* (Cambridge, MA: Harvard University Press, 1992), 9.

69. Camille, 11-2.

70. Camille, 12-3.

71. Camille, 13-4.

72. Camille, 52-3.

73. John House, *Pierre-Auguste Renoir. La Promenade* (Los Angeles: J. Paul Getty Museum, 1997), 1-2.

74. House, 1.

75. House, 78.

76. House, 79.

77. One survey of different approaches used by art historians is Laurie Schneider Adams, *The Methodologies of Art. An Introduction* (New York: HarperCollins, 1996).

78. Millard Meiss, *Painting in Florence and Siena after the Black Death. The Arts,*

Religion and Society in the Mid-Fourteenth Century (orig. publ. 1951; rpt. New York: Harper & Row, 1973), xi.

79. Meiss, 65.

80. Meiss, 70.

81. Meiss, 74.

82. Meiss, 78-9.

83. Michael Baxandall, *Painting and Experience in Fifteenth-Century Italy. A Primer in the Social History of Pictorial Style* (Oxford and New York: Oxford University Press, 1972), 1.

84. Baxandall, 40.

85. Baxandall, 40-56.

86. Baxandall, 70; general discussion of the topic, 56-70.

87. Baxandall, 71-108.

88. Baxandall, 118-50.

89. Baxandall, 152.

90. John Barrell, *The Dark Side of the English Landscape. The Rural Poor in English Painting 1730-1840* (Cambridge: Cambridge University Press, 1980), 1.

91. Barrell, 5.

92. Wheelock, 98.

93 Simon Schama, *The Embarrassment of Riches. An Interpretation of Dutch Culture in the Golden Age* (New York: Alfred A. Knopf, 1987), 56-7.

94. Svetlana Alpers, *The Art of Describing. Dutch Art of the Seventeenth Century* (Chicago and London: University of Chicago Press, 1983), Introduction, xxv.

95. Alpers, 119-23.

96. Frank Willett, *African Art. An Introduction* (New York: Thames and Hudson, 1985), 143.

97. Willett, 152-3.

98. Quoted in Willett, 212-3.

99. Roger Fry, *Last Lectures*, intro. Kenneth Clark (orig. publ. 1939; Boston: Beacon Books, 1962), 83.

100. Fry, *Last Lectures*, 77-8.

101. Meyer Schapiro, "Nature of Abstract Art," in *Modern Art. 19th & 20th Centuries. Selected Papers* (New York: George Braziller, 1978), 200-1.

102. Kenneth Clark, *The Nude. A Study in Ideal Form* (New York: Pantheon Books, published for the Bollingen Foundation, 1956), 1.

103. Clark, 97-8.

104. Clark, 101.

105. Lilian Zirpolo, "Botticelli's *Primavera*. A Lesson for the Bride," in *The Expanding Discourse. Feminism and Art History*, eds. Norma Broude and Mary D. Garrard (New York: HarperCollins, 1992), 103-4.

106. Zirpolo, 105-7.

107. Fry, *Last Lectures*, 18-20.

Bibliography

Adams, Laurie Schneider. *The Methodologies of Art. An Introduction.* New York: HarperCollins, 1996.

Alpers, Svetlana. *The Art of Describing. Dutch Art of the Seventeenth Century.* Chicago and London: University of Chicago Press, 1983.

Arnheim, Rudolf. *The Power of the Center. A Study of Composition in the Visual Arts.* Berkeley and Los Angeles: University of California Press, 1982.

Barrell, John. *The Dark Side of the English Landscape. The Rural Poor in English Painting 1730-1840.* Cambridge: Cambridge University Press, 1980.

Baxandall, Michael. *Painting and Experience in Fifteenth-Century Italy. A Primer in the Social History of Pictorial Style.* New York: Oxford University Press, 1972.

Berger, John. *Ways of Seeing.* New York: Penguin Books, 1972.

Cahill, James. *Parting at the Shore: Chinese Painting of the Early and Middle Ming Dynasty, 1368-1580.* New York and Tokyo: John Weatherhill, 1978.

Camille, Michael. *Image on the Edge. The Margins of Medieval Art.* Cambridge, MA: Harvard University Press, 1992.

Clark, Kenneth. *The Nude. A Study in Ideal Form.* New York: Pantheon Books, published for the Bollingen Foundation, 1956.

Fry, Roger. *Cézanne. A Study of His Development.* Orig. publ. 1927. New York: Farrar, Straus & Giroux, 1968.

_____. *Last Lectures,* intro. Kenneth Clark. Orig. publ. 1939. Boston: Beacon Books, 1962.

_____. *Vision and Design.* Orig. publ. 1920. New York: New American Library, 1974.

Ginzburg, Carlo. "Morelli, Freud and Sherlock Holmes: Clues and Scientific Method." *History Workshop. A Journal of Socialist Historians* 9 (Spring 1980): 5-36.

Harris, Ann Sutherland and Judith W. Mann. "Artemisia Gentileschi." *Grove Art Online. Oxford Art Online.* http://www.oxfordartonline.com (accessed August 22, 2008).

Helsinger, Elizabeth K. *Ruskin and the Art of the Beholder.* Cambridge, MA: Harvard University Press, 1982.

Herbert, Robert L. "Method and Meaning in Monet." *Art in America* 67 (September 1979): 90-108.

Holt, Elizabeth Gilmore, ed. *A Documentary History of Art.* 2 vols. Garden City, NY: Doubleday, 1958.

House, John. *Pierre-Auguste Renoir. La Promenade.* Los Angeles: J. Paul Getty Museum, 1997.

Irwin, David, ed. *Winckelmann. Writings on Art.* New York: Phaidon Press, 1972.

Johnson, Ellen H. *Modern Art and the Object. A Century of Changing Attitudes.* Rev. ed. New York: Icon Editions, 1995.

Kemp, Martin. *Behind the Picture. Art and Evidence in the Italian Renaissance.* New Haven and London: Yale University Press, 1997.

Kliemann, Julian and Antonio Manno. "Vasari." *Grove Art Online. Oxford Art Online.* http://www.oxfordartonline.com (accessed August 22, 2008).

Langbaum, Robert. *The Poetry of Experience. The Dramatic Monologue in Modern Literary Tradition.* New York: W.W. Norton, 1957.

Meiss, Millard. *Painting in Florence and Siena after the Black Death. The Arts, Religion and Society in the Mid-Fourteenth Century.* Orig. publ. 1951. New York: Harper & Row, 1973.

Panofsky, Erwin. *Early Netherlandish Painting. Its Origin and Character.* 2 vols. Cambridge, MA: Harvard University Press, 1953.

Pollitt, J.J. *The Art of Greece, 1400-31 B.C. Sources and Documents in the History of Art Series.* Englewood Cliffs, NJ: Prentice-Hall, 1965.

Pollock, Griselda. *Differencing the Canon. Feminist Desire and the Writing of Art's Histories.* London and New York: Routledge, 1999.

Potts, Alex. "Winckelmann, Johann Joachim." In *Grove Art Online. Oxford Art Online.* http://www.oxfordartonline.com (accessed August 22, 2008).

Ridderbos, Bernhard, Anne van Buren, and Henk van Veen, eds. *Early Netherlandish*

Paintings. Rediscovery, Reception, and Research. Trans. Andrew McCormick and Anne van Buren. Los Angeles: Getty Publications, 2005.

Rosand, David. "Proclaiming Flesh." *Times Literary Supplement,* 17 February 1984, 167.

Rosenblum, Robert. *Jean-Auguste-Dominique Ingres.* New York: Harry N. Abrams, 1967.

_____ and H.W. Janson. *19th-Century Art.* Rev. ed. Upper Saddle River, NJ: Pearson/ Prentice Hall, 2005.

Ruskin, John. *The Complete Works of John Ruskin* (Library Edition). Eds. E.T. Cook and Alexander Wedderburn. 39 vols. London: George Allen, 1903-1912.

Schama, Simon. *The Embarrassment of Riches. An Interpretation of Dutch Culture in the Golden Age.* New York: Alfred A. Knopf, 1987.

Schapiro, Meyer. *Modern Art. 19th & 20th Centuries. Selected Papers.* New York: George Braziller, 1978.

Slatkes, Leonard J. "Review of *Rembrandt Research Project. A Corpus of Rembrandt Paintings, 1625-1631,* by J. Bruyn, B. Haak, S.H. Levie, P.J.J. van Thiel, and E. Van der Wettering (The Hague: Martinus Nijhoff Publishers, 1982)." *Art Bulletin* LXXI (1989): 139-44.

Steinberg, Leo. "The Line of Fate in Michelangelo's Painting." In *The Language of Images,* ed. W.J.T. Mitchell. Chicago and London: University of Chicago Press, 1980.

Stokstad, Marilyn. *Art. A Brief History.* 3rd ed. Upper Saddle River, NJ: Pearson/ Prentice-Hall, 2007.

Strunk, William, Jr. and E.B.White. *The Elements of Style.* New York: Macmillan, 1959.

Sund, Judy. *Van Gogh. Art & Ideas Series.* New York: Phaidon Press, 2002.

Taylor, Joshua C. *Learning to Look. A Handbook for the Visual Arts.* 2nd ed. Chicago and London: University of Chicago Press, 1981.

Twitchell, Beverly H. *Cézanne and Formalism in Bloomsbury. Studies in the Fine Arts: Criticism, No. 20.* Ann Arbor, MI: U.M.I. Research Press, 1987.

Webb, Ruth. "Ekphrasis." *Grove Art Online. Oxford Art Online.* http://www.oxfordartonline.com (accessed August 22, 2008).

Wheelock, Arthur K., Jr. *Jan Vermeer.* Rev. ed. New York: Harry N. Abrams, 2004.

Willett, Frank. *African Art. An Introduction.* New York: Thames and Hudson, 1985.

Wölfflin, Heinrich. *Principles of Art History. The Problem of the Development of Style in Later Art.* Trans. M.D. Hottinger. Orig. publ. 1915. New York: Dover Publications, 1960.

Zirpolo, Lilian. "Botticelli's *Primavera.* A Lesson for the Bride." In *The Expanding Discourse. Feminism and Art History,* eds. Norma Broude and Mary D. Garrard. New York: HarperCollins, 1992.

APPENDIX I: WRITING THE PAPER

THE WRITING PROCESS:

1. *Know what the assignment is!* The 19th century is not the same as the 1900s and a painting is not a sculpture. Read the assignment carefully and ask questions before you begin work. Always, always, check the due date and plan your life accordingly.

2. If the subject of the paper is a work in a museum, *go to the museum as soon as possible.* This is not the same as checking the website. It means actually going and looking at what has been assigned. Regardless of the topic, make sure you know everything about the relevant works as physical objects. This includes size and the materials used. Other questions may be important. For example, if it is a sculpture, does it have one point of view that is primary? Is there one place from which everything makes sense? If it is a painting, is there an ideal viewing distance? What happens when you get closer or move farther away? You should consider these questions even if you are not able to see the original works.

3. *Write down all your visual observations.* Don't worry about putting them in order. The most important thing is to notice as much as you can, and take notes that will make sense to you later. Remember, a reproduction is not the same as the work of art it reproduces. If you are not able to see the original, you must take this into account. For example, if the original object is two dimensional, make sure that the reproduction does not crop the edges of the original. If it is three dimensional, make sure that you see as many different points of view as you can.

4. If your assignment is a visual analysis, your notes will become the basis of the finished paper. Organize them in a way that will make sense to someone who has not seen the work. The groupings you create should form an outline of what you want to say, with each group becoming a paragraph. If a paragraph is very long, if it even comes close to being a full page of text, separate the material into several paragraphs. When you have finished a complete draft, check the topic sentences of each paragraph. Sometimes it is easiest to write the topic sentence last, fitting it to the paragraph you have written.

5. Even a research paper must begin with careful visual observations. They will determine the direction of your research. Once you have identified the questions you wish to study, you should begin looking for relevant material (see below, The Research Process). Remember to *check the assignment* to see if you are supposed to use certain kinds of sources or a certain number of them. You must begin looking as soon as possible because it is *very unlikely* that everything you need will be available online.

6. **PLAGIARISM**. Once you begin your research, you must keep track of your sources and exactly what each one said. **Plagiarism occurs when you use someone else's words or someone else's ideas without indicating the source**. Changing individual words in someone else's text, even changing every word in the relevant passage, and not citing the source is still plagiarism. You have stolen the idea even if you haven't used the same phrases to express it. This can happen by accident if you have not kept good notes, because you can't be sure of where you read what. Make sure you record all bibliographic information (see Appendix III: Citation Forms), including exact pages and addresses of websites so you will be able to cite things properly.

7. Even before you have assembled everything you need, you should begin to outline your paper. It is only by actually using the material you have that you will discover what is missing. Ideally, you will have the time to find what you need to know. This will not be possible if you have waited until the last minute to complete the assignment.

8. Any paper, no matter what its length, must have a structure. The unit of an essay is the paragraph, which presents the material on a single subject in a logical order. It must begin with a topic sentence, which states the subject to be discussed. Underline your topic sentences and see if they make an outline of your paper. They should. Then make sure that the paragraph really is about the subject of the topic sentence. You may have written a fine paragraph, but not one that fits the topic sentence. Keep the paragraph and change the first sentence. Or keep the topic sentence and fit it to a new paragraph.

9. A long paper should have an introduction, several paragraphs about the subject of the paper, and a conclusion. A short paper need not have a formal introduction and conclu-

sion. In all cases, however, the first sentence or sentences must tell the reader what the subject of the paper is. If the paper is an analysis of a work of art, give the basic visual information about the work right away. Even a beautifully written paper will not make sense to a reader if the subject is not clear.

10. A direct quotation from either a primary source or a secondary source can change the pace of the writing or explain an idea more vividly than a paraphrase would. If it is part of the text, it must be in quotation marks. If it will run more than a few lines in the text, it should be single-spaced and set off as a single block, indented five spaces from the margin. The note indicating the source should come after the period at the end of the quotation.

11. You must give references to your sources in a consistent and comprehensible way, so that a reader can go to the exact place you found your information. Remember: *the forms for both footnotes and endnotes are different from those used in a bibliography.* Most art historians use the Humanities version of the Chicago Manual Style. Correct citation forms for notes and bibliography in this style are given in Appendix III.

THE RESEARCH PROCESS:

1. First, *know what your topic is!* Ideally, you should know what visual material is relevant to your topic, looked at it carefully, and decided which aspects interest you *before* you begin your research. Not all topics are equally promising and not all questions are equally useful. If you are writing a five-page paper about a major artist, you are likely to be overwhelmed with sources, and your greatest problem will be defining a thesis that can be discussed in a short essay. If it is an obscure topic or a single work of art, on the other hand, you may have difficulty finding any sources at all. Best is to have a few possibilities so you can change your topic if you discover you have reached a dead-end.

2. Once you have a topic, you must select appropriate **search terms**. The more specifically the terms relate to your topic the better. If you are writing about Claude Monet's paintings, you should limit your searches to his name, perhaps in combination with other relevant aspects of his work. Do not expand it to "French 19th-century painting" or even "Impressionism", both of which will produce an overwhelming number of references. A

helpful website for searches, especially using Google, is http://hcl.harvard.edu/research/guides/google/index.html. See Parts 3 and 4 especially.

The most useful search terms may depend upon how the particular catalogue or database you are using works. Most will look for exactly what you have entered (check for spelling mistakes!). Usually you can search for an exact phrase by putting it in quotation marks. In other places, you have to put AND between the individual words. Library catalogues distinguish between a "**keyword**" and a "**subject**." A "keyword" is one that appears anywhere in the data about the source – the title as well as the categories under which it has been catalogued. "Subject" refers to specific words that have been chosen by the Library of Congress in Washington, DC, as Subject Headings. Therefore it is better to start with keywords.

3. You must understand the basic types of resources that are available. The most important are **books**, **journal articles** (journals also are called periodicals, serials, or magazines), and **websites**. Books and journal articles also may be available in electronic form on the web or in your library (see below, 5, 6, and 7). Especially if you are looking at these things online, you may not be sure which is which. A normal **book** has one or more authors or editors, a title, a publisher, and a date of publication. If you are looking at the actual work or a scan of it, check for a title page (which usually gives the title, the author, and the publisher) and a copyright page (usually on the back of the title page, and often lists the same information, but with the addition of the date of publication after the copyright symbol). A **journal** comes out periodically (hence the name periodical or serial), and thus will have a volume and date in addition to its title. Since the article you are using is likely only one of many published in the same issue or in the same year, you must give the page numbers on which it appears as well as the name of the author, the article, the periodical, its volume, and its date. A **website** is identified by a stable URL or web address. The best way to see if you have the correct address is to paste the URL into a new browser window and see if it takes you to your source. If it doesn't, you don't have the correct information and you should check your source again. Many scholarly websites now include instructions about citation somewhere on the page. With all websites, you should give the date on which you used the site, because it may have changed or even vanished by the time a reader tries to find your source.

4. There are two places to begin your research: the Internet and the library. The **Internet** is probably a better place to start. It is easily accessible, up-to-date, and can lead you to excellent resources. It must be used with care however, since much of the information found online is wrong – on any topic, not just art history. You will start by using a **search engine**, of which Google is the most popular, to find references to your topic. Note that Google is not a source in itself, but only a way to find sources. Its URL, www.google.com, only provides a homepage with a bar into which you enter a search term, not any actual information. Using mathematical algorithms, Google sorts through all the information on the Internet that it has indexed, and provides a list of the sites its calculations suggest will be most useful to you. Since different search terms will provide different lists, you should enter as many as possible to make sure that you have found the most relevant sources. You also should read beyond the first page of results, because the order created by the search engine may not correspond to your needs.

Search engines rank sites by a variety of factors, including how many times people have linked to them. This means that the open-edit, online encyclopedia **Wikipedia** almost always appears at the top because of its immense popularity. As a source of casual, especially topical, information, it is often very useful. As a reliable research source, however, it has serious problems. The most important of them is the feature that makes it as dynamic and successful as it is: the fact that it is open-edit. This means that anyone with an Internet connection can change articles. A history of the edits to any given article can be found if you click on the tab called History at the top of the page. Unfortunately, you have no idea who the people are or where they got their information. Although sometimes a source is given (linked to the small number in brackets), more often there is not one. As a result, Wikipedia is a great place to begin, but should not be used as the final source for any information. It is a collection of facts and pictures that may be very helpful, and it may contain references to other sources where you will be able to assess the reliability of the information given.

5. Deciding **which websites are reliable** is hard even for an experienced researcher. Generally speaking, the ones with URLs that end in .org (often a non-profit organization), .edu (an educational institution), and .gov (or government) are better than ones that end in .com (commercial), but this is not always the case. Being able to find the name of the person who wrote an article is helpful, because then you can search the author's name on-

line and see if he or she has written scholarly books or articles that have been cited by other people. You also should check whether all the facts correspond to those you find in places known to be reliable (see below). This last might be misleading, however, since sometimes people repeat the same incorrect fact again and again, each having gotten it from someone who wrote earlier rather than checking the original source. Additional suggestions can be found at http://www.lib.berkeley.edu/TeachingLib/Guides/Internet/Evaluate.html.

The easiest way to deal with the problem of reliability is to begin your research with websites you can trust. The website of the Metropolitan Museum of Art of New York, **www.metmuseum.org**, which is available to anyone, has information about many of the works in its own immense collection, some of which will almost certainly be relevant to your topic. It also has the *Heilbrunn Timeline of Art History,* found through a link on the museum's homepage, which contains maps, timelines, and thematic essays on a wide range of subjects. Anything on the museum's site contains reliable information that has been reviewed by authorities in the field. Make sure you do multiple searches, checking "Entire Site" as well as "Works of Art," and "Timeline of Art History" (a category under "What's Online" in a list given above the search box), using as many different terms as possible. Entering a broad search term does not necessarily provide links to all the relevant resources.

6. Many of the best sources can be found in subscriber-only databases, which you will have to use through a library. A good place to start for an art historical topic is **Oxford Art Online**, which contains thousands of signed articles, almost all of which end with a bibliography. This means that you likely will find not only information but also references to other authoritative sources. *Oxford Art Online* is really a collection of different reference works, which include the 34 volume *Grove Dictionary of Art* published in 1996, and the 4 volume *Encyclopedia of Aesthetics,* published in 1998. Be aware that *Grove Art Online* is greatly updated and expanded compared to the published work. Therefore the online version is more useful than the print version. As always with articles on the Internet, the date you accessed it should be included whenever you refer to it.

There also are a number of **scholarly journal databases** that contain articles scanned from print periodicals. These include Academic Search Premier, Art Full Text, EBSCOhost, JSTOR, and Project Muse. In almost all cases, however, they do not include articles that have appeared during the past couple of years, so make sure you check to

see how recent the references will be. Anything available on these databases originally appeared in print and thus counts as a printed source, since you would read exactly the same thing in the magazine found on a library's shelf as you do in the database. Therefore the correct citation should include only the information that is necessary to find it in either place: the author, the title, the name, volume, and date of the periodical, and the page numbers. The name of the database is no more or less relevant than the name of the library, since both are just places to find the article.

7. In addition to being an immensely powerful search engine, Google has two special features, called **Google Scholar** and **Google Books.** These are found if you click on "more" among the tabs at the top of the homepage. **Google Scholar** directs you to articles about the search term you entered, although it does not provide links to them. As always, use as many search terms as possible, and remember, the terms have to be specific to produce manageable results. Some of the sources you will be able to access directly on the Internet, while others will be in subscriber-only databases. The reference will give you that information most of the time. One great advantage of Google Scholar is that it includes very recent sources, which allows you to find things that might not turn up on searches of subscriber-only databases.

Google Books is part of an immense undertaking by Google to scan every book ever published. Recent publications usually are not available for viewing although their names do come up as search results, and sometimes you can get a limited preview of a few pages. This might be all you need. Google Books also makes available the complete text of millions of older books and periodicals that are out of copyright, including very rare ones. Especially for 18th- and 19th-century topics, it may provide access to material owned by only a few major research libraries. As with the databases of articles scanned from periodicals, the fact that you are able to read it as a Google Book is not important. In a note or a bibliography, you give only the information any reader will need to locate it anywhere – author, title, original publisher, place of publication, and date. Look for the title page and copyright page, just as you would if you were using a print copy.

Google Images also may be helpful, although the way Google ranks what it finds means that you are as likely to get a picture from someone's blog about a trip to Europe as a good picture of a work of art. If you are working on a particular artist or a particular subject represented in art, you often are better off starting with **www.artcyclopedia.com,**

which provides links to many different sources of reproductions, including museum websites and commercial databases. Another major repository of reproductions of works of art is **ARTSTOR**, which is a subscriber-only database. Because of copyright restrictions, reproductions of modern art are much harder to find. For them, the best way to begin is to do a Google search or check **www.artchive.com**.

8. Despite all of the many resources available online, it is *extremely unlikely* that you will be able to write a good art historical research paper without using printed sources. Scholarly books, especially those published by university presses, and major exhibition catalogues synthesize large amounts of information, sometimes gathered over years of research in multiple places and languages. If you have access to subscriber-only databases, then you probably will have access to *WorldCat*, which is a union catalogue that lists the holdings of hundreds of libraries. Most publications can be obtained through Interlibrary Loan. Or you can start with the catalogue of the best library you have access to. If you know the names of the publications you want, or you have a list of names of authors who have written on the topic, you can search for them directly. You also should do a general search for your topic. Remember that there is a difference between doing a search using "keyword" and "subject" (see above, 2).

9. You should try to find much more material than you need, since not all of it will be useful. First, you must separate the reliable sources from the unreliable, and the ones you have access to from the ones you will not be able to see or, in the case of foreign languages, understand. That still may leave many sources, and you will have to decide where to start. A recent general introduction to the topic or perhaps *the textbook for your course* might allow you to figure out what you need next. Sometimes a book review is helpful. A review in the periodical *Art Bulletin*, for example, usually surveys all of the relevant scholarly literature on the subject before getting to the book being reviewed. This type of review offers a quick way to get at least one scholar's opinion of what is useful and what isn't.

10. Note that an **annotated bibliography** is DIFFERENT from the **bibliography** that comes at the end of your paper. The first consists of complete references to the sources you found, cited in the proper form for a bibliography, as well as a summary of the contents of each one. The reader should be told what is in the source and how it might be useful for

your research topic. An account of a work written by its maker, for example, will be interesting in a different way from a factual historical account of its creation written by an art historian. It is not that one is true and one is false (although that also might be the case), but that the points of view and purposes of the two writers are entirely different. Some sources might be useful for illustrations, and another because an excellent index allows you to find the information you need quickly. Perhaps the bibliography is exceptionally complete. The more specific your description is, the more helpful the annotations will be to the reader.

Appendix II provides correct citation forms for both notes and bibliography according to the Humanities version of the Chicago Manual Style. **Appendix III** includes sample papers by students, with my suggested edits and revisions. **Appendix IV** consists of an explanation of all the steps involved in the production of an actual research paper, from selecting a topic, finding sources, and taking notes, to the writing and revision of the final paper.

Appendix II: Citation Forms

Any citation must contain all the information the reader needs to find the source. This consists of the categories listed below, with differences as indicated for a book, a journal article, and a website. Once you have the correct information, you must organize it into a specific order. Most art historians use the Humanities version of the Chicago Manual Style. Other common forms are MLA and APA. *Follow whatever instructions you have been given.* **Remember: The correct forms for a note and a bibliographic entry are different.**

1. Here is an outline of the information you will need for each of your sources. A summary guide to the citation forms used in the Humanities version of the Chicago style follows.

For all publications:
Author(s) and/or Editor(s) First name MI Last name
 (An entry in a bibliography is alphabetized under the title if there is no author.)
Title (underlined or italicized for a book and put in quotation marks for an article)

For a book (check title page and copyright page):
Name of Publisher
City of publication
Date of publication
Possible additional information, such as edition, exhibition catalogue (exh. cat.), translator

For a journal (periodical, serial, magazine) **article** (check for first page of issue):
Name of journal
Volume number
Year published
Date or number of issue
Pages on which the article appears

For a website:
Website name
Author
Date posted
Stable URL (hint: paste the URL into a new browser window and see if it works)
Date accessed

2. Form of notes:

A note, whether a footnote that appears at the bottom of the page of text on which the citation occurs, or an endnote that appears at the end of the paper, gives the exact place where you found the information you have used at that point in the paper. Commas, parentheses, or colons separate the categories of information (see below), a note always ends with a period, and the first line is indented five spaces. The number of the note corresponds to the number given in your text, shown either as a number, then a period and two spaces, OR as a superscript number, space. The numbers follow each other sequentially in both the text and the notes. Even if you use exactly the same page in the same source in two different places of your paper, you create a new note for each one, numbered in sequence.

You need not give the complete citation for subsequent references to the same source. Instead use the author's name comma page number period (Taylor, 35.) or, if you have used several works by the same author, a shortened title or the date of publication should be added to make it clear which one you mean (Taylor, *Learning to Look,* 16. OR Taylor, 1981, 16.). Some people use the abbreviation *ibid.* (Latin for *ibidem,* or "the same place") when the citation has been given in the previous note. *Op. cit.*(short for "opus citatum") means the work has been cited previously. Although either is fine, a shortened form is simpler and clearer.

Note to a book:

After the number comes the name of the author (in normal first/last order), comma, the title of the publication underlined or italicized, and the place of publication followed by a colon, the publisher, and the date of publication in parentheses. If the note takes up more than one line of text, the rest is single-spaced and flush with the left margin.

Example of a note to a book:

3. Joshua C. Taylor, *Learning to Look. A Handbook for the Visual Arts,* 2nd ed. (Chicago and London: University of Chicago Press, 1981), 16.

3 Joshua C. Taylor, *Learning to Look. A Handbook for the Visual Arts,* 2nd ed. (Chicago and London: University of Chicago Press, 1981), 16.

Note to an article:

After the number comes the name of the author (in normal first/last order), comma, the title of the article in quotation marks, the name of the journal underlined or italicized, followed by the volume, the year of publication in parentheses, a colon, and the pages that

contain the information used at this particular point in the text. If the note takes up more than one line of text, the rest is single-spaced and flush with the left margin.

Example of a note to an article:

4. Robert L. Herbert, "Method and Meaning in Monet," *Art in America* 67 (September 1979): 90.

[4] Robert L. Herbert, "Method and Meaning in Monet," *Art in America* 67 (September 1979): 90.

Example of a note to an article in *Oxford Art Online* (see "Cite" at the top of every article):

5. Alex Potts,"Winckelmann, Johann Joachim," in *Grove Art Online. Oxford Art Online*, http://www.oxfordartonline.com (accessed August 22, 2008).

[5] Alex Potts,"Winckelmann, Johann Joachim," in *Grove Art Online. Oxford Art Online*, http://www.oxfordartonline.com (accessed August 22, 2008).

Note to a website:
Check to see if you can find an author, a title for the article, a name for the website, the date when it was posted, or anything else that will be useful in identifying the type of site it is. Many scholarly sites give this information in citation form somewhere on the homepage, or linked through an icon that appears on every screen. Always put the date you accessed it in parentheses at the end of the citation.

Example of a note to an unsigned website:

6. "A Scholarly Guide to Google," http://hcl.harvard.edu/research/guides/google/index.html (accessed January 4, 2009).

[6] A Scholarly Guide to Google," http://hcl.harvard.edu/research/guides/google/index.html (accessed January 4, 2009).

Example of a note to the *Heilbrunn Timeline of Art History*:

7. Andrea Bayer, "Art and Love in the Italian Renaissance," in *Heilbrunn Timeline of Art History* (New York: The Metropolitan Museum of Art, 2000–), http://www.metmuseum.org/toah/hd/arlo/hd_arlo.htm (accessed January 4, 2009).

[7] Andrea Bayer, "Art and Love in the Italian Renaissance," in *Heilbrunn Timeline of Art History* (New York: The Metropolitan Museum of Art, 2000–), http://www.metmuseum.org/toah/hd/arlo/hd_arlo.htm (accessed January 4, 2009).

3. Form of an entry in a bibliography:

Bibliographies are alphabeticized by the last name of the author. If there is no author, the item is alphabeticized under the title, ignoring participles such as the, a, or an (for example, the Bible, under "B"). There is a period between each category of information. The first line of each entry is flush with the left margin, and subsequent lines of the same entry are single-spaced and indented. If there is more than one work by the same author, indent each one and arrange the works alphabetically by title.

For a book:

The last name of the author comes first, followed by the first name, period, the title of the book underlined or italicized, period, and the publication information, period. The name of the author and title of a book usually appear on the title page of a book. The date of publication is the year of the copyright, given on the copyright page. The name of the publisher and place of publication usually appear on the title page. They also appear on the copyright page, although the publisher is not necessarily what is listed after the copyright symbol.

Example of a bibliographic entry for a book:

Taylor, Joshua C. *Learning to Look. A Handbook for the Visual Arts.* 2nd ed. Chicago and
 London: University of Chicago Press, 1981.

Bibliographic entry for an article:

The last name of the author comes first, then the first name, then a period, followed by the title of the article in quotation marks, period, the name of the journal underlined or italicized, the volume, the year of publication in parentheses, a colon, and the pages of the article, with a period at the end. If the note takes up more than one line of text, the rest is single-spaced and indented five spaces.

Example of a bibliographic entry for an article:

Herbert, Robert L. "Method and Meaning in Monet." *Art in America* 67 (September
 1979): 90-108.

Example of a bibliographic entry for an article in *Oxford Art Online* (see "Cite" at the top right of every article):

Potts, Alex. "Winckelmann, Johann Joachim." In *Grove Art Online. Oxford Art Online.*
 http://www.oxfordartonline.com (accessed August 22, 2008).

Bibliographic entry for a website:

Find as much information as possible, such as the title of the site, the author, and the date it was posted. Always include the date you accessed the site.

Example of a bibliographic entry for an unsigned website:

"A Scholarly Guide to Google," http://hcl.harvard.edu/research/guides/
 google/index.html (accessed January 4, 2009).

The article is alphabetized under the title ("S" for "Scholarly") since there is no author.

Example of a bibliographic entry for the *Heilbrunn Timeline of Art History*:

Bayer, Andrea. "Art and Love in the Italian Renaissance." In *Heilbrunn Timeline of Art
 History*. New York: The Metropolitan Museum of Art, 2000–.
 http://www.metmuseum.org/toah/hd/arlo/hd_arlo.htm (accessed January 4, 2009).

4. Modifications of these forms for special cases.

(Examples of almost all of these are in the Notes and Bibliography of *Writing about Art*).

Book with two or three authors:

The names are placed in the same order as they are on the title page of the book. In a note, two names are separated with "and" and three names are separated by comma, comma, and "and." In a bibliographic entry, the name listed first appears with the last name first, but the rest appear in their normal order, first then last name.

Book with four or more authors:

The name of the first author is followed by the abbreviation "et al." There is a period after "al" because the word is an abbreviation for the Latin "alii." The phrase means "and others."

Book with an unknown author:

The title of the book is used as if it were the name of the author (e.g., the Bible under "B").

Book with one or more editors as the author:

The names of the editors are treated as if they were the names of authors, followed by "ed." or, in the case of several, "eds."

Book with an author as well as a translator and/or editor:

The name of the author is given as it would be for any book. The name of the translator and/or editor is given after the title of the book, abbreviated as "trans." or "ed." or "trans. and ed."

Book with more than one volume:

In notes, the order is: end parentheses after the year of publication, comma, the number of the volume, a colon, and then the page number(s). In a bibliography, the total number of volumes (abbreviated as "vol." or "vols.") follows the title.

Revised edition:

If a book has been revised (not reprinted, but the text actually changed), you must indicate which edition you used. It is put after the title and number of volumes (if there is more than one) as "Rev. ed." If there are several revisions, you must give the number of the one you used.

Reprint:

If the book was published a long time ago and you are using a reprint, you should indicate in the bibliography that the date of publication is not the same as the one you list. Add "Orig. publ. [date]." before the information about the publisher and date of the reprint, or give the date of the original publication, followed by a semi-colon, "rpt." or "reprint" and then the information about the publisher of the book you used.

Standard edition of a book:

Some books have what is called a standard edition, often with scholarly notes explaining references or giving other readings of the text. If there is such an edition, you should use it when possible. Its text is authoritative and it means that everyone else can find exactly the same words you found. With the Bible, for example, often cited as book, chapter, and verse, the translation matters a great deal. Readers may look up your reference and find different words from the ones you quoted.

One section of a book:

If you are referring to a section or chapter of a book, the author of that part should be listed as the author in your notes and bibliography and the title of the section or chapter put in quotation marks, followed by "in" (for notes) or "In" (for a bibliography) the title of the book in which it appears. The author of the book (as opposed to the author of the part you used) appears after the title of the book.

Exhibition catalogue:

Exhibition catalogues should be identified by the abbreviation "Exh. cat." placed after the

title of the catalogue. The author is the name listed on the title page or, if there is none, the name of the museum that organized the exhibition, which will be on the copyright page.

Article in a popular magazine:
The specific date of the issue is given after the underlined or italicized name of the magazine, in order of day, month, year, and then the page number after a comma.

Article in a newspaper:
A newspaper article is treated like an article in a popular magazine, except that the section, if there is one, is listed as "sec. [whatever], p. [whatever]." The page is given with a "p." so that there can be no confusion with the section.

Book review:
The author of the book review is treated as the author, and the title of the review, put in quotation marks, is "Review of [the title of the book reviewed, underlined or italicized], by [the name of the author of the book]" and then the publication information in parentheses.

Exhibition review:
The form is the same as that for a book review.

Encyclopedia entry (including *Grove Art Online* and *Oxford Art Online*):
The entry should be alphabeticized under the name of the author, if there is one listed, followed by the title of the entry (the heading under which you can find it) in quotation marks, and then the name of the encyclopedia with the appropriate publication information.

Internet sources (including material from the website of the Metropolitan Museum):
The author and title of the material should be given if you can find it. The exact web address for the place you found the information must be listed, followed by the date you accessed it in parentheses.

Theses and dissertations:
The name of the author comes first, then the title of the thesis or dissertation in quotation marks, followed by parentheses Ph period D period diss period comma the name of the university which awarded the degree comma year end parentheses period. For example: (Ph.D. diss., City University of New York, 1998).

Paper presented at a meeting or a performance:

The author is the presenter or performer, the title of the paper or performance is given in quotation marks, and the particular information about when and where you saw it follows in parentheses.

Film or Video:

The title comes first, underlined or italicized, then as much information about the work as you have, with producer abbreviated as prod., director as dir., and minutes as min.

Personal communication:

The name of the person being cited comes first, then the nature of the communication (e.g., email or letter from the author, or conversation with the author), then the date of this communication.

Appendix III: Sample Student Papers

1. SAMPLE STUDENT PAPERS (visual description)

The CCNY students who wrote these papers were given a variation of the assignment below. In all cases, they were told to go to the Metropolitan Museum of Art, select one work on display in the galleries of modern art, and write a two-page visual description of it. The first version of the paper is what the students actually handed in, which did not necessarily receive an A, but showed a basically strong organization and mentioned the most important visual qualities. The second version has been edited by me for this book, underlining the topic sentences, correcting the grammar, adding significant details that were missing, and making the wording a little more graceful and a little less repetitious. I have tried to stay as close to the original texts as possible. Note that the papers could have been revised in many different ways. There is no one answer to an assignment like this, just something that succeeds more or less well for the reader.

The Assignment:
Write a two-page visual description of the work you selected. NO RESEARCH. Include the name of the artist, the title, the date, the medium, the approximate dimensions, the name of the collection, and the museum number. Be sure to give enough details for the reader to be able to visualize the work in all its important aspects. Paragraphs should be the basic unit of organization. Check your topic sentences, grammar, and spelling. To find out how effective your description is, draw a picture of what you have written or have someone else read it. Revise, revise, revise.

Two-Dimensional Works:
A two-dimensional work of art is an object before it is everything else. This means the reader must be told what it is made of as well as its size, color(s), and surface texture(s), in addition to what the visual elements are, and how they have been arranged. All of these qualities should be described in terms of what any viewer can see in the work.

SAMPLE STUDENT VISUAL DESCRIPTION #1

ORIGINAL PAPER:

"From Green to White, by Yves Tanguy"

 From Green to White (Metropolitan Museum of Art, 1999.363.82) is a surrealistic painting by Yves Tanguy in 1954. In the lower part of the painting, what appears to be an strange city, or part of some device. The rest of *From Green to White* is covered in a strange, organic-looking background, with any shadow washed out by fog or some omni-present light. In contrast, the city is naturalistically shaded, creating even greater contrast to the barren fog occupying the upper three fourths of the painting. The fog is not completely featureless, however. The lower part of it is darkened, interspersed with streaks of color. Past the dark area is a section of white with a slightly blue tinge, with streaks of bright white. The streaks gives the impression of being shimmers of light, giving the whole section a look similar to a block of partly melted ice. The ice quickly fades out the blue, leaving what appears to besky.

 The city itself has a certain organic look to it. The buildings are all rounded, with the roofs each at different slopes. In general the city is simple shapes, distorted yet still recognizable. There are a few buildings that stand out in the painting. One building in the middle, with a blue roof and curved outer walls, has strange waves on the roof, and shapes cut out from the walls. Another building, to the left of the blue-roofed one, has grey-green tubing coming from the shaft of the tower. The top of the tower has window-like openings going around its circumference.

 What Tanguy meant this painting to represent is unknown. The title, <u>From Green to White</u>, gives us no hint of what Tanguy meant by this, if he meant anything at all. One possible idea is that the city represents human innovation or civilization. This is surrounded by a vast empty gulf of nothingness, representing our potential for growth. An alternative interpretation is that the void is a barrier, restricting our growth beyond a certain point. This barrier is represented by the section of the void that has the appearance of melted ice. Beyond the wall is the sky, representing freedom. We, however, are trapped on the swamp-like surface, slowly expanding our city – until we reach this barrier.

REVISION OF PAPER #1:

1. Read the paper all the way through, underlining the first or topic sentence of each paragraph. (This will be easiest to do if you print out a copy from www.writingaboutart. org.) These sentences should form an outline of the paper. Do they? Do you know what the work looks like from this description? Do you know all of its qualities as a physical object – medium, size, colors, surface texture? Which elements are missing?

2. Find a reproduction of the painting online (Google the name of the artist and the title) so you know what it actually looks like. Is this what you imagined? Why not? In fact, this painting is extremely difficult to describe because it is very precise in its description of unrecognizable objects. If you have a choice, select a topic you can write about easily!

3. Now go back to the paper, and begin going through it sentence by sentence. First check for mistakes in spelling, grammar, and word usage. Then consider whether words have been used effectively to make the meaning clear. The first sentence is especially important because it tells the reader what the paper will be about.

ORIGINAL FIRST PARAGRAPH:

From Green to White (Metropolitan Museum of Art, 1999.363.82) is a surrealistic painting by Yves Tanguy in 1954. In the lower part of the painting, what appears to be an strange city, or part of some device. The rest of *From Green to White* is covered in a strange, organic-looking background, with any shadow washed out by fog or some omni-present light. In contrast, the city is naturalistically shaded, creating even greater contrast to the barren fog occupying the upper three fourths of the painting. The fog is not completely featureless, however. The lower part of it is darkened, interspersed with streaks of color. Past the dark area is a section of white with a slightly blue tinge, with streaks of bright white. The streaks gives the impression of being shimmers of light, giving the whole section a look similar to a block of partly melted ice. The ice quickly fades out the blue, leaving what appears to besky.

Original first sentence: *From Green to White* (Metropolitan Museum of Art, 1999.363.82) is a surrealistic painting by Yves Tanguy in 1954.

Grammar: What was in 1954? The word "made" has been left out. PROOFREAD!

Comments: What does "surrealistic" mean? CHECK A DICTIONARY: http://www.merriam-webster.com/dictionary/surrealistic: *Adjective.* 1 : of or relating to

surrealism 2 : having a strange dreamlike atmosphere or quality like that of a surrealist painting

Does the writer intend 1 or 2? The first definition means that the painting is an example of the historical style Surrealism. The second refers to a visual quality. Changing the placement of the word eliminates the ambiguity.

Possible revision: The painting called *From Green to White* (Metropolitan Museum of Art, 1999.363.82) was made by the Surrealist artist Yves Tanguy in 1954.

Comments: The reader now knows the title of the work, the name of its artist, the historical movement with which he is associated, and the year in which it was painted. Nothing has been said about the work as a physical object however – size, medium, surface, colors – nor has any indication been given of what the paper will be about. It is best to be clear, even if the result is not elegant.

Final revision: This paper will be a visual description of *From Green to White* (Metropolitan Museum of Art, 1999.363.82), an oil painting made by the Surrealist artist Yves Tanguy in 1954.

Original second sentence: In the lower part of the painting, what appears to be an strange city, or part of some device.

Grammar: This is a sentence fragment because there is no verb, and "an" is used incorrectly because the following word begins with a consonant. It can be made into a complete sentence by adding "there is" before "what appears to be."

Comments: The "lower part" is only meaningful if we can visualize the work as a whole, and it doesn't indicate exactly how much of the composition it fills. The order of the information can be reversed to get rid of the passive "there is." The phrase "part of some device" is too vague to mean anything. The more specific a description is the better. Since the most tangible phrase connected to this area of the picture is "appears to be a strange city," that can be kept, although it would be better to know a little more about what it looks like so the reader can judge the ways in which it is and isn't like a city. Furthermore, we still do not know the picture's size, orientation, subject, or how it was painted. That information must be added.

Final revision: A vertical composition of about 39 x 32 inches, the work depicts an imaginary place. Tanguy used tiny, barely visible brushstrokes, so that the surface of the painting is almost perfectly smooth. What appears to be a strange city fills the bottom fourth of the canvas.

Original third sentence: The rest of *From Green to White* is covered in a strange, organic-looking background, with any shadow washed out by fog or some omnipresent light.

Comments: Something can't be covered with a background, "organic-looking" is too vague to evoke anything specific in the mind of the reader, the absence of shadow comes as a surprise since its presence has not been mentioned, and how can something be both a "fog" and an "omnipresent light"? Although the topic – the rest of the picture – is what should come next, the information must be much more specific. Looking at the picture again suggests "sky" as another way to describe this area, which fits with the idea of organic shapes (like clouds, for example), fog, and a pervasive light. "Background" suggests that the picture contains an illusion of three-dimensional space. It is important not to confuse the two-dimensional or flat design of a picture with a three-dimensional or spatial organization. The first is described by the words top, middle, and bottom, while the second by front, middle, and back. Since it is confusing for the reader to switch between different frames of reference, and no indication of a spatial structure has been given, it is better to stay with the two-dimensional reference already used ("lower part," "bottom fourth").

Final revision: The rest of *From Green to White* looks like sky.

Original fourth sentence: In contrast, the city is naturalistically shaded, creating even greater contrast to the barren fog occupying the upper three fourths of the painting.

Comments: Something that appears to be a strange city has been transformed into a city with naturalistic shading. This would make more sense if the reader knew the ways in which it does and doesn't look like a city. Furthermore, the information about shading would be more useful if it was explained where it appears. Notice that relative dimension is now given with "the upper three-fourths of the painting." Information like this, pertaining to the entire composition, should be given as early as possible. If the relative size of the first area had been given as the bottom fourth – or fifth, which seems more accurate – it would have established the relative proportions of the two major areas of the composition.

Final revision: What appears to be a strange city, naturalistically shaded to suggest space, fills the bottom fifth of the composition. The rest of *From Green to White* looks like sky.

Original fifth and sixth sentences: The fog is not completely featureless, however. The lower part of it is darkened, interspersed with streaks of color.

Comments: First, there is no need to contradict a statement that has not been made, so the fifth sentence is not necessary. "Lower part" is vague, and the phrase has been used to

refer to two different areas of the painting (in the second sentence and in this one), which is confusing to the reader. Rather than "lower part," "darkened," and "streaks of color," be specific about the shapes and colors.

Final revision: The lower part of this section consists of dark, wavy, horizontal bands, interspersed with streaks of red, green, pink, and blue.

Original seventh sentence: Past the dark area is a section of white with a slightly blue tinge, with streaks of bright white.

Comments: "Past" suggests placement in terms of three-dimensional space. Since "lower part" locates the area in terms of two- rather than three-dimensional design, it's better to be consistent and use "above." Furthermore, the relationship between the "streaks of bright white" and the "section of white" has to be made clear. Since the "streaks" are described more fully in the next sentence, reference to them can be removed from this one. Finally, since the previous sentence used "section," the word here should be changed to another one, like "area."

Final revision: Above that is an area of white, tinged slightly blue.

Original eighth sentence: The streaks gives the impression of being shimmers of light, giving the whole section a look similar to a block of partly melted ice.

Grammar: "Streaks" is plural, so the verb should be "give."

Comments: The fact that they are "bright white," eliminated from the previous sentence, must be added. Both "shimmers of light" and "partly melted ice" are images, and it should be made clear that they are alternative descriptions for the same area. Don't use the verb "give" twice in the same sentence.

Final revision: Streaks of bright white within it give the impression of being shimmers of light, or reflections from a block of partly melted ice.

Original ninth sentence: The ice quickly fades out the blue, leaving what appears to besky.

Grammar: What is "besky"? In fact, it is a typing mistake, with the space between "be" and "sky" left out. A spelling checker would have picked this up *if it had been used*.

Comments: What does "fades out the blue" mean? Isn't a sky blue? In fact, the shimmers of light or melting ice fade into blue, to what appears to be sky. Furthermore, no indication has been given of where this takes place in the composition.

Final revision: These streaks fade out about halfway up the picture, leaving what appears to be a blue sky with a few wispy clouds in it.

REVISED FIRST PARAGRAPH:

This paper will be a visual description of *From Green to White* (Metropolitan Museum of Art, 1999.363.82), an oil painting made by the Surrealist artist Yves Tanguy in 1954. A vertical composition of about 39 x 32 inches, the picture describes an imaginary place using tiny, barely visible brushstrokes, so that the surface of the painting is almost perfectly smooth. What appears to be a strange city, naturalistically shaded to suggest space, fills the bottom fifth of the composition. The rest of *From Green to White* looks like sky. The lower part of this section contains dark, wavy, horizontal bands, interspersed with streaks of red, green, pink, and blue. Above that is an area of white, tinged slightly blue. Streaks of bright white within it give the impression of being shimmers of light, or reflections from a block of partly melted ice. These streaks fade out about halfway up the picture, leaving what appears to be a blue sky with a few wispy white clouds in it.

Comments: The revised first paragraph gives the reader an idea of the different areas of the composition, their relative sizes, and their colors. Because this paper is a visual description, it needs more information about the only part that still lacks detail, the bottom of the canvas. The elements which suggest the strange city must be described with more precision. This is the subject of the original second paragraph.

ORIGINAL SECOND PARAGRAPH:

The city itself has a certain organic look to it. The buildings are all rounded, with the roofs each at different slopes. In general the city is simple shapes, distorted yet still recognizable. There are a few buildings that stand out in the painting. One building in the middle, with a blue roof and curved outer walls, has strange waves on the roof, and shapes cut out from the walls. Another building, to the left of the blue-roofed one, has grey-green tubing coming from the shaft of the tower. The top of the tower has window-like openings going around its circumference.

Original first sentence: The city itself has a certain organic look to it.

Comments: "Certain organic look" is too vague to be useful (how would you draw it?). Furthermore, the reader never was told which elements resembled a city and which didn't. This must be explained before anything else. The most specific overall description, sig-

naled by the "in general," appears in the third sentence of this paragraph. This might make a better topic sentence than the original one.

Possible new topic sentence: In general the city is simple shapes, distorted yet still recognizable.

Comments: It is hard to imagine what the shapes might look like if they are simple and distorted – yet recognizable. The natural question is recognizable as what? This must be made more specific. Since the shapes seem to be buildings, perhaps the second sentence ("The buildings are all rounded, with the roofs each at different slopes.") and the third can be combined into a new topic sentence. However, the roofs can't each be at different slopes. Each roof can have a different slope, or all the roofs have different slopes, but the plural "roofs" can't be mixed with the singular "each." Finally, the verb "is" sounds awkward – "consists of" would be better.

Final revision: The strange city at the bottom of the composition consists of simple rounded shapes that suggest oddly proportioned buildings.

Original fourth sentence: There are a few buildings that stand out in the painting.

Comments: Eliminate "there are" or "there is" whenever possible. Since the word "buildings" was just used, and the forms only suggest, but are not, buildings, the use here should be changed.

Final revision: A few of these forms stand out in the painting.

Original fifth, sixth, and seventh sentences: One building in the middle, with a blue roof and curved outer walls, has strange waves on the roof, and shapes cut out from the walls. Another building, to the left of the blue-roofed one, has grey-green tubing coming from the shaft of the tower. The top of the tower has window-like openings going around its circumference.

Comments: Again, if they aren't buildings but only like them in certain ways, they shouldn't be called buildings. Furthermore, if the shapes are rounded, then it needn't be mentioned that the outer walls are "curved." Other changes make the sentences shorter and flow more smoothly.

Possible revision: One in the middle has strange waves on its blue roof, and shapes cut out from its walls. To the left of this one is a tower with grey-green tubing coming from its shaft and window-like openings around its top.

Comments: These sentences are better written and more descriptive than the previous ones, but they are not as clear as they can be, and the reader still needs more information.

Look at the reproduction of the painting again. Try to think of elements you can add that would help the reader imagine what the picture looks like. Here's one way:

REVISED SECOND PARAGRAPH:

The strange city at the bottom of the composition consists of many rounded shapes that suggest oddly proportioned structures made out of grey rock. The simplest are cut-off cylinders. One at the left edge of the picture is the tallest element. A flat low form in the middle, which extends across nearly a third of the width of the picture, has a blue roof with what look like strange waves and a single orange oval on it. These are the only things that are not some kind of grey color. To the left of this structure is a tower with grey-green vertical tubes along its sides. Window-like openings go around it. To the right is the largest structure of them all, like a ziggurat made of three circular flat-topped tiers. Between it and the blue roofed form are 8-10 tall, dark, flat spires. A thin grey cylinder rises along the right edge of the composition.

ORIGINAL LAST PARAGRAPH:

What Tanguy meant this painting to represent is unknown. The title, <u>From Green to White</u>, gives us no hint of what Tanguy meant by this, if he meant anything at all. One possible idea is that the city represents human innovation or civilization. This is surrounded by a vast empty gulf of nothingness, representing our potential for growth. An alternative interpretation is that the void is a barrier, restricting our growth beyond a certain point. This barrier is represented by the section of the void that has the appearance of melted ice. Beyond the wall is the sky, representing freedom. We, however, are trapped on the swamp-like surface, slowly expanding our city – until we reach this barrier.

<u>Original first sentence</u>: What Tanguy meant this painting to represent is unknown.

<u>Comments</u>: The idea of making the last paragraph about meaning is a good one, since the reader surely wonders if the picture has one. Anything about what Tanguy thought, though, has to have a source given in a note, since it is not possible to know by looking at the work. Therefore, this sentence should be eliminated.

<u>Original second sentence</u>: The title, <u>From Green to White</u>, gives us no hint of what Tanguy meant by this, if he meant anything at all.

<u>Comment</u>: First of all, the title of the painting has been italicized in the rest of the paper,

and so it should be here too. Bringing in the title seems like a good idea, especially since it is very specific, but doesn't seem to correspond to anything we can see in the painting. "If he meant anything at all," however, is unnecessary, because it is covered as a possibility by the "no hint." As a topic sentence, this addresses the question of the title, while introducing the subject of meaning, which can be the subject of the rest of the paragraph.

<u>Final revision</u>: The title, *From Green to White*, gives us no hint of what Tanguy meant by this picture.

<u>Original third sentence</u>: One possible idea is that the city represents human innovation or civilization.

<u>Comments</u>: Suggesting a meaning is fine as long as it is clearly presented as the writer's idea. An interpretation must be substantiated by what is shown in the picture, however, which this is not since no evidence has been given that the city – if, in fact, it is one – was made by people. Without something visual to support it, the suggestion cannot be used.

<u>Original fourth sentence</u>: This is surrounded by a vast empty gulf of nothingness, representing our potential for growth.

<u>Comments</u>: The "this" must refer to the city, although it is not entirely certain. It is essential that references be clear. The "vast empty gulf of nothingness" is confusing, because the first paragraph described shapes and colors in that area. No reason is given for why this might represent "potential for growth." Again, without visual evidence, the suggestion is meaningless. The same can be said of the other suggestions the writer offers, which also use new terms, so we can't be sure what they refer to ("void," "swamp-like surface").

<u>Original last sentences</u>: An alternative interpretation is that the void is a barrier, restricting our growth beyond a certain point. This barrier is represented by the section of the void that has the appearance of melted ice. Beyond the wall is the sky, representing freedom. We, however, are trapped on the swamp-like surface, slowly expanding our city – until we reach this barrier.

REVISED LAST PARAGRAPH:

The title, *From Green to White*, gives no hint of what Tanguy meant to represent in this painting. The picture itself also provides no clues. The shapes and forms that are so carefully described do not suggest an interpretation that makes sense of what we see. Therefore, the work remains a mystery, a precisely detailed view of an imaginary world we can never know.

REVISED PAPER:

This paper will be a visual description of *From Green to White* (Metropolitan Museum of Art, 1999.363.82), an oil painting made by the Surrealist artist Yves Tanguy in 1954. A vertical composition of about 39 x 32 inches, the picture describes an imaginary place using tiny, barely visible brushstrokes, so that the surface of the painting is almost perfectly smooth. What appears to be a strange city, naturalistically shaded to suggest space, fills the bottom fifth of the composition. The rest of *From Green to White* looks like sky. The lower part of this section contains dark, wavy, horizontal bands, interspersed with streaks of red, pink, green, and blue. Above that is an area of white, tinged slightly blue. Streaks of bright white within it give the impression of being shimmers of light, or reflections from a block of partly melted ice. These streaks fade out about halfway up the picture, leaving what appears to be a blue sky with a few wispy white clouds in it.

The strange city at the bottom of the composition consists of many rounded shapes that suggest oddly proportioned structures made out of grey rock. The simplest are cut-off cylinders. One at the left edge of the picture is the tallest element. A flat low form in the middle, which extends across nearly a third of the width of the picture, has a blue roof with what look like strange waves and a single orange oval on it. These are the only things that are not some kind of grey color. To the left of this structure is a tower with grey-green vertical tubes along its sides. Window-like openings go around it. To the right is the largest structure of them all, like a ziggurat made of three circular flat-topped tiers. Between it and the blue roofed form are 8-10 tall, dark, flat spires. A thin grey cylinder rises along the right edge of the composition.

The title, *From Green to White*, gives no hint of what Tanguy meant to represent in this painting. The picture itself also provides no clues. The shapes and forms that are so carefully described do not suggest an interpretation that makes sense of what we see. Therefore, the work remains a mystery, a precisely detailed view of an imaginary world we can never know.

SAMPLE STUDENT VISUAL DESCRIPTION #2

ORIGINAL PAPER:

For my analysis, I chose a painting by Emil Nolde, <u>Large Sunflowers 1</u>. This piece is rather large, about a yard in each direction and is encased in a gold frame. The medium is oil paint on a wood base. The paint is thick, wet on wet, using a big brush.

The composition is of eight sunflowers, some of them cropped, allowing us a partial view of their blooms. The colors of the flowers range from yellow, yellow-orange, light red, to dark red. All but one of the yellow toned flowers have deep brown centers. The artist used deep reds and browns to represent the centers of the red toned flowers. Their size range from about the size of a melon to the size of an orange. They are surrounded by large green leaves and stalks, suggesting a bush. The painting is of an outdoor space. Through the pockets of leaves, there are hints of dark blues and greens, suggesting shadow and depth, possibly a large garden or field. Towards the bottom of the painting, there are dashes of red visible through the leaves, alluding to more sunflowers in the depth of the bush. The sunflowers and leaves take up most of the composition, except for a few inches on the top of the painting. This space is a horizon line, an awesome sunset using reds, oranges, yellows, and browns; with an orb of the deepest red and orange depicting the sun itself.

The focal point of this composition is the biggest sunflower, in the center/left side and a pocket of leaves in the center itself. The flower is deep yellow with a muddy, yellow-brown center. Some of the petals are bending, possibly wilting or swaying in the wind. It has a bright green stalk, with a yellow streak of paint through it. The leaves in the center are a bright green with hints of blue, whereas the other leaves in the painting are a deeper green, about the color of an actual sunflower leaf. The brush stroke is also different than the other leaves in the painting. The center leaves are painting with a wavy, lyrical stroke. The painter used the same size brush with the other leaves, but a shorter, straighter stroke.

As I previously mentioned, this piece was painted using a wet on wet technique. The painter applied color on top of color, while all were still wet. He used the base colors to blend new colors on the canvas, instead of on a palette. I believe he also used some type of liquin base to enhance the wet look. By painting wet on wet, the artist not only blends colors, but edges also bleed into each other, creating a very loose,

painterly composition. The entire painting is thick, accentuated by many especially gloppy areas.

The painter used a very large brush throughout the painting, with various brush strokes. He used long, continuous strokes to depict the stalks, for example. He also used short strokes, cross weaves, and waves. All appeared to be applied with a loose, relaxed hand.

All of the aforementioned elements, create an image of nature and tranquility. The use of a wood base, instead of typical weaved canvas, accents the ties to the natural world that are seen throughout this piece. The colors are warm, and the piece is fluid and flowing. Nolde used wet paint and a loose hand to capture a feeling of relaxation and an image of unprocessed beauty.

Topic sentences: First, underline the topic sentences. Do they form a clear outline? Does the first sentence tell you what the paper will be about? Here they are:

For my analysis, I chose a painting by Emil Nolde, Large Sunflowers 1.

The composition is of eight sunflowers, some of them cropped, allowing us a partial view of their blooms.

The focal point of this composition is the biggest sunflower, in the center/left side and a pocket of leaves in the center itself.

As I previously mentioned, this piece was painted using a wet on wet technique.

The painter used a very large brush throughout the painting, with various brush strokes.

All of the aforementioned elements, create an image of nature and tranquility.

Comments: The first sentence does identify the artist, and the title and medium of the work, although not the collection or the museum number. It indicates that the paper will be an "analysis," although we are not told of what. Then, in order, the paper will discuss the composition of the subject (sunflowers), the most important part visually of the composition, the technique, the brush and brush strokes, and a sense of its meaning or emotional mood. Although it would seem that the discussion of brushes and brush strokes should come before the technique, the topics in and of themselves seem reasonable. Is there anything that seems to be missing?

ORIGINAL FIRST PARAGRAPH:

For my analysis, I chose a painting by Emil Nolde, <u>Large Sunflowers 1</u>. This piece is rather large, about a yard in each direction and is encased in a gold frame. The medium is oil paint on a wood base. The paint is thick, wet on wet, using a big brush.

<u>Comments</u>: "Analysis" is not as precise a description of the paper as it could be, because it doesn't answer the question of what kind of analysis it will be. "Painting" can be made more specific by adding the information from the third sentence. Many art historians object to describing art as a "piece" because it seems too casual and, perhaps, commercial. There are lots of other possibilities, such as "work" and "object." "Rather large" is vague, and unnecessary when it is followed by actual dimensions. The measurement given, however, suggests that canvas is a square, which it is not. This has to be changed. Unless the gold frame is going to be mentioned again, it should be eliminated because it is not part of Nolde's painting. "Wet on wet" is a specific technique of painting that should be explained, as should the ways in which it can be recognized visually. The description "big brush" is vague. Meanwhile, the reader has not been told anything more about what the painting shows then is indicated by the title. Perhaps the second paragraph, introduced by a topic sentence about the composition, should be incorporated in whole or part into the first paragraph.

ORIGINAL SECOND PARAGRAPH:

The composition is of eight sunflowers, some of them cropped, allowing us a partial view of their blooms. The colors of the flowers range from yellow, yellow-orange, light red, to dark red. All but one of the yellow toned flowers have deep brown centers. The artist used deep reds and browns to represent the centers of the red toned flowers. Their size range from about the size of a melon to the size of an orange. They are surrounded by large green leaves and stalks, suggesting a bush. The painting is of an outdoor space. Through the pockets of leaves, there are hints of dark blues and greens, suggesting shadow and depth, possibly a large garden or field. Towards the bottom of the painting, there are dashes of red visible through the leaves, alluding to more sunflowers in the depth of the bush. The sunflowers and leaves take up most of the composition, except for a few inches on the top of the painting. This space is a horizon

line, an awesome sunset using reds, oranges, yellows, and browns; with an orb of the deepest red and orange depicting the sun itself.

Grammar: "Their size range from about the size of a melon to the size of an orange." "Their size" is singular, so the verb "range" should be "ranges," except that the point of the sentence is that there are multiple sizes, so it would make more sense to make "size" plural – "Their sizes range." Strictly speaking, "their" refers to the last noun, which would be "the centers," because "of the red toned flowers" only modifies "centers." In any case, the sentence is awkward, because of the unclear reference, and the word "size" is used three times.

Comments: The number of flowers, the range of colors and sizes, and the presence of leaves, seem like information the reader needs to form the most fundamental idea of the painting. The ideas of space and a sunset, however, seem secondary and might be developed in another paragraph. If this reasoning is followed, a new first paragraph can be made from the revised first and parts of the second paragraph. A number of small changes can be made to some of the other sentences too, to make it all read more smoothly. As always, there is not a single way to revise it, but here's one possibility:

REVISED FIRST PARAGRAPH:

For my visual description, I chose to write about an oil painting on wood by Emil Nolde, Large Sunflowers I, in the collection of the Metropolitan Museum of Art (2002.386). The work, which is about two and a half feet high and three feet wide, shows eight sunflowers with their leaves, seen from close up. Some of them are cropped by the edges of the canvas, so we have only a partial view of their blooms. They vary from about the size of a cantaloupe melon to about the size of an orange, which might be the actual dimensions of these flowers. The colors range from yellow, yellow-orange, and light red, to dark red. All but one of the yellow-toned flowers have deep brown centers, while the red ones have deep reds and browns at their centers. The sunflowers are surrounded by large green leaves and stalks. The brilliantly colored paint is thick, and has been applied in big, visible brush strokes.

Rest of original second paragraph:

The painting is of an outdoor space. Through the pockets of leaves, there are hints of dark blues and greens, suggesting shadow and depth, possibly a large garden or field. Towards

the bottom of the painting, there are dashes of red visible through the leaves, alluding to more sunflowers in the depth of the bush. The sunflowers and leaves take up most of the composition, except for a few inches on the top of the painting. This space is a horizon line, an awesome sunset using reds, oranges, yellows, and browns; with an orb of the deepest red and orange depicting the sun itself.

Comments: The first sentence can function as a topic sentence for what follows. It seems that the most striking visual element, however, is the top of the painting, the "awesome sunset," which is mentioned last. Perhaps the paragraph should begin with that area. The sentence before locates it, so it has to be included. The "few inches" are "at" the top of the painting though, not "on." "On" the top of the painting means on the surface of the top layer of the paint on the canvas, rather than at the top of the composition. The rest of the sentences can be made simpler by using fewer words. This is one way to reorganize and revise the paragraph:

REVISED SECOND PARAGRAPH:

The sunflowers and leaves take up most of the composition, but there are indications of an outdoor space around them. A strip a few inches high at the top of the painting forms a horizon line, filled with an awesome sunset of reds, oranges, yellows, and browns. An orb of the deepest red and orange toward the center depicts the sun itself. Between the leaves, hints of dark blues and greens suggest shadow and depth, possibly in a large garden or field. Towards the bottom of the painting, dashes of red suggest more sunflowers behind the ones we see.

ORIGINAL THIRD PARAGRAPH:

The focal point of this composition is the biggest sunflower, in the center/left side and a pocket of leaves in the center itself. The flower is deep yellow with a muddy, yellow-brown center. Some of the petals are bending, possibly wilting or swaying in the wind. It has a bright green stalk, with a yellow streak of paint through it. The leaves in the center are a bright green with hints of blue, whereas the other leaves in the painting are a deeper green, about the color of an actual sunflower leaf. The brush stroke is also different than the other leaves in the painting. The center leaves are painting with a wavy, lyrical stroke. The painter used the same size brush with the other leaves, but a shorter, straighter stroke.

Grammar: The phrase "center/left side" in the first sentence needs to be set off by commas at its beginning and end to make clear that it refers to the sunflower, and "focal point" is confusing since the end of the sentence reveals that there are two areas of visual interest – the sunflower and the pocket of leaves. "The brush stroke is also different than the other leaves" is not correct. It is not the brush stroke compared to the other leaves, but the brush stroke used for these leaves that is "different from that used for the other leaves in the painting." In the next sentence, the center leaves definitely are not "painting," which obviously should be "painted." It should be "for" the other leaves, not with.

Comments: Giving the reader a sense of what is most important in the composition is a reasonable subject now that the entire composition has been outlined. Note that the order in which the "focal points" are first mentioned is the order in which they are discussed. It is important to maintain the same order of information at all times, so the reader knows what to expect. Since "lyrical" is not a visual quality, but an emotional or, perhaps, a poetic one (check the dictionary!), a more visually descriptive word should be selected or the idea left out. Finally, the size of the brush has nothing to do with the composition. A few changes make the paragraph a little shorter and the writing read more smoothly.

REVISED THIRD PARAGRAPH:

The focal points of this composition are the biggest sunflower, to the left of center, and a pocket of leaves in the center itself. The flower is deep yellow with a muddy, yellow-brown center. Some of its petals are bending, possibly wilting or swaying in a wind. It has a bright green stalk, with a streak of yellow paint through it. The leaves in the center are a bright green with hints of blue, whereas the other leaves in the painting are a deeper green, more like the color of an actual sunflower leaf. They also are distinguished by the wavy brush stroke that appears here, which is different from the shorter, straighter stroke used for the other leaves in the painting.

ORIGINAL FOURTH PARAGRAPH:

As I previously mentioned, this piece was painted using a wet on wet technique. The painter applied color on top of color, while all were still wet. He used the base colors to blend new colors on the canvas, instead of on a palette. I believe he also used some type of liquin base to enhance the wet look. By painting wet on wet, the artist not

only blends colors, but edges also bleed into each other, creating a very loose, painterly composition. The entire painting is thick, accentuated by many especially gloppy areas.

Comments: "As I previously mentioned" is never a compelling opening for a paragraph and, as the order of the topic sentences revealed, discussing the brush strokes first seems to make more sense. If the paragraphs are reversed, then the fourth one would be this:

ORIGINAL FIFTH PARAGRAPH:

The painter used a very large brush throughout the painting, with various brush strokes. He used long, continuous strokes to depict the stalks, for example. He also used short strokes, cross weaves, and waves. All appeared to be applied with a loose, relaxed hand.

Comments: Distinguishing between the brush used and the various types of brush strokes made with it is a good idea. "Very large" is vague, however – compared to what? Substitute a more precise measurement. In addition, these two paragraphs raise similar issues, so perhaps the information can be better organized. The subjects can be defined as the brush (apparently a single "very large" one), the handling of the brush, including strokes ("long," "continuous," "short," "cross weaves," "waves") and the more general "applied with a loose, relaxed hand," which perhaps relates to the "very loose, painterly composition." Other terms relating to specific techniques of paint application include "wet-on-wet," with its blended edges, "thick" paint, and "many especially gloppy areas." Finally, there is the character of the color, mixed on the canvas instead of a palette. "Liquin base," which most readers probably would take to be a typing mistake for "liquid base," actually is a technical term referring to a particular kind of medium for paint, which enhances drying time and increases glossiness. Unless you know that your audience will understand such specific technical terms, it is better to avoid them. One way to reorganize this information is:

REVISED FOURTH PARAGRAPH:

The artist seems to have used the same large brush throughout the picture, although the paint was applied in different ways. Long, continuous strokes appear in some of the stalks, for example, while the flowers have been made with short strokes, cross weaves, and waves. In many places, the paint was applied thickly and wet on

wet, color on top of color before any of it had dried. The result is that the edges of the strokes bleed into each other. In some areas, new colors were made by blending colors directly on the canvas.

ORIGINAL FINAL PARAGRAPH:

All of the aforementioned elements, create an image of nature and tranquility. The use of a wood base, instead of typical weaved canvas, accents the ties to the natural world that are seen throughout this piece. The colors are warm, and the piece is fluid and flowing. Nolde used wet paint and a loose hand to capture a feeling of relaxation and an image of unprocessed beauty.

Grammar: There shouldn't be a comma after "elements" in the first sentence. The base is made of wood, but it is a "wooden" base, and the typical canvas is "woven" not "weaved." Comments: "All of the aforementioned elements" is a very awkward beginning for any paragraph, especially the last one in the paper. The rest of the sentence is obvious – a picture of sunflowers certainly is an "image of nature" – as well as contradictory, since intensely colored, thickly painted sunflowers in front of a brilliant sunset don't seem likely to create an image of tranquility. The point about the wooden base is not relevant if this is information given by the museum label instead of something that can be seen, and the paper contains no evidence that it is visually apparent. The rest of the characterization reads like something thrown together to end a paper. The colors are warm (although the comment wasn't made above), but that has nothing to do with nature or tranquility. Surely it isn't the work itself, but the composition that is "fluid and flowing" (although that wasn't exactly said above either). Of course Nolde used wet paint – any painter has to! – but neither that nor the "loose hand" leads to a "feeling of relaxation," at least without explanation. Finally, the ways in which this painting has been constructed demonstrates that it is not at all "an image of unprocessed beauty." This can be reduced to one sentence.

REVISED PAPER:

For my visual description, I chose to write about an oil painting on wood by Emil Nolde, Large Sunflowers I, in the collection of the Metropolitan Museum of Art (2002.386). The work, which is about two and a half feet high and three feet wide, shows eight sunflowers with their leaves, seen from close up. Some of them are

cropped by the edges of the canvas, so we have only a partial view of their blooms. They vary from about the size of a cantaloupe melon to about the size of an orange, which might be the actual dimensions of these flowers. The colors range from yellow, yellow-orange, and light red, to dark red. All but one of the yellow-toned flowers have deep brown centers, while the red ones have deep reds and browns at their centers. The sunflowers are surrounded by large green leaves and stalks. The brilliantly colored paint is thick, and has been applied in big, visible brush strokes.

The sunflowers and leaves take up most of the composition, but there are indications of an outdoor space around them. A strip a few inches high at the top of the painting forms a horizon line, filled with an awesome sunset of reds, oranges, yellows, and browns. An orb of the deepest red and orange toward the center depicts the sun itself. Between the leaves, hints of dark blues and greens suggest shadow and depth, possibly in a large garden or field. Towards the bottom of the painting, dashes of red suggest more sunflowers behind the ones we see.

The focal points of this composition are the biggest sunflower, to the left of center, and a pocket of leaves in the center itself. The flower is deep yellow with a muddy, yellow-brown center. Some of its petals are bending, possibly wilting or swaying in a wind. It has a bright green stalk, with a streak of yellow paint through it. The leaves in the center are a bright green with hints of blue, whereas the other leaves in the painting are a deeper green, more like the color of an actual sunflower leaf. They also are distinguished by the wavy brush stroke that appears here, which is different from the shorter, straighter stroke used for the other leaves in the painting.

The artist seems to have used the same large brush throughout the picture, although the paint was applied in different ways. Long, continuous strokes appear in some of the stalks, for example, while the flowers have been made with short strokes, cross weaves, and waves. In many places, the paint was applied thickly and wet on wet, color on top of color before any of it had dried. The result is that the edges of the strokes bleed into each other. In some areas, new colors were made by blending colors directly on the canvas. These techniques combine to make this painting a vivid image of nature.

Three-Dimensional Works:

Works of art that occupy space instead of being flat present additional elements to describe. In addition to size, medium, and subject, the writer must indicate what it looks like from different points of view and how it engages the space around it. The shape may be complicated to describe, especially if it does not correspond to a representation of the natural world. A sample paper follows. Treat it exactly like the ones above. Underline the topic sentences and see if they make sense and if the order seems logical. Look at the first sentence and see if it tells the reader what the paper will be about. Then look at the organization of each paragraph and see if it makes sense. Each sentence should lead logically to the next one, and they all should be about the topic introduced in the first sentence of the paragraph. Can you draw the work? Do certain parts of the paper seem more successful than others? Why?

SAMPLE STUDENT VISUAL DESCRIPTION #3

FINAL PAPER:

Auguste Rodin created *The Burgers of Calais* (Metropolitan Museum of Art, 1989.407) between 1885 and 1897. The bronze sculpture consists of six life-size male figures standing on a low rectangular base, arranged as if they are within an invisible cube. One figure, who seems to be the leader of the group, is placed almost in the middle of one of the long sides. Otherwise, there is no obvious organization in their positions. Furthermore, there is no point of view from which the six figures can be seen at once. For this reason the monument is visually interesting from all sides and, as the viewer walks it, additional details appear.

Even though the burghers do not have much contact with each other, not even eye contact, they create a sense of a group by sharing many things. They are about the same height (around 75"), wear similar long robes, and are barefoot. Although there are differences in the design of the clothes (some are sleeveless, some slit on the sides), the deep folds of the simple robes create a strong vertical rhythm throughout the composition. Their disproportionately large hands and feet seem to weigh the men down. Two of them carry large keys. There are pieces of ropes hanging or twisted on some of the figures.

Looking at the work from the front (the longer side, with two figures facing

towards us), the viewer first sees the man who seems to be the leader of the group, emphasized by an empty space in front of him. He is leaning forward with his shoulders hunched, his arms hanging by his sides, standing on a diagonal that runs from the front right corner towards the back left corner of the base. He is not facing us but turned about 30 degrees towards our left, with his head down. He has a beard, long hair, and he looks concerned.

A second burgher is lined up on the same diagonal, with his large bare left foot placed almost on the right corner of the base. Also turned toward the left, he looks straight forward with a grim expression. He holds a giant key in front of his body. These two burghers are connected by their position within the sculpture and they seem older than the others.

On the left front corner of the base is a younger man who has turned his back to the group and seems to be walking away from the leader. While his body is facing the left side of the invisible cube of the composition, his head is turned towards the back and he is looking down. He holds his heavily muscled right arm in front of him at a 90 degree angle. His fingers are spread apart as if he is questioning the situation. If we move to the short side of the monument and face this figure, we see that he is leaning to his right side. His movement creates a curving line that defines that edge of the composition.

From this point of view we can see the fourth burgher, who had been mostly hidden before. He is positioned right next to the previously mentioned man. The fourth burgher is facing the center of the composition. He is in the midst of stepping forward, with his arms out and hands open. His mouth is open, suggesting that he is asking something. Seen from the short side of the sculpture, the two figures overlap, creating dynamic lines as they lean towards one another. These two burghers seem joined, not only because of their interlocking movements but because they are both young and seem to be questioning the situation.

There are two more burghers in the composition, who cannot be paired with any of the others. Looking at the other long side of the monument, we have a side view of the fifth burgher. He is an older bearded man who seems to be stepping from the right side towards the left. His face looks blank as he stares straight forward. He holds a large key with his left fingertips. His facial expression and posture seem to

express resignation. From this point of view we also see the back of the last burgher, who is placed in the corner to the left. He is slightly leaning away from the group. Moving to the short side, we can see that this older burger has the most dramatic position. He is bent over with his hands covering his lowered head, so that his face is hidden. He seems to be in total despair. From this point of view, we also discover that thick ropes hang around the neck of the second burgher.

Although the size, the bronze material, and the seriousness of the expressions of the men make you realize that this is a monument, the composition makes you feel as if the figures are part of the world in which you are standing. Walking around the work, you discover that the figures also are walking in something like a circle, except for the central man. As might be true in real life, each step reveals new details and hides others. A head or an arm of an invisible figure appears above the other men, or an elbow or hand blocks the view of something that normally would be more important. For this reason, *Burghers of Calais* has a much more immediate emotional impact on the viewer than a formal grouping on a high base would have had.

Comments: The first test of any description is whether the reader can visualize the work of art. Is this description clear? Could you draw Rodin's sculpture? Do you know what it contains? Do you know all of the facts about it as a physical object – size, material, shape? The next question is whether you are left feeling confused, or if there are things you still want to know. Are there issues that are raised but not answered? Look at a reproduction of it (unless you can see the real sculpture!). Do you find aspects that seem essential but have been left out? There is never only one way to write a description.

2. SAMPLE STUDENT PAPERS (stylistic analysis)

The CCNY students who wrote these papers were given variations of the assignment below, with the exhibition or area of the Metropolitan Museum from which they could select their objects specified. These papers did not necessarily receive an A, but they showed basically strong organization and mentioned important visual qualities. Although I have edited them lightly for this book, what appears here is, in all important ways, the same as what the students gave me. These sample papers should be read critically in the same way that the visual descriptions were in the previous section. Underline the topic sentences and see if their sequence of topics seems logical. Look at each paragraph and see if it develops the idea introduced by the topic sentence. Look at the first paragraph with special care. This is where the reader should learn what the paper will be about, and what specific issues will be addressed. Does the paper do what it promises? Is enough visual information given for the reader to be able to follow the analysis? Find reproductions of the works. Does the paper discuss the relevant things that you see in them?

The Assignment:

Go to the Metropolitan Museum of Art. Select THREE WORKS and identify them using the information that appears on the object label, including the museum number. In 2-3 double-spaced pages (maximum 1000 words), explain the most important ways in which the works you have chosen look alike. What visual qualities do they share? Think about how the subjects have been defined and represented, the handling of the materials, and the formats and sizes of the works. There will be other qualities you'll need to consider, depending on what you select. Look carefully at what you have chosen and then create your own definition of their style, based ONLY on what you see – not what you have read about them. NO RESEARCH. Be sure to give enough details so that the reader will be able to visualize the works in all important aspects.

SAMPLE STUDENT STYLISTIC ANALYSIS #1

Three oil paintings by Claude Monet, all in the collection of the Metropolitan Museum of Art, share important visual characteristics that define his artistic style. "Camille Monet on a Garden Bench" (2002.62.1) shows a woman, who looks out at the viewer of the picture, sitting on a bench in a garden. A top-hatted man leans over the bench and, farther

back in the scene, another woman stands next to a bed of red flowers. "Camille Monet in the Garden at Argenteuil" (2000.93.1) shows a woman walking on a garden path. She appears at the left of the picture, next to a tree. Flowers in a large garden to the right and a house behind them fill most of the composition. "La Grenouillère" (29.100.112) depicts a scene on a river with boats in the foreground, and an island with one tree and a number of people on it in the middle of the composition. An open building filled with people projects into the picture on the right, and people are bathing on the left. A row of trees on the other bank fills the background. All three paintings are about two and a half feet high and three and a half feet wide. The size is important because it helps to determine where the viewer should stand to best see the work.

The distance from which these works are viewed has a strong impact on what is seen. In all the pictures, the paint is applied to the canvas in strong, thick brushstrokes, as well as in dabs of color and shaky lines. The woman's dress in "Garden Bench" is made of layers of shapes, accented by black lines that seem to be nothing when seen up close, but eloquently convey the fabric when viewed from far away. The flowers that make up the center of the composition in "Garden at Argenteuil" look like random splatters of paint when viewed from a foot away. From a distance, they become an organized floral arrangement in vibrant, buzzing colors that look as if they are about to rustle in the breeze. The water in "La Grenouillère" looks like nothing more than squiggly lines until the viewer takes a few steps back to recognize gorgeous, inviting ripples in the water reflecting afternoon light.

Another common element in these pictures is the use of color. Monet has chosen cool, subdued colors for the centers of the compositions, while the backgrounds are bathed in warm light. The woman and man in the foreground of "Garden Bench" are under the shade of a tree, cast in a greenish hue, while the woman and flowers behind them are glowing like the over-exposed part of a photograph taken in low light. The woman and flowers in the foreground of "Garden at Argenteuil" are shown in shade as well, while the house behind them beams pink and orange, reflecting the bright light. The shade in the foreground of "La Grenouillère" makes the water seem almost too cold to swim in, but the trees in the distance show the light of a summer afternoon.

These works also describe similar subjects. All three show leisurely moments in the lives of people who seem to be relatively wealthy. Both the men and the women appear to be well dressed. The gardens contain flowers, not food, and they are well-maintained. The outdoor pleasure spot at La Grenouillère is for people to enjoy themselves. No one is

shown working. The weather is sunny and pleasant. These scenes give modern viewers a positive feeling, as if they are welcome to join in the relaxation.

SAMPLE STUDENT STYLISTIC ANALYSIS #2

Pierre Bonnard's oil paintings *Dining Room Overlooking the Garden (The Breakfast Room)* (1930-31, The Museum of Modern Art), *Dining Room on the Garden* (1934-35, Solomon R. Guggenheim Museum), and *Table in Front of the Window* (1934-35, private collection) display several visual qualities that define a recognizable style. These similarities can be seen in the works' subject matter, composition, texture, color, and stylization.

All three works show the same subject matter. *Dining Room Overlooking the Garden* depicts a tabletop covered with various objects, including a book, tableware, and fruit, in front of a large window that frames a garden landscape. To the left of the window is a woman, cut in half by the edge of the picture. Outside is a balustrade and, beyond it, a path surrounded by dense vegetation. *Dining Room on the Garden* also shows a tabletop in front of a wall with a window. This tabletop contains two bowls of fruit, a vase with flowers, a pitcher, a mug, and two books, among other objects. Behind the table are two chairs. To the right of the window is a standing woman. Through the window, a strip of water is visible between the sky and a garden path that is flanked by trees on either side. Like the other two paintings, *Table in Front of the Window* also depicts a tabletop in the foreground and a wall containing a large window behind it. The window frames a landscape composed of an area with vegetation sandwiched between a path and the sky. The tabletop contains a bowl of fruit, a book, and other tableware. The top of a wooden chair is visible directly behind the table. The arm and head of a human figure emerge from the right border of the painting.

The arrangement of the subject matter in the composition is also very similar. Each one depicts an interior space with a human figure and a table in front of a window that frames a landscape. In the foreground, a combination of books, fruit, and tableware is dispersed around the tabletop, which fills the lower portion of the work. The viewer of the picture looks down on the table. Behind the tabletop, a large window occupies most of the remaining space. The window is divided into one or two sections by its frame, and it is shown between curtains or the walls of the room. The figure at the side of the window is only partly visible, cut by the edge of the picture, cast in shadow, or blended into the wall. In the background, a landscape with trees and a path can be seen through the window.

There is a strong emphasis on the vertical in each of the compositions. In *Dining Room Overlooking the Garden*, the tabletop is patterned with blue and white vertical stripes. Two vertical strips, which divide the window, are parallel to the woman. The balustrade in the garden has repeated upright columns. Behind the fence, a winding path leads upwards toward the horizon. In *Dining Room on the Garden*, the woman stands parallel to a vertically oriented window frame. The chairs behind the table contain vertical elements as well. There is a darkened, vertical stripe on the left side of the wall. Almost all of the objects on the table, especially the pitcher, mug, vase with flowers, and bowls of fruit, open upwards. In *Table in Front of the Window*, the tabletop is patterned with white and red vertical stripes. The book and bowl of fruit on the table, as well as the three supports of the chair behind the table, guide the viewer's eye upward along the vertical window frame.

A seemingly chaotic use of texture and color typify the paintings. The brushstrokes are clearly visible and appear to come from many different directions. The paint is applied quite heavily so that globs project from the canvas. This creates the impression of a rough and splotchy surface. Furthermore, the colors are never completely mixed. For example, in *Table in Front of the Window*, the bowl of fruit appears to be white from afar. When examined up close, however, it turns out to have various streaks of differing hues, including red, purple and black. Therefore, the colors look saturated and vibrant when viewed from a distance, but appear muted in close proximity. This creates the illusion that the work is pulsating.

The highly stylized forms in Bonnard's paintings are characterized by warped shapes and indistinct attributes. The shape of each element in the paintings is slightly askew from what it might look like in real life. For example, the bowls and plates are not perfectly rounded. Instead, the edges constantly waver. Similarly, the window frame, which one would assume is completely erect, curves slightly. These warped forms are further distorted by the blurring of their features. This can be seen most obviously in the garden landscapes. The vegetation is composed of masses of variously colored blobs, which are only recognizable as branches or bushes by their context within the work.

Bonnard uses obstructed forms to play with the viewer's sense of space. In each work, the lower border of the picture cuts off the tabletop, and the upper border cuts off the window. Only a small sliver of the wall can be seen on either side of the window. This makes it impossible for the viewer to know the exact size of the table and window, or of the room

that contains them. Only a portion of the garden landscape is visible through the window. The vertical framing in the windows further disrupts this view. The human figure in each of the works is also obstructed. In *Dining Room Overlooking the Garden*, the left border cuts off half of the woman's body. The woman in *Dining Room on the Garden* is hidden behind the tabletop and a vase with flowers. In *Table in Front of the Window*, only a portion of the figure's head and arm is visible. These obstructed forms give an air of mystery to Bonnard's paintings and leave the viewer wanting more.

SAMPLE STUDENT STYLISTIC ANALYSIS #3

1) Wang Hui, *Water Village After Zhao Danian*, 1662, Palace Museum, Beijing
2) Wang Hui, *Reading Next to the Window in the Mountains*, 1666, Palace Museum, Beijing
3) Wang Hui, *Autumn Forests at Yushan*, 1668, Palace Museum, Beijing

These three works of art, distinctly different from each other upon first glance, share many stylistic features that distinguish them as landscape paintings by a single artist – Wang Hui. *Reading Next to the Window in the Mountains* depicts a grand mountain range, painted on a one foot by five foot, vertically-oriented hanging scroll. What caught my attention was the spatial composition, the way in which a long sequence of mountains fits on such a narrow picture. They run the entire length of the paper, weaving left to right as they work their way upwards to the highest peak. Not only is there an illusion of recession in space, but an illusion of rising in space is worked in as well. You can see that the peaks higher up on the composition are farther away, as well as physically taller. This spatial organization is repeated in both *Autumn Forests*, which has a very similar set of mountains, and *Water Village*, with its gently rolling hills winding up to a modest peak.

This double-effect of space is made possible by a visual backbone found in all three works. Wang Hui creates a pattern of repetition with mountains and hills that looks like the backbone of an animal. Especially in *Reading* and *Autumn Forests,* rocks and peaks overlap each other, with each one slightly higher than the last, acting as vertebrae in the mountain chain. To distinguish the individual geological forms from one another, the painter uses gradients of grays and colors to highlight the edges. The result is a light and dark banded pattern which gives the forms dimension, and directs your eye along the backbone, and up the painting.

The scale of these mountains is also a stylistic signature of Wang Hui. Civilization

is evident in all three works, but it is represented as insignificant, almost an afterthought. The rooftops, boats, and people which appear in the pictures are miniscule – each subject taking up no more than one square inch, and completely swallowed by the surrounding landscape. The sweeping shapes of nature are the focus of the compositions.

Wang Hui depicts these scenes using ink in a consistent manner. Although the materials are different, with only black ink in *Reading* and a very limited color palette – mostly light green, light orange, and gray – in *Water Village* and *Autumn Forest,* the technique is the same. He uses very light washes to fill in the rocks and formations after he has established their edges with slightly darker lines. The washes of green and orange often fade into each other, and his gray washes are gradiated with white.

On top of these washes are complex and meticulously rendered details painted with dark ink and a very fine brush. For example, it seems as if every leaf and ripple of bark is shown on the trees. *Autumn Forest* features about a dozen trees in the foreground, with each individual branch and leaf drawn and overlapping, creating a dense mesh of lines. *Reading* features three large trees which take up the bottom quarter of the composition. Again, the branches are so finely detailed that, seen from afar, the trees become a dark sprawling mass. The trees in *Water Village* are on a much smaller scale, but fine details can be seen on them as well.

The impressive trees are not the only showcases of fine details. Countless tiny dabs of paint, no more than one-quarter inch long, create varying textures. *Reading* is a study in density, with seemingly millions of tiny touches of paint forming shrubbery, depicting tiny trees in the distance, and providing a rough texture to the rocks. The amount of detail in grayscale makes the mountains seem solid and impenetrable. *Autumn Forest* is not nearly as dense, though the dabs are still plentiful. Refreshingly, *Water Village* offers a reprieve from the frenetic paint strokes, as a mostly blank river takes up much of the composition. Here, lines are longer, finer, and swirl around each other to describe waves and currents.

This contrast between *Water Village* and the other two paintings is what interested me the most. Though all three have nearly identical meandering compositions, *Water Village* looks like a photographic negative. Instead of a dominating mountain chain, dense with color and details, the backbone of this painting is a river created by the negative space of the paper. Its winding form is determined by the shapes of the gentle hills that frame the riverbanks. The exact opposite is true of the other two, where the negative space is used to depict mist that further defines the shape of the mountains.

Even though *Reading, Autumn Forest,* and *Water Village* are different in terms of color, density, and use of negative space, these differences do not overwhelm the stylistic similarities. The ink is always light, the palette is limited, and the attention to detail remains consistent. Combine this with the shared grand representation of nature and similar spatial organizations, and it is very clear that these three paintings are stylistic kin.

SAMPLE STUDENT STYLISTIC ANALYSIS #4

Three medieval sculptures representing heads, found in the collection of the Metropolitan Museum of Art, show the same stylistic qualities. *Head of a David* (38.180) is a life-size limestone head from Paris, made in about 1150. *Head of Joseph* (2007.143) is slightly smaller than life-size, made of limestone with traces of paint, and comes from Chartres Cathedral in France, ca. 1230. *Head of a King* (47.100.55) is twice life-size, and made in the vicinity of Paris about 1230. In their symmetry, idealization, carved lines, and use of shadow, the works seem very similar.

The most obvious common characteristic is the symmetrical arrangement of the features, which idealize the figures by suggesting perfection. All three heads are shown in a frontal pose, looking straight ahead. David's hair, which shows under his low, cylindrical crown, and his beard are arranged in bilateral symmetry. The symmetry in Joseph's head is emphasized by deep eye sockets that create triangular shadows which are identical on both sides of his face, cast by the eyebrows towards his nose. His beard is split to two, creating a long central axis. The King's head also shows symmetry in his crown, and his long, falling, curly hair. Two curls on his forehead and his long mustache fit into the same organization.

The smooth surface of the faces also idealizes the heads. David's cheeks are smooth until they gradually become a surface with another texture which is his beard. Joseph's skin stretches smoothly across his high, pronounced cheek bones. The areas under his eyes, between his eyebrows, and between his mouth and nose, are without wrinkles or marks. The King's face is deteriorated in many parts, but some smooth areas on his cheeks suggest that it once resembled the others.

Although the three heads are idealized, they do not represent ageless figures. David has an expressive fold of skin that extends from the base of the nose to the sides of the mouth. Joseph has a very pronounced and developed bone structure, which is definitely

that of a mature adult. Several superficial grooves on his forehead represent wrinkles. The King's head also indicates age by very shallow grooves on the forehead.

Similar curvilinear lines are used to describe the hair and beards of the three heads. Seen from the side, David's hair consists of equally spaced, continuous, shallow grooves. The beard is represented in a similar fashion, but with narrower and shallower channels than the ones of the hair. Joseph's hair has wide and shallow grooves contrasted to narrower, but deeper ones on his beard. The King's hair has both wider and deeper grooves than those in his beard.

The shadows cast by the deeply carved forms create dramatic visual effects. The decorative cuts in David's crown are pairs of equally-spaced, slender, vertical, round-edged rectangles. These are deep dark spaces that draw the eye to the top of the head, and create a rhythmical movement around it. Curls in the first row of the beard are placed in measured increments, each bordered by deep cavities that create a shadow. These, too, create a rhythm that is parallel to the line of the jaw bone. On Joseph's face, the shadows cast by the eyebrows form diagonals towards the sides of the nose. A soft shadow created by the cheek-bones repeats the diagonal movement downwards. Finally, the King's face is visually framed by shadows that arrest the viewer. Deep spaces between the sides of the face and the long hair create two strong, vertical, dark areas. A horizontal shadow is cast by the curls above the forehead. Another dark horizontal is cast by the upper lip, continued in a deeply carved, concave area the mustache. The result is that our eye is drawn to the face, moving and bouncing within this visual frame of verticals and horizontals.

3. SAMPLE STUDENT PAPERS (Iconographic Analysis)

The CCNY students who wrote these papers were given variations of the assignment be-
low, with the iconographic subject and the visual details that identify it specified in the as-
signment. These papers did not necessarily receive an A, but they showed basically strong
organization and they explained how the viewer's attention was drawn to the essential
iconographic elements. Although I have edited them lightly for this book, what appears
here is, in all important ways, the same as what the students gave me.

These sample papers should be read critically in the same way as those in the previous
sections. Underline the topic sentences and see if their sequence of topics seems logical.
Look at each paragraph and see if it develops the idea introduced by the topic sentence.
Look at the first paragraph with special care. This is where the reader should learn what
the paper will be about, and what specific issues it will address. Does the paper do what it
promises? Is enough visual information given for the reader to be able to follow the analy-
sis? Find reproductions of the works. Does the paper discuss the relevant things that you
see in them?

The Assignment:

Go the Metropolitan Museum and select two [or three] works of art in any medium that
tell the same story. Identify the works by using all the information on the object label,
including the museum number. Write a 2-3 page essay (no more than 1000 words) de-
scribing the ways in which the works visually indicate what the subject is. You must give
the reader a general idea of what the objects look like and what their subjects are. (Use
the information about the subjects given on the assignment sheet. NO RESEARCH.)
Then explain exactly which details identify the subject and why the viewer notices them.
For example, have they been emphasized by color or by the composition? Do the works
draw your attention to the same details in different ways? Make sure you include enough
information for the reader to be able to follow your analysis.

SAMPLE STUDENT ICONOGRAPHIC ANALYSIS #1

This paper will analyze the iconography of two medieval works from the collection of the
Metropolitan Museum of Art. Both of them depict the appearance of the resurrected
Jesus Christ to his follower Mary Magdalene (*Gospel of John* 20:11-17). According to the
Bible, three days after Christ died by crucifixion and was buried, he was resurrected. On

that day, Mary Magdalene came to his tomb early in the morning, alone, and found the tomb empty. As she was weeping in the garden outside the tomb, she recognized a man she thought was a gardener, and asked him what had become of Jesus' body. When the man spoke her name, Mary Magdalene recognized that he was Jesus Christ, who had been resurrected. As she reached out to embrace Jesus, he motioned for her to stay back, saying "Do not touch me," because he had not yet ascended into heaven.

The first work I will discuss is a tapestry from the South Netherlands, *The Resurrected Christ Appearing to Mary Magdalene in the Garden* (The Cloisters Collection, 56.47), which is about 5' x 6'. The tapestry was woven of wool, silk, and gilt-metal wrapped thread between 1500 and 1520 CE. It presents Jesus standing just right of center, in front of a large fruit tree, with Mary Magdalene kneeling to his right. Because Mary and Jesus are centered horizontally in the composition, and they are both large (between 2 and 3 feet tall), the viewer can determine that they are the primary subjects in the tapestry. Christ is wearing a red robe, and the wounds on his hands and feet from where he was nailed to the cross are visible. These signs identify the figure as Christ, indicating his mortality and recent death. He is holding a shovel in his left hand, which explains Mary's mistake in identifying him as a gardener. Behind Jesus, in the upper right corner of the tapestry, is a small cliff with an open cave and a boulder sitting in front of it. This cave represents Jesus' tomb.

In the tapestry, Mary reaches out toward Jesus, as if to embrace him with both arms, but he holds his right hand up in protest, gesturing that she stop. This body language communicates the most important part of the story, when Jesus tells Mary Magdalene not to touch him. Mary Magdalene is wearing a red robe over her blue dress, colors which attract the viewer's attention. A small ceramic jar that is placed on the ground at the base of the fruit tree also identifies the woman as Mary Magdalene. It reminds viewers of the biblical story when she washed Jesus' feet with her hair, after breaking open a jar of ointment.

The second work I have selected is *Ivory Plaque with the Journey to Emmaus and Noli Me Tangere* (17.190.47). This plaque is a small relief, carved in ivory around 1115-20 CE in Spain. The sculpture, which is about 5" x 11", depicts two scenes, one in the top half and the other in the bottom. Between the two scenes, the following words are inscribed: DNS LOQVITVR MARIE, which is Latin for *The Lord Speaks to Mary*. This fits the elements in the bottom panel, which depicts a bearded man standing on the right side of the panel, pointing to and partly pulling away from a woman on the left who is reaching out toward

him. The inscription as well as the presence of a man and a woman, and the positions of the figures, make it clear that the scene in the bottom half of the plaque portrays Jesus in the garden with Mary Magdalene. The figures are further identified by their haloes. Christ's is marked with three decorative, v-shaped rays, symbolizing the Holy Trinity. The woman has a simple halo around her head and is placed to the right side of Jesus, which indicates that she is a saint. From all of these things, the viewer can conclude that this scene shows Jesus warning Mary Magdalene, *"Noli Me Tangere"* – "Do not touch me."

SAMPLE STUDENT ICONOGRAPHIC ANALYSIS #2

This paper will analyze two paintings in the collection of the Metropolitan Museum of Art that show the Adoration of the Shepherds, when shepherds come to pay their respects to the infant Jesus. The first is an immense oil painting, about ten by six feet, by Ludovico Cardi, also known as Cigoli (1991.7). The second is a small tempera painting by Andrea Mantegna (32.130.2), only 15 by 21 inches. In both paintings, the baby Jesus is in the center of the composition, emphasized by his position as well as the fact that he is the focus of the other figures' attention. Mary is the one who is closest to him, indicating her importance. The shepherds, across from her and on the other side of Jesus, are identified by their ragged clothes and their attitudes of respect. The angels and haloes show that the subject is holy.

Cigoli's painting depicts a dramatic scene, illuminated by golden light and a star. The baby lies in the center of the composition, a third of the way from the bottom of the painting. He is emphasized by his position, the light, a star directly above him, and a white cloth held behind him. He also is naked and still in the middle of a lot of color and activity. The figure holding the cloth is Mary, who also is illuminated, has a halo, and is physically connected to the baby by the cloth. To the left and just in front of her is a seated old man dressed in a yellow cape, with his hands resting on the top of a cane. He forms a visual unit with Mary and Jesus, and is illuminated by the same light, indicating that he is Joseph. Across from the Holy Family, a man dressed in green kneels, while holding a lamb by its legs in his left hand. Next to him is a standing man dressed in red. The color and size of these figures make them stand out against the darkness behind them, and their clothes and the lamb identify them as shepherds. A few other figures stand outside this group.

The second major area of Cigoli's painting is the top third of the composition, which contains angels and a large star set within golden and pink clouds. This light contrasts

with the small crescent moon and single flaming torch shown against the night sky in the lower part of the picture. Angels depicted as nude babies with blue wings appear within the light, lying above or resting on a layer of dark clouds that separates this area from the figures below. Two angels in the front hold a banner which reads "Gloria in Excelsis Deo," Latin for Glory to God in the highest. The visual splendor of this heavenly part, which is high above the viewer of the painting because of the work's size, makes the painting seem joyous.

Mantegna's picture treats the subject very differently. Here too, the baby is at the center of the composition, a third of the way from the bottom of the painting. Instead of being illuminated by heavenly light and a star, however, a very small naked Jesus lies on a dark blue cloth on rocky ground, with a detailed, hilly landscape extending far behind him. Mary kneels just to the baby's left, overwhelming him with her size, and marked as special by her halo and the brightly colored angels around her and the baby. To her left sits a sleeping old man who wears a bright yellow cape. He and Mary wear red robes, have haloes, and are the largest figures in the scene. Therefore he is Joseph. In the other corner of the picture, to the right of the baby, two men in ragged clothes approach with gestures of prayer and respect. They are the shepherds. All of these figures seem very serious. The background includes a rocky mountain behind the baby which emphasizes him and Mary, a river, several roads, a grassy hill with people and sheep on it, and a dark cliff. More people are coming on the right.

Despite the great differences in size, style, and emotional tone, the two paintings tell the same story. They also both invite the viewer to join in the worship by giving us direct visual access to the baby. We complete the circle of figures around Jesus. Thus they are devotional images, which encourage us to participate in the adoration.

SAMPLE STUDENT ICONOGRAPHIC ANALYSIS #3

Walking through the Egyptian galleries at the Metropolitan Museum of Art, I found representations of the Egyptian king, a pharaoh, depicted in many different ways. There were pharaoh statues, mummies, coffin cases, figurines, reliefs, and drawings, all of which had key details that identified the figures as an Egyptian pharaoh. The three statues I selected show the pharaoh wearing a traditional headdress. The first work is *Head of a King, possibly Mentuhotep III* (66.99.3). From about 2000-1988 BCE, it is made of limestone and is just under life size. It has been damaged. The second work, *Bust from Statue of a King*

(no number, Gallery 23), under life-size, was made of granite between 664-595 BCE. The final statue I chose was *Head of King Amenmesse* (34.2.2), made of quartzite around 1200 BCE, and it seemed to be about life size.

The three statues display an elaborate head covering. Both *Head of a King, possibly Mentuhotep III*, and *Bust from Statue of a King* have one that begins from the middle of the forehead and rises up before stretching across the top of the head, with flat sides projecting out from behind the ears. In the first one, the headdress ends just below the chin, while in the second example, the headdress ends just above the chest. Both also are decorated with chiseled lines, vertical (on the top) and horizontal (on the sides), spaced about a centimeter apart. The third statue wears a headdress that rises above his head in a tall, oval shape. It is larger than the pharaoh's head, and the crown is rounded at the top with a flat back.

The headdresses are adorned with a standing cobra, called a uraeus. The uraeus was a symbol of royalty and divine authority in ancient Egypt. The first statue has been damaged and the uraeus itself is missing, but the place where it once was is clear. The cobra is very noticeable in the other two sculptures. Many of the people represented in images and statues throughout the Egyptian galleries are wearing headdresses, but only the royal figures (and very few important gods like Osiris) also have the uraeus.

These statues depict very regal and powerful men, who look straight ahead, with their heads held up, blank eyes wide open, and very solemn expressions. The right shoulder of *Bust from Statue of a King* indicates that his posture was tall and straight. The symmetry of their features and the smoothness of their skin make them seem removed from us, their viewers. They are not part of our world. This also suggests their authority and power.

SAMPLE STUDENT ICONOGRAPHIC ANALYSIS #4

Buddhism is a religion that began in India and spread across Asia. Its art is filled with representations of Buddha, its founder, at different stages of his life. This paper will discuss how three different works in the collection of the Metropolitan Museum of Art help one identify the subject as Buddha and how the representations differ. *Standing Buddha* (63.25) is a nearly 2' tall limestone sculpture from the Northern Qi dynasty of China, approximately 550-577 A.D. The sculpture shows a standing man with his arms outstretched. We can identify him as Buddha by his elongated earlobes, the bulge on top of his head or ushnisha, and the lotus halo behind his head. He also wears the simple

robe of monks, with a buckle connecting the left and right parts hanging in front of his body. The robe shows the curves and contours of his body beneath it.

The second work, *Seated Preaching Buddha* (20.43), is a black stone sculpture from 11th-century India. This Buddha has an ushnisha that is textured like his hair and elongated earlobes. There also is a small high relief circle between his eyebrows called an urna, another physical symbol of Buddha. Wearing a simple robe with a "U" shaped neckline, he sits on a double lotus throne with his legs crossed so that the soles of his feet are visible. In the center of each foot is a chakra, or ancient sun symbol that represents the various states of existence and the Buddhist doctrine (Wheel of the Law). There is also a chakra on his right palm.

The third work is a hanging scroll called *Welcoming the Descent of Amida Buddha* (30.72.1), from the Muromachi period (1392-1573) in Japan. It depicts a standing Buddha descending from heaven on clouds to escort a believer to the Western Paradise (Museum object label). Buddha is in the center of the scroll, surrounded by two differently sized pale halos. One surrounds his head and the other surrounds his body. His feet rest on lotus flower thrones that are floating on curvaceous white clouds that look like puffs of cigarette smoke. He has a textured ushnisha, elongated earlobes, and wears a robe that is draped like a monk's but is made of a richer, more decorative, fabric. His hands are gesturing as he floats down the scroll.

All three of these works represent Buddha with an ushnisha, elongated earlobes, and a simple robe. They also show the lotus. The works differ in how they present the shared symbols. The works from India and Japan have textured hair and ushnishas, while these features are smooth in the Chinese sculpture. The Chinese and Japanese artists made the flow and movement of the robe very evident, while the Indian sculptor only indicated the presence of the cloth at the neckline. Finally, the lotus appears in a halo in the statue from China, while it is part of a throne in other two. In all of them, however, Buddha seems to be gentle and welcoming.

Appendix IV: The Research Paper

Doing The Research:

1. The assignment:
Write a research paper of 8-10 pages about a single object on display in the Greek and Roman Galleries at the Metropolitan Museum of Art. You must use at least four authoritative sources. At least two of them must have appeared in print form first. Cite them properly in your paper, using the Humanities version of the Chicago Manual style.

2. Selecting a topic:
The student went to the galleries of Greek and Roman Art at the Metropolitan Museum of Art and selected three objects as possible topics for his paper. The first was a Greek cuirass, the second a Roman portrait head, and the third a marble sarcophagus. He looked at all three, taking notes and photographing the details that seemed significant. It quickly became clear that the sarcophagus had many more aspects to discuss than the other works – its form, use, and complicated carvings with lots of figures arranged into different scenes. He then went to the website of the museum (www.metmuseum.org), which is easy to use because it is free, it is authoritative, and it contains a great deal of information about all kinds of works of art. In the case of these three objects, searching with the museum numbers as well as the descriptive titles from the object labels, the student found a lot of information about the sarcophagus, but almost nothing about the other two objects. As a result, he selected the sarcophagus. BE PRACTICAL IN YOUR CHOICE OF TOPIC.

3. Beginning the research:
Gather the basic information about the object or topic you are writing about. In the case of this sarcophagus, the object label at the museum provided a reliable first step. REMEMBER: *Always begin any reading notes with all the facts about the source that you will need for a citation.*

Metropolitan Museum of Art object label:

Marble sarcophagus with the myth of Endymion and Selene

Roman, Severan period, early 3rd century A.D.

Marble

Rogers Fund, 1947 (47.100.4)

The last line indicates that the museum acquired the work in 1947, using money from the Rogers Fund. The number in parentheses is the **museum number**, a unique number assigned to each object in the collection. In this case, it means that the sarcophagus was the fourth part of the 100th acquisition in [19]47. The museum number is essential for identification, and the year of acquisition might be important in looking for relevant art historical literature. The rest of the label tells us that it was made by the Romans during the Severan period, in the early 3rd century A.D. ("Anno Domini," or Year of Our Lord, a term some historians replace with C.E. or "Common Era"). The work is a sarcophagus made of marble, and shows the myth of Selene and Endymion on it. This is a great start, but to make sense of it, you need to know when the Severan period was and what it might mean in relation to the work, what a sarcophagus is, and what the myth of Endymion and Selene is about. You could do a Google search for those terms, but it's better to go back to the Met's website, which you already know has a lot of material. **Because all of the information on www.metmuseum.org has been checked by scholars, it can be used as a source for the research paper.**

A search of the website using the museum number – 47.100.4 – locates a paragraph about the specific work, which turns out to be called the Endymion sarcophagus, in the *Heilbrunn Timeline of Art History*. The entry reads:

"Endymion sarcophagus [Roman] (47.100.4)". In *Heilbrunn Timeline of Art History*. New York: The Metropolitan Museum of Art, 2000–. http://www.metmuseum. org/toah/hd/rsar/ho_47.100.4.htm (accessed November 30, 2008), **quotation**:
An inscription at the center of the lid informs us that this trough-shaped sarcophagus was dedicated to a woman named Arria, who lived fifty years and ten months, by her daughter Anina Hilaria. Arria's matronly looking portrait is carved just to the right of the inscription. The story of Endymion is shown in daringly undercut high relief on the front of the sarcophagus. In the center, the moon goddess Selene alights

from her chariot to visit her beloved, the shepherd Endymion, who reclines at the right. Endymion, most beautiful of men, has been granted eternal youth and eternal sleep; a female figure stands over him pouring out the magic potion of immortality and holding a bunch of sleep-inducing poppies. The scene is flanked on the left end of the sarcophagus by a rising Helios, the sun god, and on the right by a descending Selene, each in a chariot. On the back, a bucolic scene with herdsmen among grazing bulls and unyoked horses is cut in low relief. At once flamboyant and precise, the workmanship of the sarcophagus represents the peak of Antonine-Severan technical mastery. Allusions to the changeless cycle of nature form the background for a myth of fulfillment through unending sleep.

This passage gives a lot of information, but it also leaves important things unexplained. Ten arched panels line the edge of the lid, one of which shows the portrait of the dead woman. What do the others show? Is it common to have these additional elements on the lid? How is it known that the two most important figures are Selene and Endymion and who are all the others? Where does the sarcophagus come from? Where was it made? Is anything known about who might have made it? Who was the woman? Was it common to make such an elaborate sarcophagus for a woman? Commissioned by a daughter? **You should keep a list of your questions to guide your reading and research**. Add new ones as they occur to you.

A number of links appear below the paragraph about the sarcophagus. The first is "Related Timeline(s) – Italian Peninsula, 1-500 AD." None of the "Key Events" listed there seem to be relevant, but clicking on "Roman empire" immediately beneath the strip of pictures provides a history organized by emperor. "The Severans," the name of the period from which this sarcophagus comes, refers to the dynasty established by Septimius Severus, who ruled between 193 and 211, followed by his son Caracalla (r. or reigned 211-7). It ended with the assassination of Alexander Severus in 235.

The next link is to "Related Thematic Essay(s) – Roman Sarcophagi," an essay signed by Heather T. Awan. This might answer some of the questions raised above. The first paragraph is:

Awan, Heather T. "Roman Sarcophagi." In *Heilbrunn Timeline of Art History*. New York: Metropolitan Museum of Art, 2000-. http://www.metmuseum.org/toah/hd/rsar/hd_rsar.htm (accessed November 26, 2008), **quotation**:

A sarcophagus (meaning "flesh-eater" in Greek) is a coffin for inhumation buri-
als, widely used throughout the Roman empire starting in the second century A.D.
The most luxurious were of marble, but they were also made of other stones, lead
(65.148), and wood. Prior to the second century, burial in sarcophagi was not a com-
mon Roman practice; during the Republican and early Imperial periods, the Romans
practiced cremation, and placed remaining bones and ashes in urns or ossuaries.
Sarcophagi had been used for centuries by the Etruscans and the Greeks; when the
Romans eventually adopted inhumation as their primary funerary practice, both of
these cultures had an impact on the development of Roman sarcophagi. The trend
spread all over the empire, creating a large demand for sarcophagi during the second
and third centuries. Three major regional types dominated the trade: Metropolitan
Roman, Attic, and Asiatic.

First, this defines what a sarcophagus is, and places its use in terms of Roman practice.
But what is an "inhumation burial"? (Google search for "inhumation burial definition":
http://ancienthistory.about.com/od/deathafterlife/a/RomanBurial.htm: "Romans could
bury or burn their dead, practices known as inhumation (burial) and cremation (burn-
ing)." and http://en.wikipedia.org/wiki/Burial: "Burial, also called interment and inhu-
mation, is the act of placing a person or object into the ground." Question: so how is a
burial different from inhumation? Is this a specialized term that has a different meaning
from the normal one? CHECK.) Marble was a luxurious material, Roman sarcophagi
were influenced by the Etruscans and the Greeks (Question: how?), and there must have
been lots of sarcophagi made at the same time as this one if there was a "large demand."
There are three types – which is this?

The second paragraph is:

Awan, Heather T. "Roman Sarcophagi." In *Heilbrunn Timeline of Art History*. New
York: Metropolitan Museum of Art, 2000-. http://www.metmuseum.org/
toah/hd/rsar/hd_rsar.htm (accessed November 26, 2008), **quotation**:

Rome was the primary production center in the western part of the empire,
beginning around 110–120 A.D. The most common shape for Roman sarcophagi
is a low rectangular box (48.76.1) and a flat lid. The *kline* lid, with full-length sculp-
tural portraits of the deceased reclining as if at a banquet (1993.11.1), was inspired

by earlier Etruscan funerary monuments. This type of lid gained popularity in the later second century, and was produced in all three production centers for very lavish sarcophagi. The *lenos*, a tub-shaped sarcophagus resembling a trough for pressing grapes, was another late second-century development, and often features two projecting lion's head spouts on the front (47.100.4). Most western Roman sarcophagi were placed inside mausolea against a wall or in a niche, and were therefore only decorated on the front and two short sides. A large number are carved with garlands of fruit and leaves, evoking the actual garlands frequently used to decorate tombs and altars. Narrative scenes from Greek mythology were also popular, reflecting the upper-class Roman taste for Greek culture and literature (55.11.5; 47.100.4). Other common decorative themes include battle and hunting scenes, weddings and other biographical episodes from the life of the deceased, portrait busts (47.100.4), and abstract designs such as strigils (2005.258). Simpler, less expensive sarcophagi were commissioned by freedmen and other nonelite Romans, and sometimes featured the profession of the deceased (48.76.1).

The Endymion sarcophagus is clearly a western Roman *lenos* type because it is given as an example "(47.100.4)" and it has two projecting lion heads. What is the association between a sarcophagus and a tub used for pressing grapes? Perhaps the carving on the back is in low relief because it was placed against a wall. But then the scene couldn't be seen at all, so carving it would make no sense. Are there others like this? If narrative scenes from Greek mythology were favored by upper class Romans (again the Endymion sarcophagus is used as an example), does this mean that the dead woman and/or her daughter were upper class? This sarcophagus also is used as an example of one that has a portrait bust. What are some others? Do the faces look the same or were they modified to suggest specific individuals? Again, there's a great deal of information here, but at least as many questions as answers.

The second to last paragraph also is relevant to the Endymion sarcophagus:

Awan, Heather T. "Roman Sarcophagi." In *Heilbrunn Timeline of Art History*. New York: Metropolitan Museum of Art, 2000-. http://www.metmuseum.org/toah/hd/rsar/hd_rsar.htm (accessed November 26, 2008), **quotation**:
Mythological iconography on sarcophagi has been a subject of considerable in-

terest; the myths shown on sarcophagi are often the same as those chosen to decorate homes and public spaces, but they can acquire different meanings when viewed in a funerary context. Some scholars think the images are highly symbolic of Roman religious beliefs and conceptions about death and the afterlife, while others argue that the images reflect a love of classical culture and served to elevate the status of the deceased, or that they were simply conventional motifs without deeper significance. For instance, the myths of Endymion (47.100.4) and Eros and Psyche (70.1) are tales of mortals who are loved by divinities and granted immortality; in funerary art, these scenes are thought to express the hope for a happy afterlife in the heavens. Scenes featuring heroes such as Meleager or Achilles can be expressions of the bravery and virtue of the deceased. Dionysiac scenes evoke feelings of celebration, and release from the cares of this world; the cult of Dionysos also seemed to offer hope for a pleasureable afterlife (55.11.5). Gorgon faces are apotropaic images for protection against evil forces. The Seasons can represent nature's cycles of death and rebirth, or the successive stages of human life. . . . It is likely that these images had multiple levels of interpretive possibilities, which varied among individual viewers.

This suggests different meanings that the myth of Endymion might have had, from expressing a belief in the afterlife to being a status symbol to meaning nothing (pretty pictures?). Are there any visual clues that support one interpretation or the other? (LOOK AT IT MORE CAREFULLY.) Could all of them be true? What do other scholars think?

The essay ends with suggested readings:

Koch, Guntram, and Hellmut Sichtermann. *Römische Sarkophage*. Munich: Beck, 1982.

Koortbojian, Michael. *Myth, Meaning, and Memory on Roman Sarcophagi*. Berkeley: University of California Press, 1995.

McCann, Anna Marguerite. *Roman Sarcophagi in the Metropolitan Museum of Art*. New York: Metropolitan Museum of Art, 1978.

Toynbee, J. M. C. *Death and Burial in the Roman World*. Baltimore: Johns Hopkins University Press, 1996.

Walker, Susan. *Memorials to the Roman Dead*. London: British Museum
 Publications, 1985.

The first is not useful unless you read German, but the others sound helpful.

Awan's essay includes several links to the object numbered 55.11.5. This work turns out to be another Roman marble sarcophagus, called "The Triumph of Dionysus and the Seasons Sarcophagus" or the "Badminton Sarcophagus" and dated c. 260-70. It too has its own page on the Met's website. Like the Endymion sarcophagus, this one shows a scene from Greek mythology, as well as figures representing the Seasons and Earth. It also is carved in very high relief, with some of the figures separated from the background entirely. According to this entry, unsigned, the design was copied from a "sculptor's pattern book" because another exists with the same composition. (ARE THERE OTHER ENDYMION SARCOPHAGI?) Originally some of the details would have been painted. (IS THIS TRUE OF THE ENDYMION SARCOPHAGUS?) The sarcophagus relates in a couple of ways to the subject of the paper, and they can be looked at together because it's also in the Met. This might make an interesting comparison. (SEE IF OTHER SCHOLARS COMPARE THEM.)

4. Check your textbook!

Another thing you should do right away is **check the textbook your professor assigned for the course**. In this case, it was Nancy H. and Andrew Ramage, *Roman Art. Romulus to Constantine*. 4th ed. (Upper Saddle River, NJ: Pearson/Prentice-Hall, 2005). Although the book doesn't mention the Endymion sarcophagus, it does discuss the Badminton Sarcophagus, described as "a tub-shaped marble coffin that reminds us of a wine vat." The figures "show a dependence on classical models . . . [without] the same interest in individual details of anatomy and drapery as their predecessors [had]." (p. 292) "The whole gives a rich impression, with a high polish, of people, animals, and vegetation." (p. 293) This passage confirms the idea that the two sarcophagi would make an interesting comparison for the paper. Perhaps they can be used to define a period style (**stylistic analysis**), or the figures from Greek mythology that they share are identified in the same way (**iconographic analysis**).

5. Organizing reading notes and developing questions for further research.

It is time to begin organizing your reading notes. You have to figure out what you know and which questions need additional research, and you have to make a list of sources to check. If the paper is supposed to have a thesis (*check the assignment*), it should be developed now because it will determine many of the subsequent research steps. Keep careful track of the sources of your information, so you can check what you are writing against your notes and so you can cite your sources properly. Remember: *not crediting information properly is plagiarism.*

SUMMARY OF NOTES:

–What: "Endymion sarcophagus" – marble coffin meant to hold corpse for burial; placed above ground, so often decorated; this one shows figures from the Greek myth of Endymion and Selene (MMA)

–When: made during the Severan period of the Roman Empire, early 3rd c CE (MMA)

–Where: western Roman empire, "lenos" type, tub-shaped, first appeared late 2nd c CE, lion heads on front like the spouts on the troughs used for pressing grapes (Awan)

–How: "daringly undercut high relief," "peak of Antonine-Severan mastery" (MMA), marble most luxurious material used for Roman sarcophagi (Awan)

–Who: made for Arria, aged 50 years, 10 months (MMA, from inscription), see her portrait to right; commissioned by Anina Hilaria, daughter (MMA, from inscription), but main scene illustrates the myth of Endymion, love, youth, eternal sleep, and moon goddess Selene (MMA); Greek myths common decoration on sarcophagi bought by upper-class Romans (Awan)

–Why: Romans began to use sarcophagi for burial instead of cremation in 2nd c. CE; decorations reflect class – upper-class liked Greek culture, non-elite classes simpler subjects, sometimes showed profession; and choice of Endymion myth has possible relation to death, afterlife (Awan) as do visual references to cycles of nature (MMA, Awan)

–Related works: Badminton sarcophagus (Awan, Ramage)

QUESTIONS:

–Identify all the figures and scenes! How do you know which is which? (**iconography**)
GET RELIABLE SOURCE FOR MYTHOLOGY

–Is there anything else known about the dead woman or her daughter? Does her portrait look like a recognizable person? Do sarcophagi like this often include inscriptions?

–Are there other examples of the Endymion sarcophagus? How are they similar? (**style**)

–Find other marble sarcophagi from same time – designs, carving the same? (**style**)

–Find other examples of the "lenos" type – why the relationship to trough for pressing grapes?

6. *Oxford Art Online:*

The Met's website provided a lot of information, but didn't answer all of the questions raised by the sarcophagus by any means. **One of the best places to begin research on any art historical topic is the subscriber-only database (which you will have to use through your library),** *Oxford Art Online*. Most of the articles were written by leading scholars (look for the name at the end of each article), and they include bibliographies.

Searching for "Endymion sarcophagus" leads to an article by Marianne Bergmann about Roman sculpture made during the 3rd century AD, which uses the work in the MMA as an illustration. Unfortunately it is very general and doesn't add any new information.

Searching for "Sarcophagus" leads to a helpful article. Clicking on the icon for Cite at the top right provides the information that will be needed for the bibliography, in Chicago style.

Bianchi, Robert S. et al. "Sarcophagus." In *Grove Art Online. Oxford Art Online*, http://www.oxfordartonline.com/subscriber/article/grove/art/T075996 (accessed January 18, 2009).

Reading Notes:

"I. Introduction." Decorated sarcophagi can be important works of art because burial is an important cultural activity, and designs and inscriptions will be important indications of culture. Usually placed within larger structure, like pyramid, mausoleum, tomb.

"II. Ancient world. 5. Roman Empire." [Article signed by Susan Walker, who should appear as the author instead of Robert S. Bianchi, et al., for anything that refers to this particular section of the larger essay about sarcophagi.] Roman sarcophagi fashionable 2nd c AD. Like Etruscan, displayed in alcoves, had carved front sides. Long, low box and flat or ridged lid and decorative panel front. Also like Etruscans in using scenes from Greek myths, plays. 3rd c AD, most portraits of dead put in medallions, frames, and sometimes individuals shown in mythological scenes. Endymion popular subject.

The article ends with a link: *See also* Rome, ancient, §IV, 1(iv)(b). Going to the beginning of "IV," which is an article about ancient Roman sculpture, produces some interesting results.

Favro, Diane et al. "Rome, ancient." In *Grove Art Online. Oxford Art Online*, http://
 www.oxfordartonline.com/subscriber/article/grove/art/T073405pg7 (accessed
 January 18, 2009).

Reading Notes:

"Rome, ancient. IV. Sculpture. (ii) Subject-matter." [signed by Richard Brilliant,
who should be cited as the author] 100s of sarcophagi show how wealthy Romans
wanted to be remembered. Many subjects depicted, including Greek myths, cycle of
seasons for continuity. Often have a portrait of dead, sometimes related to subject of
scenes on sides, lid. Might be shipped from quarry roughed out, finished in metro-
politan areas. "
(iii) Materials and techniques. [signed by A. Claridge] (a) Materials. White marble."
Became the most typical medium for Roman sculpture. Came from Greece, Aegean
islands, Turkey, imported to west by Roman emperors. Colors and size of crystals
indicate place of origin. Sometimes made of more than one piece. "(b) Tools and
painting." All Roman carving began with pointed tools, from large to smaller as
work became finer. Lots of single vertical blows, long parallel strokes. Drills used for
large openings, channels. Often clothes, hair, facial features, were painted. 2nd, 3rd
c, usual to incise irises, pupils, probably plus painting.

SUMMARY OF NOTES:

These sources added some details, especially about the process of making, and a sense of
context. Sarcophagi are important works of art because burials matter, some elements of
the form and the use of Greek myths come from the Etruscans, portraits of the dead ap-
peared in the 3rd c, sometimes within the scenes, and Endymion was a popular subject.
[LOOK FOR OTHER EXAMPLES.] White marble became most typical medium for
Roman sculpture, details painted.

7. JSTOR:

A number of subscriber-only databases of articles from print journals, such as Academic
Search Premier, Art Full Text, JSTOR, and Project MUSE, might contain useful items.
Since JSTOR includes both the periodicals published by the Metropolitan Museum and
the College Art Association, it is the best place to start research on this sarcophagus.
JSTOR consists of scans from hard-print publications, and all the material in it has

been peer-reviewed. It does not include things published within the last few years however. The dates of the "moving wall" for each periodical can be found by clicking "Browse" and then select "By Title" from the drop-down menu. Go to the name of the journal you want and look at "JSTOR Coverage."

The first article that turned up in a **search for "Endymion sarcophagus"** is very relevant. Click on "Article Information" and look at "Bibliographic Info" to get the correct information about it.

> **An Endymion Sarcophagus Rediscovered**
> Author(s): Friedrich Matz
> Source: *The Metropolitan Museum of Art Bulletin*, New Series, Vol. 15,
> No. 5 (Jan., 1957), pp. 123-128
> Published by: The Metropolitan Museum of Art
> Stable URL: http://www.jstor.org/stable/3257726

This has to be formatted correctly for the citation style you are using. The publisher is not given for periodicals in Chicago style. Sometimes the "Stable URL" is included: http://www.jstor.org/stable/3257726. However, using that web address will get you only the first page of the article. To read the whole thing, you need to use JSTOR, and enter "Endymion sarcophagus," the name of the author, or title of the article. No part of the URL will work. This is an argument for not including it in a citation. Chicago Humanities style for a bibliography would be:

Matz, Friedrich. "An Endymion Sarcophagus Rediscovered." *The Metropolitan Museum of Art Bulletin* n.s. 15, no. 5 (Jan 1957): 123-8.

Reading notes:

p. 123: main scene between two lion heads. Right, sleeping hunter Endymion. Winged figure above him is Night, holding poppy plant and horn, used to pour drug over Endymion. Selene in center. Looks at Endymion as gets out of chariot. Veil over head represents veil of night. Right hand holds wreath with ties [what is this?]. Six small Erotes, four hold flaming torches, two guard chariot. Horses pull to continue nightly trip through sky. Girl holding reins also divinity (wings). [see next paragraph] Reclining figure of Earth under horses, holding snake in hand. Seated herdsman left, dog and herd, adds calm, pastoral. Under lion head on left – Eros and Psyche – right – two Erotes. Left end – rising chariot of Sun god, over reclining figure of Ocean. Eros with torch is Morning Star. Right end – setting Moon god-

dess in chariot, over reclining Earth. Eros with burning torch falling down is setting Evening Star. Back – low relief – two herdsmen, cattle, horses, continue pastoral theme. Two girls on right, one points out scene on front. Both wear reeds in hair, one holds jar pouring water, so they are nymphs. Panels of lid connected to main subject. Mountain gods at two ends. Then Autumn on left, Spring on right. Cycle of nature adds idea of life of soul after death.

127: next panel on left, Eros and Psyche, paired with right, Aphrodite. Aphrodite on next panel right, partner war god Ares on left. Other references to story Endymion and Selene. United couple Selene and Endymion to left of inscription, and same place on right is portrait of dead. Inscription central panel – dead was woman named Arria, caste of freedmen, aged nearly 51. Daughter Aninia Hilara buried her. Hair style on portrait like that made fashionable by Julia Domna, wife Emperor Septimius Severus (193-211). Dates sarcophagus to between about 195 and 210. From same workshop as other surviving sarcophagi. Myth good for graves, poetic image of life after death. Almost 70 sarcophagi with Endymion survive from 2nd, 3rd c. Model probably famous painting from 3rd, 2nd c BC. MMA, another sarcophagus, same subject, from 30/40 years earlier. Almost same pictorial elements, but later one has looser, freer design and relation to shape of sarcophagus. Structure of later one symbolic – like troughs for grape pressing, where lion masks had spouts for new wine, hint of life of spirit after death.

128: sarcophagus found in Ostia, 1825. Lots of bibliography, not useful, too specific, German.

This source names almost all of the figures, but now you need to know who they are. Googling them, you find that Aphrodite is the Greek name for the goddess of love the Romans called Venus, the Greek god of war, Ares, is the Roman Mars, and Roman freedmen were people who had been slaves but became free in some ways. The mention of another sarcophagus that shows Endymion in the Met is very useful [LOOK AT OTHER ENDYMION SARCOPHAGUS IN THE MMA], and it sounds as if it would make a great stylistic comparison. The idea that they share a common pictorial source is interesting. [FIND OUT IF OTHER SCHOLARS AGREE] The explanation about the relationship between the sarcophagus and the wine trough doesn't make sense – how does wine hint at the life of the spirit after death? [CHECK RELATIONSHIP WINE, DEATH]

When you have finished with an article, click on "Back to Search Results" at the upper right of the screen. The next article that seemed relevant, based on the title, is:

A Roman Sarcophagus
Author(s): G. M. A. Richter
Source: *The Metropolitan Museum of Art Bulletin*, Vol. 20, No. 3 (Mar., 1925), pp. 77-80
Published by: The Metropolitan Museum of Art
Stable URL: http://www.jstor.org/stable/3254350

Remember to format the citation correctly for a bibliography at the top of your notes!

Richter, G.M.A. "A Roman Sarcophagus." *The Metropolitan Museum of Art Bulletin* 20, No. 3 (March 1925): 77-80.

Reading Notes:

p. 77: so many Roman sarcophagi survive that they are excellent way to study sculpture

78: new acquisition of MMA (dimensions suggest tall, thin dead person) shows Endymion asleep on ground. Somnus God of Sleep behind him. Goddess Selene getting out of chariot, marked by crescent on head, escorted by little Erotes. Aura, air deity, guards horses. Standing Eros asleep at each end of composition on front. Griffin on each end. One at head very rough and back not carved at all, so probably meant to be pushed against wall. Early example of one where scene moves from left to right. Landscape style.

80: shepherd boy asleep in cave emphasizes that mythological scene is set in actual landscape. Figures Aura, Selene, and Endymion based on Greek models, sleeping Erotes Roman, basis of Renaissance sleeping putti.

Since the major elements of the scene on the front of the two sarcophagi are nearly the same, including the shepherd, the comparison is very useful. Richter identifies the figure behind Endymion as Sleep, not Night, and the figure who guards the horses as Aura. [CHECK IF THE FIGURES LOOK THE SAME – COULD THIS BE TRUE OF THE LATER SARCOPHAGUS TOO?] This sarcophagus is the same type as the one that is the subject of the paper, and it makes an interesting comparison. In addition, some of the information (for example, that the ledge above the shepherd represents a cave) might relate to both of them.

Another article that looked useful is

Sorabella, Jean. "A Roman Sarcophagus and Its Patron." *Metropolitan Museum Journal* 36 (2001): 67-81.

Reading notes:

p. 67: if choice of subjects on sarcophagi depended on the dead, then interpretations might be different. Should study inscriptions, see if people can be identified, a relation to myth can be established. Endymion sarcophagus "one of very few" known dedicated by daughter. "mari" means mother, "inconparabile" common flattering adjective, "Cl." stands for "Claudia" so full name was "Claudia Arria."

69: sarcophagus would have cost most of daughter's money, but otherwise not found in documents, unless she is freedwoman "Aninia," named in funerary plaque set up by husband

70: found in chamber tomb, Ostia, 1825. "Remarkable for the refinement of the sculptural decoration." Endymion story found on about 120 sarcophagi from Roman workshops. Earliest examples, 130 AD, simple compositions, Selene often walking right to left. Later changed to left to right, possibly related to direction Greek and Latin texts read [why? Change in language?]. Early 3rd c, single scene of Selene arriving, lover asleep, lots of other figures, most common. Relevance of subject obvious – elimination of barriers mortality/divinity, and sleep/love, alternative to death. Others explain it differently.

71: sometimes subject related to particular death – Endymion slept "well and long." Subject used for sarcophagi of men, children, and married couples, as well as this woman. Long survival of story on sarcophagi suggests some meaning. Model for Jonah in Early Christian art. Even without important text, story could have been part of tradition, familiar to all

74: typical of Severan sculpture, extensive undercutting and use of drill make depth in relief, no space empty, filled with motion. Selene most significant action. Tree, etc indicate pastoral landscape, and flock of cupids suggest love, weddings. Poses of

Selene and Endymion suggest erotic, sensual. Arched panels on lid also show later moment in Selene story – unique

75: God Mars [Ares] may be Paris, Venus [Aphrodite] holding apple of victory. Other scenes about natural phenomena, attributes of seasons or Dionysus, god of wine. Abundance of earth. Sun god and Moon put myth in time cycle.

76: daughter possibly chose sarcophagi from others with different subjects

77: probably bought nearly finished. Possibly even portrait there already, and just finished for commission, so more expensive. In others, dead shown in face of Selene, Endymion – not here.

8. Find the books:

So far, the reading has produced a list of possibly relevant books that must be located as soon as possible. Combining the bibliographies, the books are:

Koortbojian, Michael. *Myth, Meaning, and Memory on Roman Sarcophagi*. Berkeley: University of California Press, 1995.

McCann, Anna Marguerite. *Roman Sarcophagi in the Metropolitan Museum of Art*. New York: Metropolitan Museum of Art, 1978.

Toynbee, J. M. C. *Death and Burial in the Roman World*. Baltimore: Johns Hopkins University Press, 1996.

Walker, Susan. *Memorials to the Roman Dead*. London: British Museum Publications, 1985.

Begin by looking for them on Google Books, in case they are available in Limited or Full View. The first one turns out to be there, although without illustrations:

Koortbojian, Michael. *Myth, Meaning, and Memory on Roman Sarcophagi*. Berkeley: University of California Press, 1995. HTML of book (without illustrations) http://www.escholarship.org/editions/view?docId=ft4199n900&brand=ucpress

Reading notes:

Preface: reference to H. Sichtermann, study of the Endymion sarcophagi, revised series of the *Corpus der antiken Sarkophagreliefs* TRY TO FIND IN LIBRARY FOR PICTURES

Endymion's Tale:
http://www.escholarship.org/editions/view?docId=ft4199n900&chunk.
id=ch4&toc.depth=1&toc.id=ch4&brand=ucpress

Few textual sources from classical world for Endymion myth. One used for sarcophagi is eastern tradition, Sappho, Asia Minor. Relation of death and sleep important.
Note 14: 110 examples of Endymion sarcs. Visual representations emphasize Selene's coming at night and sleeping shepherd. Selene's blowing veil sign of divinity. Shown getting out of chariot, pulled by Aura, Breeze [check MMA – is she there??]. Erotes [Google for definition: plural of Eros, winged babies, children or figures related to love] light way with torches. Gods being there show sleep is magical. Many sarcophagi show Endymion in lap of Hypnos, god of sleep [check MMA]. Tree indicates sacred grove where meeting happened in Sappho's account. Sequence of chariot, Selene, Endymion, only appeared later, c. 180 CE. Endymion sarcophagi different from other myths on sarcophagi because most show only one scene, not many scenes

http://www.escholarship.org/editions/view?docId=ft4199n900&chunk.
id=s1.4.19&toc.id=ch4&brand=ucpress

MMA's sarcophagus one of most elaborate examples of allegorical treatment of Endymion myth. Figures everywhere, even front edge lid. Cupid and Psyche at left represent similar story, mortal/divine love, meeting in darkness.

http://www.escholarship.org/editions/view?docId=ft4199n900&chunk.
id=s1.4.20&toc.id=ch4&brand=ucpress:

Signs of cycles of day and year show endlessness of Endymion's sleep. Pastoral scene not connected to story, but shows "bucolic idyll," "Theocritan pastoral," so tranquility after death. Used without myth too, so has independent association with death.

McCann, Anna Marguerite. *Roman Sarcophagi in the Metropolitan Museum of Art*.
Not available on Google Books. FIND IN LIBRARY.

Toynbee, J. M. C. *Death and Burial in the Roman World*.
Available as Limited Preview, Google Books. Search book for "Endymion sarcophagus," no results. Search "Endymion" and "sarcophagus." Second has too many references to be helpful. Look at Table of Contents to see what might be relevant. Many sections not available in preview. FIND IN LIBRARY.

Walker, Susan. *Memorials to the Roman Dead*.
Not available on Google Books. FIND IN LIBRARY.

9. Check your library catalogue and *WorldCat* to locate the books you need.

You will need to go to a library to use the sources that are not available online. Some professors make this mandatory. *Check your assignment.* Start by looking them up in the catalogue of the best library you have access to. If you can't find the titles in any local library, you will have to request them through Interlibrary Loan. The easiest way to do this is to look them up in a subscriber-only database called ***WorldCat*** (so you will have to use it through a library), which is a union catalogue of the holdings of many libraries. In theory, it lists every book held by American libraries, and some foreign ones as well. *WorldCat* is not always complete, however, so you should not give up if it doesn't have something. Ask a librarian for help!

The basic search page on *WorldCat* gives you many different fields to fill in. In the case of these books, author and title should be enough. Remember to indicate what category of information you have entered in the box to the right, which has a default setting of "Keyword". Check your spelling! The first attempt to find the book by McCann turned up no results because the student had typed "Rooman" instead of "Roman".

According to *WorldCat,* 176 libraries owned McCann's book, 988 had Toynbee's, and 188 had Walker's, so they should not be hard to find. The names of the libraries are given, organized by location, if you click on "Libraries worldwide that own item." Clicking on the name of the institution should take you to the library catalogue of that place. If you want to request that it be sent to your library through ILL, or Interlibrary Loan, you should click "Get It" at the top of the list of the libraries and follow the directions. The book you want may not be available, or it may take several weeks to arrive, so make sure you **request Interlibrary Loans well before the paper is due.**

10. Go to the library.

Once you have the call numbers of the items you want, and have found the place in the library where they are located, you should look at the other books shelved in the same place. They are grouped by subject, so some might be useful. The Internet is fast and efficient, but it provides no equivalent to the ease with which you can flip through pages. This is especially true for looking at lots of reproductions quickly. For this reason, you should try to use a library where you can get the books yourself instead of one with closed stacks, where someone else gets them for you.

The library the student went to had the books by Koortbojian, McCann, and Walker on the shelf. The one by Toynbee could not be located (not on the shelf, not recorded as

checked out in the system, not with books in the process of being reshelved), but the others had so much information, that it didn't seem necessary to find it.

McCann, Anna Marguerite. *Roman Sarcophagi in the Metropolitan Museum of Art.* New York: Metropolitan Museum of Art, 1978.

Reading notes:

Introduction

p. 19: striking that Roman sarcophagi do not appear until 2nd c AD

20: sarcophagi and inhumation appear so suddenly, so widespread in 2nd c – why? Suggested influence of Hadrian (r. 117-37), his imperial taste, classical tradition. Also sculptural workshops of Rome attracted people from Asia Minor, who came with the idea. But more than changed taste. Mid-2nd c, deepening belief in life beyond grave – increasing interest in care for dead and more elaborate monuments, memorials. No change in pagan state religion, but growing mystery cults, Christianity, so ideas of immortal soul and resurrected body gave motivation.

Practical too – large amounts of marble from Hellenistic eastern quarries available time of Hadrian, and sarcophagus provided more space for elaborate decoration. Stone sarcophagi spread rapidly, symbol of wealth – greatest number, mid-2nd – mid-3rd c. 5000+ survive today. Largest amount of sculpture left from later Roman empire, so material for study of style, subject. Two types, different shape and place of decoration: 1. Roman, western, carving on 3 sides only because back against wall of tomb or niche. Lids are low-pitched roofs or

21: flat, edged with upright carved panel running length of front and decorated at ends with masks. First long, low shape popular, but 3rd c, round-ended, trough-like form, called *lenos* (gives Endymion and Badminton sarcophagi in MMA as examples). 2. Asia Minor, eastern, largest group is Attic, from Greek mainland. Carved on all 4 sides, continuous frieze decoration, put in open or on "streets of dead" in cities, so all sides visible. Lids high gabled roofs or couches with reclining figures – influence Italic-Etruscan. Subjects vary – earlier western, friezes decorated garlands, imitation actual swags on tombs, symbolism fruitfulness of afterlife. Second most popular, narrative scenes after Greek myths, or scenes from life of deceased. Myths interpreted allegorically as hopes for afterlife, so do good deeds in this one. 3rd c, away from narrative to allegorical (see Badminton sarcophagus).

22: Severan age, most critical shift to late Antique style takes place – "release of the human figure from background by deep undercutting" – drill used extensively, contrast highly polished layer of forms, creates play light/shadow. Originally had gilt on details – instead of polychromy (see Badminton). Ancient Romans saw gold as symbol divine, Christians as symbol light. So looked different – 3-d created by drilling, gilt versus white of marble, figures no longer restricted to classical canons of proportion, elongated bodies without bodily structure, differences in scale, emphasis on eyes (large pupils), compositions centralized with figures frozen in frontal positions. Narratives go from left to right in 2nd c, change to hieratic scale designs, purely abstract patterns popular too, and medallion portrait type flanked by figures.

34: Endymion sarcophagus (24.97.13), mid-Antoinine, 150-60 AD, found Via Ardeatina, outskirts Rome, 19.5 in. H, 78.5 in. L, 20 in. D. See source Cumont, identifies moon as actual home of blassed. Putti at corners cross legs, poses from Praxiteles [4th c BC Greek sculptor], represent death, extinguishes light of life.

35: Endymion with male figure Sleep behind him, with moth wings and stalk of seeded poppies, pouring sleeping potion over Endymion. Flying putto pulls mantle away from Endymion. Draped female on branch with jar of water must be nymph – places scene on Mt. Latmos. Selene, identified by crescent moon on forehead, steps from chariot to Endymion. Upper putti hold lit torch and encircling mantle of Selene, on each side of her. Aura, winged, personifies Breeze, holds 2 horses. Two putti on horses, one holds reins, other [on right] holds torch, mantle of Selene. Far right, sleeping shepherd sitting on rock, dog in front of him, goats and sheep above [all have horns]. Griffin carved on each end – guardians of dead, frequently appear context Bacchus.

36: Endymion myth popular subject for sarcophagi from Antonine to Severan periods, 70+ examples known. P. 36, Note 7: Roberts divided into 2 classes – story goes from left to right, like this one, is later class. This is early example, before other figures added – one in collection Villa Pamphili similar – both based on common prototype. Also shows development from long, low single ground line (this one) to taller, rounded ends of lenos type.

39: Endymion sarcophagus (47.100.4), found in funeral chamber, Ostia [Italy], in 1825. Lid is Luni marble, coffin probably poor quality Pentelic marble [like the

Parthenon]. Sarcophagus has rounded ends, and body flares upward. Carved on four sides, although back lower relief. Lion's heads may relate to ancient wine trough, symbolizing spouts for new wine used on troughs when grapes pressed – new form has symbolic meaning, possibly connected to mystery rites, Dionysus, hope of new life [note to Matz article, p. 127 – CHECK]. Endymion's pose common for sleeping figures in Greek statues.

42: winged female Night, holding stalk with poppy seed pods, pours sleeping potion over him. Selene encouraged by putti, attendants of love. Probably Aura, Breeze, holding reins. Mother Earth beneath chariot holding sacred snake. Bearded shepherd with dog by knees and kid beside him. Sheep and goats on rocky ledge above. Eros and Psyche. Myth given cosmological setting by having figures of Sun, Moon on ends. Sun with crown of rays, with Morning Star and bearded Ocean. Moon with crescent crown, Aura, Evening Star, going down toward Earth. Ocean and Earth represent realm dead leaves. Helios in quadriga, later becomes Christ as Helios. Back shows bulls, horses, herdsmen. One to left reclines in same pose as Endymion, links back to front. Two nymphs, water jar, to right, represent a spring, continuation of pastoral tradition of Endymion, possibly took place on Mt. Latmos, Caria. Back not as well executed as the front. Possibly made by assistant, not master.

43: two gods on end panels along lid, personification of mountain setting – one to left possibly Mt. Latmos, right possibly young God Sylvanus with hare and dog. Next males Seasons – Spring with hare, stalk of flowers, hare and tragic Mask at feet; Fall with bowl of fruit and panther at feet. Renewal of nature appropriate subject, common on sarcophagi. Left, Eros and Psyche; right, Venus. Left, Mars; right, Venus. Left, Endymion and Selene, possibly unique representation of embrace. [CHECK THIS!] Erotes around them. Both have crescents in hair, which means that Endymion has become eternal. Surely represents hope of daughter who ordered and had inscribed elaborate coffin. Recurring theme of love suggests devotion. Hair style in portrait of dead associated with Julia Domna, simple large waves, parted middle, covering ears, pulled back to upper neck. Allows secure date after which sarcophagus had to have been carved, and fashion might have continued longer in private instead of Imperial circles. Unique among 70+ examples

44: in rich imagery, fine quality, no longer single ground line, figures loosened, float

above one another, new spatial construct, deep drill work for hair, fur, manes, bodies no longer about gravity – see Endymion, flattened and elongated, polished rapidly moving forms, crowded surface, lovely composition, naturalistic details – "early Severan baroque style" fulfilled in Badminton sarcophagus.

45: ill. examples in Museo Capitolino, Rome, Galleria Doria Pamphili, Rome.

94: Badminton sarcophagus.

95: 40 human, animal figures, 3 sides. Winter, far left, rushes for wreath, brace of ducks and carries

96: a reed, with wild boar at feet. Spring, garlanded with flowers, basket flowers, flowering branch, with small stag below. Summer next, wreath of wheat, basket of wheat, sickle, goat. Fall, cornucopia fruit and hare, garland with fruit in hair.

97: Earth and Ocean on ends give theme of afterlife (Dionysus in center of front), renewal (Seasons), cosmological framework.

101: no longer rational space, instability, virtuoso techniques, originally gilding hair, attributes, composition focuses center, no naturalness of movement still found in Endymion sarcophagus, bodies don't show structural form or classical beauty, large eyes of Late Antique style.

102: Matz wrong in idea that composition of Endymion comes from Hellenistic painting

103: style seems like Endymion sarcophagus in Louvre, so date of 220-35 accepted. [Note: not the date given on the MMA's website or Rampage for the Badminton sarcophagus.]

Walker, Susan. *Memorials to the Roman Dead*. London: British Museum, 1985.

Reading notes:

p. 18: Greek quarries dominated Roman market, possibly because fashion for sarcophagi came from east. Roughly cut, arrive in Rome often without lid, which then was made of Luna marble from Carrara, Tuscany. [SEE ENDYMION SARCOPHAGUS!] Long distance trade, 3 quarries – one Mount Pentelicus, Attica.

20: Mount Pentelicus produced marble for Parthenon, fine-grained, crisp details, weathers to honey color. Presumably very expensive.

31: Museo Civico, Urbino – Roman carving of sculptor making lion's mane with drill, aided by assistant rotating strap, shows Christian Greek-speaking sculptor Eutropus.

36: taste for portraits on sarcophagi greatest in Rome. Sleeping Endymion or Ariadne obvious choices of subject.

43: sarcophagus often bought hurriedly, in stock, sometimes portraits required drastic alteration of sculpture that was there.

11. The myths

You still need **a reliable source for the stories of the myths**. Look in the reference section of the library, or check Google books for a relatively recent book about classical mythology published by a major university press. **Searching for "Endymion and Selene myth" in Google Books** produced Mark P.O. Morford and Robert J. Lenardon, *Classical Mythology*, 6th ed. (New York: Oxford University Press, 1999), available in Limited Preview. All the relevant pages appear in the preview.

Morford, Mark P.O. and Robert J. Lenardon. *Classical Mythology*. 6th ed. New York: Oxford University Press, 1999.

Reading notes:

p. 42: myth of Selene and Endymion only famous one about Selene, goddess of Moon. Brother is Helius [or Helios]. Has chariot, usually with two horses. Loved handsome youth Endymion, usually a shepherd. She saw him asleep in cave, Mt. Latmus (Caria). Came back repeatedly to be with him as he slept. Many variations, but in the end, Zeus gave Endymion perpetual sleep and youth so that Selene could have him forever.

43: ill. MMA's Endymion Sarcophagus, repeats information from museum website

136: Cupid and Psyche. Classic version story from Roman author, 2nd c AD, Apuleius, *Metamorphoses* and *The Golden Ass*. Cupid (Eros), Psyche (Soul). Psyche youngest of three daughters of King and Queen. So beautiful, thought to be Venus and so goddess very angry. Venus ordered son Cupid to make Psyche fall in love with most awful thing in world, but instead Cupid fell in love with her. Since no one would marry her, father consulted god Apollo, who said put her on mountaintop to wed serpent. Psyche fell asleep, and after waking entered beautiful palace there. Anonymous husband visited her every night, but left before sun rose. He allowed her sisters to visit her, but warned about trying to find out who he was.

137: husband warned that sisters were evil, and said that Psyche was pregnant with

child who would be divine if secret kept, mortal if not. Sisters returned for third visit, said husband was a serpent. Psyche persuaded to kill him, hid knife and lamp. After he fell asleep, she raised lamp, saw beautiful Cupid. Lamp dropped oil on shoulder, he woke up, flew away. Went to mother Venus, who vowed revenge on Psyche. Psyche brought to her, and Venus gave her impossible jobs.

138: with help, she completed all of them. Cupid went to Jupiter, who agreed to marriage, and Psyche made an immortal.

117: Venus. Venus/Aphrodite goddess of beauty, love, marriage.

127: Helios. Also Helius. Sun god.

WRITING AN OUTLINE OF THE PAPER

These reading notes contain more than enough information about the sarcophagus for an 8-10 page research paper. An outline will organize the notes and help uncover whatever facts are still missing. The one that follows is not the only one that could be created from these notes. For example, it does not include any discussion about the change in Roman burial practices and its influence on the development of the Roman sarcophagus, or the way in which this example was carved. Many different papers can be written about this work, so your choice of thesis will determine the direction of your discussion.

Outline:
Intro (paragraph)
Thesis – Sarcophagus depicts scenes of love and immortal sleep
Brief description
Name, date, museum id, material, who discovered, when acquired by the museum

Physical description
General sarcophagus info – called lenos, dimensions, material
Deep, undercut relief, packed with figures
Descriptions of scenes shown on front, sides, back
Top panels – description of figures, inscription

Identify figures (iconography)
Selene and Endymion
Cupid and Psyche
Gods: Helios, Nyx (Night), Venus, Mars
Others: flying erotes – like cupids, mountain gods, nymphs
Scenes on top – portrait, seasons, myths

Lion heads – replace spouts on wine container
Pastoral scenes – shepherd, herdsmen on back

Myths shown (iconography)
Selene and Endymion myth – no single source – assembled from fragments
Other myths – Cupid and Psyche, Venus

Comparisons to style of other works made at the time (iconography, style)
Earlier Endymion sarcophagus, Badminton sarcophagus, find other examples!

Endymion sarcophagi (history, interpretation)
70 found- many, many more lost (?)
Sleep and death- (find out what Romans at this time believed happened to the dead.
Hades?)
Peaceful existence, immortal – link to dead person and Endymion
Cycle of death and life – pastoral scene, depiction of seasons
Person surrounded by life, in deep sleep (Will wake someday?)

Conclusion
Why so popular?

First Draft

(Topic sentences underlined)

<u>The Endymion Sarcophagus (47.100.4) is a Roman marble sarcophagus created between 200-220 CE during the Severan Dynasty, decorated with scenes dealing with love and immortality.</u> The base of the sarcophagus is 73 inches wide by 20 inches tall, with the top an additional eight inches high. The shape of the sarcophagus is known as *lenos*, which resembles a trough for pressing grapes.[1] The heavily decorated sarcophagus depicts many figures in a deeply undercut relief. It was found at Ostia in 1825, but then lost until 1913, and was bought by the Metropolitan Museum of art at 1947.[2]

<u>The sarcophagus has decorations on both the base and lid.</u> The major carvings are on the long sides. The front, distinguished by the depth of the carving, shows the main myth of Selene and Endymion bracketed on either side by a large lions' head. The back shows a pastoral scene in a lower relief. The low reliefs on the back are to let it sit flush against the wall of a vault. The sides have depictions of Selene and Helios. The lid of the sarcophagus is bare except for the front, which is ornamented with a panel with an inscription in the center, and ten small scenes in arches on either side.

<u>The central myth depicted on the sarcophagus is that of Selene and Endymion.</u> The Greek goddess Selene represents the moon, and is the sister of Helios, the sun god. Selene fell in love with Endymion, a beautiful young huntsman or shepherd. She came to him while he was asleep in a grotto and put him into an eternal sleep.[3] This event supposedly took place on Mount Latmos, near Miletos. The main scene on the front of the sarcophagus illustrates Selene meeting Endymion while he sleeps. Because of cupids holding torches and Selene riding her chariot, the scene is set in the nighttime. One of the small scenes on the lid of the sarcophagus shows Endymion having awoken to be with Selene.

1. Heather T. Awan, "Roman Sarcophagi," in *Heilbrunn Timeline of Art History* (The Metropolitan Museum of Art, 2000–). http://www.metmuseum.org/toah/hd/rsar/hd_rsar.htm (accessed November 26, 2008).

2. Friedrich Matz, "An Endymion Sarcophagus Rediscovered," The Metropolitan Museum Art Bulletin, New Series, 15 (January 1957): 128.

3. Yves Bonnefoy and Wendy Doniger, *Greek and Egyptian Mythologies* (Chicago: University of Chicago Press, 1992): 178.

To the right of the scene, Selene is mounting her chariot after the meeting with Endymion.

The front consists of many figures arranged between two matching lions' heads. Despite the complexity of the design, the major characters are easily identifiable. On the front of the base, near the center is a woman that is around one and a half feet tall. She is the goddess Selene, stepping down from a chariot pulled by two rearing horses located to her left.[4] She wears a flowing dress that leaves her right breast uncovered. She holds a veil above her head that forms a crescent moon shape, and holds a wreath in her right hand. She is depicted from the side, leaning over a man to the right.

The man is Endymion, shown lying on the ground with his eyes closed.[5] He is mostly nude, with only a cloth partially covering his chest. He has one arm held to his head, in the classical Greek position of sleep. Standing above him is a winged female figure dressed in a robe that may be the goddess Night, or Nyx.[6] She is holding poppy flowers in her right arm and pouring a potion out of a drinking horn with her left hand. Surrounding the figures are six nude winged cupids watching the scene between Selene and Endymion.[7] Four of them hold torches to light Endymion, and two hold the reins of Selene's horses.

There are many other characters depicted in the scene that are not part of the myth. To the left of the chariot is a female figure that is slightly smaller than Selene is. She holds the reins of the horses in her right hand and a whip in the left, attempting to calm the horses down. Sitting on the ground to directly to her left is a bearded shepherd who is scratching a dog. Around him lay several sheep. On both the left and right of the figures are two large lion heads with their mouths open. They are placed in a place where the spouts are found on grape pressing troughs upon which the shape of the sarcophagus is based.[8] Under the head of the lion on the left, next to the man are two small winged figures embracing one another, identified as Cupid and Psyche.[9]

Beyond the lions, the sides of the sarcophagus curve around, containing more figures. On the left side of the sarcophagus, a nude male figure wearing a cloak, identified as

4. Matz, 123.

5. Matz, 123.

6. Mark P. O. Morford and Robert J. Lenardon, *Classical Mythology* (New York: Oxford University Press, 2003), 59.

7. Matz, 123.

8. Jean Sorbella, "A Roman Sarcophagus and Its Patron," *Metropolitan Museum Journal*, 36 (2001): 70.

9. Matz, 123.

Helios, is depicted climbing into his chariot, pulled by four horses.[10] The right side of the sarcophagus shows Selene again, this time in the process of getting into her chariot. The reins of the two horses that pull the chariot are held by a winged female figure.

The back depicts a pastoral scene in a shallower relief than the front. On the left, past Selene, sits an older bearded man dressed in a robe who looks back at Selene. Behind him are three large bulls and a sheep. In the center are three grazing horses. On the right stand a herdsman and his dog. Beyond the man and his dog are two women who stand near Helios, with one pointing to the scene on the front.

On the front of the lid is an inscription that reads,

"ANINIA HILARA / CL·ARRIAE MARI /·INCONPARABILE / FECIT·VIXIT·/ ANN·L·MEN /·X"[11].

This means that the sarcophagus was created for a freedwoman[12] named Claudia Arria, who lived for fifty years and ten months. The daughter of Claudia, Aninia Hilaria, dedicated the sarcophagus.[13] The content of inscription is unusual as it indicates that the daughter, not a husband, father, or son-in-law paid for the sarcophagus.[14] In fact, according to Saller and Shaw, funerary inscriptions from daughters to mothers make up only three percent of all dedications.[15]

On either side of the inscription are ten six inch tall reliefs arranged in a row, five on each side, each depicting a different scene in an arch. The scenes on both the far left and far right depict male figures at rest within a pastoral landscape. Moving forward toward the center, the reliefs depict cupids with fruits and animals, symbolizing the seasons and the bounty of the earth. The next panel, the third from the left, depicts Cupid and Psyche embracing. Cupid turns away from Psyche, while Psyche pulls his chin to face her.[16] The fourth panel from the left is of a man dressed in armor and carrying a spear and shield, and faces right. He can be identified as Mars, god of war and Venus's lover.[17]

The final panel on the left side shows a seated nude man facing a seated woman dressed

10. Matz, 123.
11. Sorbella, 67.
12. Matz, 127.
13. Sorbella, 67-69.
14. Sorabella, 67.
15. Sorabella, 79.
16. Sorbella, 74-75.
17. Sorabella, 75.

in a flowing robe. They are Selene and Endymion, after Endymion awakens.[18] Two cupids, watching the scene, surround the two figures.

The panel on the right of the inscription is of the woman for whom the sarcophagus was made, Claudia Arria.[19] She has a stern expression and crossed arms, and faces out at the viewer. The portrait helps to date the work, as she is depicted with a specific hairstyle made popular by Empress Julia Domina (193 – 211 C.E.), wife of Septimius Severus.[20]

To the right of the portrait is a semi-nude female figure, interpreted as Venus, who stands among cupids. She holds out an apple with her right hand and a spear in her left. To the right of the relief is another scene with Venus. In it she rests on a rock nude while cupids play around her.[21]

Another story that shown on the sarcophagus is that of Psyche and Cupid. Cupid is the god of love and son of Venus, goddess of love and beauty. Psyche is an extremely beautiful mortal woman, of whom Venus is jealous. Venus sends Cupid to cause Psyche to fall in love with someone ugly, but he falls in love himself and takes her away. Psyche accidentally harms Cupid, and then appeals to Venus to appease her. Venus then sets Psyche to a series of impossible tasks. Eventually, Cupid recovers and convinces Jupiter to plead their case to Venus. Jupiter succeeds, and Psyche becomes immortal and marries Cupid.[22]

Approximately one hundred and twenty sarcophagi from the second and third centuries that depict Selene and Endymion survive to this day, with many more presumably lost. The earliest versions, which date to around 130 C.E., have simple compositions, and Selene usually walks from right to left. Later versions have Selene walking left to right, which some historians believe to reflect the direction of which Latin and Greek is read.[23] In the early third century, a single scene becomes the most prevalent, either of Selene approaching the sleeping Endymion, or of Selene getting back up into her chariot. Also during this time, many other characters are added to the scene, such as the shepherds and cupids depicted here.[24]

18. Matz, 127.

19. "Endymion sarcophagus [Roman] (47.100.4)" in *Heilbrunn Timeline of Art History*. (New York: The Metropolitan Museum of Art, 2000–). http://www.metmuseum.org/toah/hd/rsar/ho_47.100.4.htm (accessed November 30, 2008).

20. Matz, 127.

21. Sorabella, 75.

22. Thomas Bulfinch and Bob Fisher, *Bulfinch's Mythology* (Charleston, North Carolina: Forgotten Books, 1964): 74-82.

23. Sorabella, 70.

24. Sorabella, 70.

Stylistically similar sarcophagi of this time depict other mythological scenes. One example is the sarcophagus of Maconiana Severiana made in 210 C.E., which features the same undercut relief of the Endymion Sarcophagus, but depicts the myth of Ariadnea and Dionysos. This myth has some similarities to the myth Selene and Endymion, as it also features a mortal gaining the love of a god and gaining immortality.

Dionysos is also depicted on the Triumph of Dionysos and Seasons Sarcophagus from 260-270 C.E.[25] One of the noticeable features of this sarcophagus is the depiction of the four Seasons, which is also a theme on the Endymion Sarcophagus, albeit not as prominently.

Another marble sarcophagus from around the middle of the second century depicts another version of the Selene and Endymion myth. In this, the emphasis shifts to the pastoral aspects of the story.[26]

The Endymion sarcophagus likely was made in a workshop based in Rome. After it was purchased, the inscription was added, which is seen in the relatively poor quality compared to the rest of the carvings. The portrait of the deceased was also finished later, as the generalized costume and gesture can be made to suit anyone, and tool marks around her head indicate the rough form from which the portrait was created.[27]

25. "Triumph of Dionysos and Seasons sarcophagus [Roman] (55.11.5)" in *Heilbrunn Timeline of Art History*. (New York: The Metropolitan Museum of Art, 2000–). http://www.metmuseum.org/toah/ho/05/eust/ho_55.11.5.htm (accessed December 5, 2008).

26. Sorabella, 73.

27. Sorabella, 77.

TOPIC SENTENCES:

The Endymion Sarcophagus (47.100.4) is a Roman marble sarcophagus created between 200-220 CE during the Severan Dynasty, decorated with scenes dealing with love and immortality.

The sarcophagus has decorations on both the base and lid.

The central myth depicted on the sarcophagus is that of Selene and Endymion.

The front consists of many figures arranged between two matching lions' heads.

The man is Endymion, shown lying on the ground with his eyes closed.

There are many other characters depicted in the scene that are not part of the myth.

Beyond the lions, the sides of the sarcophagus curve around, containing more figures.

The back depicts a pastoral scene in a shallower relief than the front.

On the front of the lid is an inscription that reads,

On either side of the inscription are ten six inch tall reliefs arranged in a row, five on each side, each depicting a different scene in an arch.

The final panel on the left side shows a seated nude man facing a seated woman dressed in a flowing robe.

The panel on the right of the inscription is of the woman for whom the sarcophagus was made, Claudia Hilaria.

To the right of the portrait is a semi-nude female figure, interpreted as Venus, who stands among cupids.

Another story that shown on the sarcophagus is that of Psyche and Cupid.

Approximately one hundred and twenty sarcophagi from the second and third centuries that depict Selene and Endymion survive to this day, with many more presumably lost.

Stylistically similar sarcophagi of this time depict other mythological scenes.

Dionysos is also depicted on the Triumph of Dionysos and Seasons Sarcophagus from 260-270 C.E.

Another marble sarcophagus from around the middle of the second century depicts another version of the Selene and Endymion myth.

The Endymion sarcophagus likely was made in a workshop based in Rome.

Comments:

Compare the outline of topic sentences to the outline of the paper. Do they match? Note how the outline separates the physical description from the identification of the figures.

The topic sentences, on the other hand, seem to mix the two. The paper moves from the "central myth" to "front," but isn't the central myth on the front? Then it moves to Endymion, but isn't he part of the "central myth"? This confusion continues, and some, but not all, of the arched panels along the top of the front, have an individual paragraph. In the last section, discussion of Endymion sarcophagi seems to be split. The paper apparently ends with the fact that this example was made in Rome, which seems like new information rather than a conclusion. Note that none of the topic sentences relates to the theme of sleep and death, which is an entire section in the outline. The conclusion there follows naturally – why was the theme popular?

MAKE YOUR OWN REVISIONS TO THE PAPER AND CHECK THE NOTES FOR ERRORS IN FORMAT **BEFORE** READING THE EDITED VERSION BELOW.

An edited version of the first draft follows, with comments and questions in brackets. The notes have been eliminated for the sake of the clarity of this presentation, although in actual practice they always should be kept with the information.

Paragraph 1:

The Endymion Sarcophagus (47.100.4) is a Roman marble sarcophagus created between 200-220 CE during the Severan Dynasty, decorated with scenes dealing with love and immortality. [*This is a little long for the first sentence of a paper, and contains some repetition. The word sarcophagus is used twice, and Roman, the dates, and Severan are different ways of referring to the same period of time. Furthermore, if the paper will be about the carved scenes, it would be better to condense the facts and make the last part of the sentence come after the verb.*] The base of the sarcophagus is 73 inches wide by 20 inches tall, with the top an additional eight inches high. [*Top is vague – is this part of the body of the sarcophagus or a lid?*] The shape of the sarcophagus is known as *lenos*, which resembles a trough for pressing grapes. [*Since a modern reader has no idea what a trough for pressing grapes looks like, or why it is relevant, another description of the shape would be helpful.*] The heavily decorated sarcophagus depicts many figures in a deeply undercut relief. [*This relates to the last part of the first sentence rather than the physical facts that precede it. Perhaps the order should be changed.*] It was found at Ostia in 1825, but then lost until 1913, and was bought by the

Metropolitan Museum of art at 1947. [*Where is Ostia, what was the context in which it was found, and why does it matter that it was lost? The "a" of "art" is part of the proper name of the museum and should be capitalized.*]

Paragraph 2:

The sarcophagus has decorations on both the base and lid. [*This is the first mention of a lid (called "top" above), and the information is basic enough to be part of the first paragraph.*] The major carvings are on the long sides. [*It wasn't clear from the first paragraph that the sarcophagus has long sides and – presumably – short sides. This also should be established in the first paragraph.*] The front, distinguished by the depth of the carving, shows the main myth of Selene and Endymion bracketed on either side by a large lions' head. [*The main myth, which apparently gives the sarcophagus its name, should be mentioned in the first paragraph. The use of depth of carving is confusing – does this mean that the front is different from all the other sides? If head is singular ("a"), it should be a "lion's" head.*] The back shows a pastoral scene in a lower relief. [*"Lower" than what? It also would be more graceful to say that it was or is carved in lower relief.*] The low reliefs on the back are to let it sit flush against the wall of a vault. [*Now the reliefs are plural, when the previous sentence mentions only one scene, the reference for "it" is not clear, and there has been no mention of a vault. What is it, how do we know about it, and does this mean that any sarcophagus carved in low relief was meant to stand against a wall?*] The sides have depictions of Selene and Helios. [*Each side depicts Selene and Helios, or one side depicts one and the other, the other?*] The lid of the sarcophagus is bare except for the front, which is ornamented with a panel with an inscription in the center, and ten small scenes in arches on either side. [*Again, the lid should be mentioned in the first paragraph, and the ten arched scenes amount to a total of ten, five on each side, or a total of twenty, ten on each side?*]

Paragraph 3:

The central myth depicted on the sarcophagus is that of Selene and Endymion. [*This should have been said in the first paragraph, so there will be no need to repeat it here.*] The Greek goddess Selene represents the moon, and is the sister of Helios, the sun god. [*The phrasing is awkward. Selene doesn't represent the moon. She is the goddess of the moon.*] Selene fell in love with Endymion, a beautiful young huntsman or shepherd. She came to him while he was asleep in a grotto and put him into an eternal sleep. This event supposedly took place on Mount Latmos, near Miletos. [*Unless this place is relevant to what is shown, it seems like a fact that is an extra for this paper. Not everything about Selene and*

Endymion is worth mentioning.] The main scene on the front of the sarcophagus illustrates Selene meeting Endymion while he sleeps. Because of cupids holding torches and Selene riding her chariot, the scene is set in the nighttime. [*Awkward wording – the scene is not set in the night because the cupids hold torches. Instead, we as viewers understand that it takes place at night because of the torches and the fact that Selene, the goddess of the moon, is out.*] One of the small scenes on the lid of the sarcophagus shows Endymion having awoken to be with Selene. [*This comes as a surprise, so it might be more effective to mention above that they are shown more than once on the sarcophagus.*]

To the right of the scene, Selene is mounting her chariot after the meeting with Endymion. [*Which scene?*]

Paragraph 4:

The front consists of many figures arranged between two matching lions' heads. [*This is a basic description of the organization of the major area of carving, so it should have come above.*] Despite the complexity of the design, the major characters are easily identifiable. [*Indicating how the composition helps tell the story is important, especially when there are as many elements are there are here. So it should be explained how they are made noticeable and identifiable. The first is about visual aspects, while the second is about iconography – which means that they probably need to be discussed separately.*] On the front of the base, near the center is a woman that is around one and a half feet tall. [*To call the front "the front of the base" is confusing – use consistent terms for the sections and major elements. In this case, the actual height is not nearly as useful as how high she is in relation to the entire scene. There should be a comma after "center."*] She is the goddess Selene, stepping down from a chariot pulled by two rearing horses located to her left. [*Is it to her left or our left?*] She wears a flowing dress that leaves her right breast uncovered. She holds a veil above her head that forms a crescent moon shape, and holds a wreath in her right hand. She is depicted from the side, leaning over a man to the right. [*This paragraph is not, in fact, about the topic of the topic sentence, but rather it is about Selene. So there should be a new topic sentence. If she is the major figure visually, then it makes sense to start with her and make the various aspects of her appearance the subject of a single paragraph. The sentences should be varied so that each one does not begin with "she."*]

Paragraph 5:

The man is Endymion, shown lying on the ground with his eyes closed. [*The "the" in "the man" only makes sense in relation to the last sentence of the previous paragraph. It is bet-*]

ter that topic sentences be able to stand alone.] He is mostly nude, with only a cloth partially covering his chest. [*This is not an adequate description of the cloth, and the visual emphasis on his genitals should be mentioned, especially since it is a story of consummated love.*] He has one arm held to his head, in the classical Greek position of sleep. [*"Held to his head" is not precise enough. No reader could draw his position from that description.*] Standing above him is a winged female figure dressed in a robe that may be the goddess Night, or Nyx. [*The awkward syntax suggests that it is the robe that may be the goddess Night, not the female figure.*] She is holding poppy flowers in her right arm and pouring a potion out of a drinking horn with her left hand. [*They are not flowers, but the pods from which the poppy seeds come.*] Surrounding the figures are six nude winged cupids watching the scene between Selene and Endymion. Four of them hold torches to light Endymion, and two hold the reins of Selene's horses.

Paragraph 6:

<u>There are many other characters depicted in the scene that are not part of the myth.</u> [*"in the scene" is not clear – on the front? In this group? It is important to be very specific here.*] To the left of the chariot is a female figure that is slightly smaller than Selene is. She holds the reins of the horses in her right hand and a whip in the left, attempting to calm the horses down. [*If she holds the reins to Selene's horses, she is related to Selene and thus the main scene.*] Sitting on the ground to directly to her left is a bearded shepherd who is scratching a dog. [*Shouldn't be a "to" after "ground." The appearance of this shepherd in the description is so surprising that his visual relationship to the main figures has to be made clear, and where is the dog?*] Around him lay several sheep. [*Grammar: the sheep "lie" not "lay."*] On both the left and right of the figures are two large lion heads with their mouths open. [*"To" instead of "on" is better, and if the heads are on the left and right, are there a total of two or four?*] They are placed in a place where the spouts are found on grape pressing troughs upon which the shape of the sarcophagus is based. [*Place shouldn't be used twice, and this fact is hard to make sense of – why? Do they have spouts on the sarcophagus too?*] Under the head of the lion on the left, next to the man are two small winged figures embracing one another, identified as Cupid and Psyche. [*It should be "to" the left, and what man? If there is a comma after "left," setting off the next phrase, there must be a comma after "man" too.*]

Paragraph 7:

<u>Beyond the lions, the sides of the sarcophagus curve around, containing more figures.</u> [*It isn't that the sides curve, but that the long sides curve into the ends.*] On the left side of the

sarcophagus, a nude male figure wearing a cloak, identified as Helios, is depicted climbing into his chariot, pulled by four horses. [*Make sure the reader always knows what the frame of reference is – here, to the left of what? What identifies him as Helios? Does his action have a meaning?*] The right side of the sarcophagus shows Selene again, this time in the process of getting into her chariot. The reins of the two horses that pull the chariot are held by a winged female figure. [*Is this a continuation of the scene on the front? If the sun is on one end and the moon on the other, do they refer imply the passage of time? In addition, there are other figures that have not been mentioned.*]

Paragraph 8:

The back depicts a pastoral scene in a shallower relief than the front. [*"carved in shallower relief than the scenes on the front" is more graceful wording, and the sides also are carved deeply. How big are the figures in relation to the height of the sarcophagus?*] On the left, past Selene, sits an older bearded man dressed in a robe who looks back at Selene. [*Which Selene this is should be specified if only to remind us, there's no need to repeat her name twice, and left from which point of view, because it is not the same as the last time "left" was used.*] Behind him are three large bulls and a sheep. In the center are three grazing horses. On the right stand a herdsman and his dog. Beyond the man and his dog are two women who stand near Helios, with one pointing to the scene on the front. [*An indication of how these figures relate to each other in terms of two- and three-dimensional design would be helpful. Are they strung out, do they overlap, are they clearly all meant to be in the same space? "Beyond" is especially confusing, because it does not refer to either dimension unambiguously.*]

Paragraph 9:

On the front of the lid is an inscription that reads,

"ANINIA HILARA / CL·ARRIAE MARI / ·INCONPARABILE / FECIT·VIXIT·/ ANN·L·MEN /·X".

This means that the sarcophagus was created for a freedwoman named Claudia Arria, who lived for fifty years and ten months. The daughter of Claudia, Aninia Hilaria, dedicated the sarcophagus. [*This translation is not quite accurate, according the article by Sollabella. It doesn't say call her freedwoman, but mother, and she is "inconparabile," a common flattering adjective, perhaps something like the English incomparable.*] The content of inscription is unusual as it indicates that the daughter, not a husband, father, or son-in-law paid for the sarcophagus. [*What is unusual is the act, not the inscription.*] In fact, according to Saller and Shaw, funerary inscriptions from daughters to mothers make up only three per-

cent of all dedications. [*No need to mention the names of the authors in the text, especially because they didn't write the article that is cited.*]

Paragraph 10:

On either side of the inscription are ten six inch tall reliefs arranged in a row, five on each side, each depicting a different scene in an arch. [*On either side of the inscription are five arched panels, carved in low relief.*] The scenes on both the far left and far right depict male figures at rest within a pastoral landscape. Moving forward toward the center, the reliefs depict cupids with fruits and animals, symbolizing the seasons and the bounty of the earth. [*"The reliefs next to them" would be simpler.*] The next panel, the third from the left, depicts Cupid and Psyche embracing. [*If this is all going to be about the ones on the left side, then that should be stated in the topic sentence of the paragraph. Otherwise, the reader assumes from the second sentence that the discussion will move in toward the center from both the right and the left.*] Cupid turns away from Psyche, while Psyche pulls his chin to face her. The fourth panel from the left is of a man dressed in armor and carrying a spear and shield, and faces right. [*Better to avoid the verb "to be" as much as possible, and instead define the relationship exactly – the panel shows, represents, depicts, the man.*] He can be identified as Mars, god of war and Venus's lover.

Paragraph 11:

The final panel on the left side shows a seated nude man facing a seated woman dressed in a flowing robe. They are Selene and Endymion, after Endymion awakens. Two cupids, watching the scene, surround the two figures. [*Why is this a separate paragraph? It follows naturally from the previous topic sentence and the description of the other panels on the same side of the inscription.*]

Paragraph 12:

The panel on the right of the inscription is of the woman for whom the sarcophagus was made, Claudia Arria. [*Again, "is of" is less descriptive than "shows" or "portrays."*] She has a stern expression and crossed arms, and faces out at the viewer. [*This portrait is so important that it deserves more detail. She is the woman for whom this entire work was made!*] The portrait helps to date the work, as she is depicted with a specific hairstyle made popular by Empress Julia Domina (193 – 211 C.E.), wife of Septimius Severus.

Paragraph 13:

To the right of the portrait is a semi-nude female figure, interpreted as Venus, who stands among cupids. She holds out an apple with her right hand and a spear in her left.

To the right of the relief is another scene with Venus. In it she rests on a rock nude while cupids play around her. [*Not having all the panels to the right of the portrait mentioned here is confusing. It also would be useful to know how big these figures are and a little bit more about the reliefs. Are they as complicated in composition as the scenes below them?*]

Paragraph 14:

Another story that shown on the sarcophagus is that of Psyche and Cupid. [*This was mentioned above, so the explanation of the myth doesn't fit here. Perhaps a paragraph about the other mythological figures should follow the one about Selene and Endymion.*] Cupid is the god of love and son of Venus, goddess of love and beauty. Psyche is an extremely beautiful mortal woman, of whom Venus is jealous. Venus sends Cupid to cause Psyche to fall in love with someone ugly, but he falls in love himself and takes her away. Psyche accidentally harms Cupid, and then appeals to Venus to appease her. [*Reference for "her" is not clear.*] Venus then sets Psyche to a series of impossible tasks. Eventually, Cupid recovers and convinces Jupiter to plead their case to Venus. Jupiter succeeds, and Psyche becomes immortal and marries Cupid. [*Who is Jupiter? Which parts of this story matter for this sarcophagus?*]

Paragraph 15:

Approximately one hundred and twenty sarcophagi from the second and third centuries that depict Selene and Endymion survive to this day, with many more presumably lost. The earliest versions, which date to around 130 C.E., have simple compositions, and Selene usually walks from right to left. Later versions have Selene walking left to right, which some historians believe to reflect the direction of which Latin and Greek is read. [*"Believe to reflect" should be believe reflects, and "of which" should be "in which." Why does this make sense, when the audience also was using Greek and Latin at the time the earlier ones were made? Just because a scholar says something doesn't make it true or interesting!*] In the early third century, a single scene becomes the most prevalent, either of Selene approaching the sleeping Endymion, or of Selene getting back up into her chariot. Also during this time, many other characters are added to the scene, such as the shepherds and cupids depicted here.

Paragraph 16:

Stylistically similar sarcophagi of this time depict other mythological scenes. [*"Made during the Severan period" or "made during the early 3rd century" would be clearer than "of this time" – of what time?*] One example is the sarcophagus of Maconiana Severiana made

in 210 C.E., which features the same undercut relief of the Endymion Sarcophagus, but depicts the myth of Ariadnea and Dionysos. [*Should be "Ariadne." More information has to be given about this sarcophagus, at minimum where it is located today. Since the undercut relief has not been explained, the similarity is hard to follow. If the myth also needs to be explained, it may be that the comparison is not worth the space it will take to make all the aspects clear.*] This myth has some similarities to the myth Selene and Endymion, as it also features a mortal gaining the love of a god and gaining immortality. [*Repetition of "gain" should be avoided, and the one is the result of the other – "thereby gaining" or "through that love gaining."*]

Paragraph 17:

Dionysos is also depicted on the Triumph of Dionysos and Seasons Sarcophagus from 260-270 C.E. [*Why is this a separate paragraph? It follows from the previous topic sentence. Again, at least the present location of the sarcophagus should be given.*] One of the noticeable features of this sarcophagus is the depiction of the four Seasons, which is also a theme on the Endymion Sarcophagus, albeit not as prominently. [*Like the sarcophagus mentioned above, this one needs more discussion to make sense as a comparison. These bare facts don't add much to the paper.*]

Paragraph 18:

Another marble sarcophagus from around the middle of the second century depicts another version of the Selene and Endymion myth. [*Since this one is also in the collection of the Metropolitan, and shares many of the same elements, a discussion of it in much greater detail would make the paper richer.*] In this, the emphasis shifts to the pastoral aspects of the story. [*"In this" what? How?*]

Paragraph 19:

The Endymion sarcophagus likely was made in a workshop based in Rome. [*It would be better to know why this is so and why it matters.*] After it was purchased, the inscription was added, which is seen in the relatively poor quality compared to the rest of the carvings. [*"The inscription was added after it was purchased" would read more smoothly. How is the quality poor? This comment should be made more specific.*] The portrait of the deceased was also finished later, as the generalized costume and gesture can be made to suit anyone, and tool marks around her head indicate the rough form from which the portrait was created. [*Finished later than what? What generalized costume and gesture? The "the" indicates that it*

was explained before, but it wasn't. The tool marks also have to be explained, since this is the first time there has been any mention of the way in which the sarcophagus was carved.]

Final comments:

This last paragraph is not a conclusion, which should summarize the main points of the paper without repeating them. In fact, the information seems so basic that it would have been more appropriately mentioned earlier. Perhaps the end of the paper could be about the popularity of the subject, as suggested in the Outline. That would remind the reader about the subject and its popularity while looking at it in a new way. One of the major omissions is any discussion of how the sarcophagus was made, or what the color and surface of the marble look like. More information about this would give the reader a better sense of its physical presence. A longer comparison to other Endymion sarcophagi also would be interesting, and more relevant than references to other sarcophagi with mythological subjects. Note that the paper does not include a discussion of the Severan style, mentioned in the outline. It's a relevant topic, but not a necessary one, and if examples are not easy to find or describe, eliminating it is fine.

FINAL PAPER

After another trip to the Metropolitan to look at the sarcophagus again and another round of revisions, the student turned in this paper. How is it different from the first draft? What has been added? Underline the topic sentences! Do they make sense as an outline?

The Severan Endymion Sarcophagus in the Metropolitan Museum of Art

The Endymion Sarcophagus (Metropolitan Museum of Art, 47.100.4), a marble coffin created between 200-220 CE during the Roman Severan period, is decorated with scenes from classical mythology about love and immortality. Shaped like a tub, the sarcophagus is in the form known as *lenos,* which resembles the container in which grapes were pressed. Such containers also had two lions' heads on the front, just as this sarcophagus does.[1] The body is about 73 inches long, 20 inches tall, and about 16 inches at the base of the end, increasing to about 23 inches at the top. A row of standing panels along the front edge of a flat marble lid adds approximately eight inches. The major story, shown on the long front of the sarcophagus and in a scene on one of the panels, is the myth of Endymion and Selene. It is found on more than 70 Roman sarcophagi from the 2nd and 3rd centuries.[2] The subject may have been popular because of the association between sleep and death, and the idea of the gods granting mortals an eternal happy life in the heavens after death.[3] The sarcophagus, which was found in a chamber tomb located in Ostia, Italy, in 1825, was bought by the Metropolitan Museum of Art in 1947.[4]

Carved figures and animals cover the two long sides as well as the ends of the sarcophagus. The most important side, carved in very deep relief, shows the goddess of the moon Selene coming to the sleeping Endymion.[5] The entire scene, which includes the horses of

1. Heather T. Awan, "Roman Sarcophagi," in *Heilbrunn Timeline of Art History* (The Metropolitan Museum of Art, 2000–). http://www.metmuseum.org/toah/hd/rsar/hd_rsar.htm (accessed November 26, 2008).

2. Jean Sorabella, "A Roman Sarcophagus and Its Patron," *Metropolitan Museum Journal* 36 (2001): 70.

3. Sorabella, 71; and Awan.

4. Sorabella, 70; and Metropolitan Museum of Art object label.

5. Friedrich Matz, "An Endymion Sarcophagus Rediscovered," *The Metropolitan Museum Art Bulletin*, New Series, 15 (January 1957): 123. Unless otherwise indicated, subsequent identifications of the figures on the sarcophagus are taken from this page.

Selene's chariot as well as other figures, is bracketed on either side by a large lion's head. The back, carved in low relief so that the sarcophagus can be pushed against the wall, shows a pastoral scene with two men, bulls, sheep, horses, and two nymphs.[6] The short, curved ends show the sun god Helios on the left and Selene on the right, both in their chariots. The lid of the sarcophagus is bare except for the front, which is ornamented with five upright arched panels on either side of a nearly square panel which contains the dedication. Scenes showing mythological scenes as well as a portrait of the deceased, carved in low relief, fill the panels.

The story of Selene and Endymion is about love between a goddess and a mortal man. Selene fell in love with Endymion, a beautiful young shepherd, when she happened to see him asleep in a grotto on Mount Latmos. She visited him for many nights, until finally he was given eternal youth and put him into an eternal sleep.[7] Then they could be together forever. The main scene on the front of the sarcophagus depicts Selene leaving her chariot to visit Endymion while he sleeps. Cupids holding torches around her and the presence of her chariot indicate that it is nighttime. In a small panel above, Selene and Endymion are shown again, together and awake. The goddess is shown once more, on the rounded end to the right of the main scene, leaving in her chariot.

The sarcophagus contains another story of love between a god and a mortal with meetings at night, the myth of Psyche and Cupid. They are represented as small figures under the lion's head on the left side of the front, and in one of the arched panels. Cupid, the god of love, is the son of Venus, goddess of love and beauty. Psyche is an extremely beautiful mortal woman, of whom Venus is jealous. Venus sends Cupid to cause Psyche to fall in love with someone ugly, but instead he falls in love with her himself. He hides her in a beautiful palace, where he visits her every night in darkness, so she doesn't know who he is. Finally Psyche hides a lamp which she uses to look at him after he has fallen asleep. She discovers that her lover is a beautiful young man, but she also allows oil from the lamp to fall on him, which wakes him. He escapes, and goes to his mother Venus. Psyche, to avoid Venus's rage, appeals to her for forgiveness. Venus then gives Psyche a series of impossible tasks. Eventually, Cupid convinces Jupiter to plead their case to Venus. Jupiter succeeds, and Psyche becomes immortal and marries Cupid.[8]

6. Awan.

7. Mark P.O. Morford and Robert J. Lenardon, *Classical Mythology*, 6th ed. (New York: Oxford University Press, 1999), 42.

8. Morford, 136-8.

The major characters on the front of the sarcophagus are easily identifiable. Almost in the center of the composition is a woman who is emphasized by her placement in the middle, her height, around one and a half feet tall, which fills the height of the sarcophagus, and the rounded shape of the veil she holds above her head. She is the moon goddess Selene, identified by the crescent moon she has on her head, stepping out of a chariot pulled by two rearing horses facing to the left. Further visual emphasis comes from the many folds of her full-length dress, which is gathered above her waist and falls off her right shoulder, leaving her right breast uncovered. Although her upper body faces us, her legs and her head are turned to the right, drawing our attention to an almost nude man who lies stretched out along more than a third of the width of the front. He rests on his left elbow and holds his right arm bent behind his head, in a classical Greek position of sleep.[9] Although his body faces us, his head is turned away, shown nearly in profile, and his eyes are closed. Standing above him is a winged, robed female figure who is the goddess Night. She is holding a stalk of poppy seed pods in her left arm and pouring a sleeping potion made from them out of a drinking horn in her right hand. Surrounding these figures are six small nude winged boys or cupids, three on each side of Selene. Four of them hold torches to light Endymion, and two hold the reins of Selene's horses.[10]

The figures on the left side of the front of the sarcophagus are not directly related to the story of Selene and Endymion. To the left of the two rearing horses is a female figure, probably Aura, personification of the breeze, who holds the reins in her raised left hand and a whip in her right. Beneath the horses is a much smaller reclining female figure, who holds a snake in her hand as she looks toward Endymion. She represents Earth.[11] Sitting on the ground directly to the left of these two women is a bearded man, who is turned to face Selene. He looks down at a dog which sits in front of him, while he scratches under its head. Above him, lying on a projecting ledge that may represent a cave, lie two sheep facing a goat.[12] Next to him is a kid goat. Under the head of the lion on the left, next to

9. Anna Marguerite McCann, *Roman Sarcophagi in the Metropolitan Museum of Art* (New York: Metropolitan Museum of Art, 1978), 39.

10. Matz, 123.

11. McCann, 42.

12. The identification of the ledge as part of a cave in which the shepherd sits comes from the discussion of the same elements in another Endymion sarcophagus in Gisela Richter, "A Roman Sarcophagus," *The Metropolitan Museum of Art Bulletin* 20, no. 3 (March 1925): 80.

the shepherd, are Cupid and Psyche, shown as two small winged figures embracing one another.

The figures of Helios and Selene are carved on the rounded ends of the sarcophagus. The sun god Helios is to the left of the main scene, shown as a nude man wearing a billowing cape and a crown made of rays, who stands in a chariot drawn by four horses. Next to him is a winged cupid holding a flaming torch. He represents the rising morning star. Beneath them is a reclining man who symbolizes the Ocean. Selene is shown on the other end, depicted with the same attributes as she has on the front. Standing in a chariot drawn by two horses, moving away from Endymion, she has the same curved veil over her head, the same crescent on her head, and the same full-length dress which falls to expose her right breast. In front of her is a descending cupid with a torch, representing the setting evening star. This figure has been badly damaged. Beneath the horses is a reclining female figure who personifies Earth.[13] In front of the chariot, holding the reins and a whip, is the same winged woman who appears with the chariot on the front of the sarcophagus.

Every area on the front and ends of the sarcophagus is packed with figures, animals, and natural elements, piled around one another without being located in a single coherent space. For example, Selene's left foot appears between Endymion's legs, and the figure of Earth lies between the back legs of the horses pulling the chariot. Some parts have been carved so deeply that they stand out from the marble entirely, only connected by a small link needed to support them. This is true of figures, like the cupids, as well as the animals and plants. Looked at from the front, this creates a very active visual play of light and shadow. Selene's profile, for example, stands out against the darkness of the shadow cast by her veil. Looked at from the side, the sarcophagus seems to be covered with heads that pop out from the surface. The carving also describes very small naturalistic details, like the finger and toenails shown on many of the figures, the differently shaped and textured horns of the sheep and the goat, and the seedpods of the poppies. This creates a visual richness that gilding of the details would have increased dramatically.[14]

The back depicts a pastoral scene carved in low relief. On the left, next to the woman holding the reins to Selene's chariot, is an older bearded man, who reclines, leaning on his right elbow with his left hand above his head. Unlike Endymion, who has a similar position, this man is clothed, awake, and turned to the left, as if looking at Selene in her chariot shown on the end. Behind him and to the right are three large bulls with a sheep

13. Matz, 123.
14. McCann, 22.

above them. In the center, between two trees, are two grazing horses. Another horse faces them. In front of it is a standing bearded man who looks to the left, while he scratches the head of a dog seated next to him. Both men wear a short robe that ends above their knees. To the right of this man, only partly visible from the back because of the rounded corner of the sarcophagus, are two standing women. One of them is almost nude, and she holds a jar from which water flows. They are nymphs.[15]

On the front and center of the lid is a nearly square panel with an inscription which reads:

"ANINIA HILARA / CL · ARRIAE MARI / · INCONPARABILE
/ FECIT · VIXIT · / ANN · L · MEN / · X"

This means that the sarcophagus was created for a woman named Claudia Arria, called mother and incomparable, who lived for fifty years and ten months. Her daughter, Aninia Hilaria, whose name comes first in the inscription, dedicated the sarcophagus. The fact that this extensively carved marble sarcophagus was bought by the daughter, not a man in the family, is very unusual.[16] Funerary inscriptions from daughters to mothers make up only three percent of all the dedications known today.[17] The inscription is not well spaced within the panel. The letters run onto the border on the right, the last line consists of only the last letter, and the lines are crooked.

A bust portrait of the dead woman, Claudia Arria, appears in the panel to the right of the inscription.[18] She faces us, robed, with her arms crossed and her right hand held flat against her chest. She has large eyes with incised pupils, a long nose, and a serious expression. Her hairstyle of waves on either side of her face helps date the work, because this style was made popular by Empress Julia Domina (193 – 211 C.E.), wife of Septimius Severus.[19] The carving seems less skillful than it is on the rest of the sarcophagus. She is not quite in the center of the panel, so that her arm hits its right edge and the shoulder above it is longer than her other one. In addition, her head does not quite sit above her body.

The scenes in the arched panels on the lid are arranged so that the ones in the same positions on either side seem to be related. On both the far left and far right, male fig-

15. Matz, 123.

16. Sorabella, 67.

17. Sorabella, 79, note 7.

18. "Endymion sarcophagus [Roman] (47.100.4)" in *Heilbrunn Timeline of Art History*. (New York: The Metropolitan Museum of Art, 2000–). http://www.metmuseum.org/toah/hd/rsar/ho_47.100.4.htm (accessed November 30, 2008).

19. Matz, 127.

ures representing mountain gods are seated within a landscape, indicated by trees and animals.[20] The next panels toward the center depict winged nude boys with fruits and animals, symbolizing Autumn on the left and Spring on the right, and the bounty of the earth. The next panel on the left shows Cupid turning his face away from Psyche and holding up his right hand as if to say no, while Psyche reaches out as if to pull him around to face her.[21] The equivalent panel on the right shows the goddess Venus, seated in a landscape with one cupid behind her and another at her knees. A third small figure, lying on the ground in the lower left corner of the panel with arms stretched out, has the same wings and dress as Psyche. Perhaps it shows the moment when Psyche pleads for Venus's forgiveness. The next panel on the left depicts a nude man wearing a helmet, with a sword in its case at his waist, carrying a spear and shield. He is Mars, god of war and Venus's lover. The equivalent panel on the right shows a standing nude woman, perhaps Venus, holding an apple in her right hand and a spear in her left. There are cupids around her, one of whom holds what seems to be a fruit up to her. The fifth and last panel on the left side, corresponding to the portrait of the dead woman on the right, shows a seated nude man facing a seated woman dressed in a flowing robe. A crescent on her head identifies her as Selene. The man is Endymion, awake, with a crescent on his head also, indicating that he is now immortal and in heaven. Selene reaches out to turn his head toward hers, while two cupids watch the scene.

The Endymion sarcophagus probably was made in a workshop based in Rome, although the marble might have come from Greece.[22] The inscription was added after it was purchased, which explains the awkwardness of the placing and formation of the letters compared to the finer quality of the sculpture. The portrait of the deceased was also finished after the sarcophagus had been bought. The generalized costume and gesture could suit anyone, and tool marks around the head show the rough form from which the portrait was created.[23]

Considering the composition as if the portrait of the dead woman is the most important element makes it clear how many ways she has been related to Selene and to love. The moon goddess approaching Endymion is immediately below her bust. The panel that cor-

20. Matz, 123. Unless otherwise noted, all subsequent identifications of the figures come from this page.

21. Matz, 127. Unless otherwise noted, all subsequent identifications of the figures come from this page

22. Awan; and McCann, 37.

23. Sorabella,77.

responds to her portrait, on the other side of the inscription, shows Selene and Endymion together and immortal. This may be the only surviving representation where they appear this way.[24] On the other side of the portrait are two depictions of Venus. Finally, Cupid and Psyche appear together twice, and small cupids are everywhere. The repetition of the theme of love suggests it was important to the way her daughter wanted her mother to be remembered.[25]

Another Endymion sarcophagus (Metropolitan Museum of Art, 24.97.13), from around 160 CE, includes almost the same basic elements as the one from the early third century, but they are handled very differently. Selene, nearly in the middle of the composition, walks from her two-horse chariot toward a sleeping Endymion. Here too she is encircled by a billowing veil and she has a crescent on her head. Her full-length dress also falls to exposes her right breast. There are small cupids on either side of her. A winged female figure, looking very much like the one in the later version and also identified as Aura, holds the reins of the horses. It is a man not a woman, however, who holds a poppy stalk and stands behind Endymion. He is Somnus, the god of sleep.[26] Standing cupids, leaning on upside-down torches and asleep, bracket the scene. The carving is less deep, so there is no dramatic play of light and shadow, and there are many fewer visual elements. Everyone seems to move at a steady pace, making the composition visually calmer. The carving also does not extend around the ends, which have shallow reliefs showing a griffin on each side. There is no carving at all on the back or the lid.

The popularity of the myth of Selene and Endymion on Roman sarcophagi may come from the variety of ways in which it can be related to the idea of death and a peaceful afterlife. Endymion can symbolize the dead person, sleeping until awoken to be with the gods. The practice of carving the face of one of the mythological figures on a sarcophagi with the features of the deceased supports this identification between the two.[27] It may have been inappropriate to do that in this case because Claudia Arrias was a woman, or her daughter may have decided that it cost too much to make the additional changes. The pastoral scenes can suggest the tranquility that comes after death. Finally, the figures of the seasons as well as those of the moon and sun represent the endless cycles of nature. All

24. McCann, 43.
25. Sorabella,76.
26. Richter, 78.
27. Sorabella, 77.

of these themes have been represented clearly in the Endymion sarcophagus from the early 3rd century in the collection of the Metropolitan Museum.

Bibliography

Awan, Heather T. "Roman Sarcophagi." In *Heilbrunn Timeline of Art History*. New York: The Metropolitan Museum of Art, 2000–. http://www.metmuseum.org/toah/hd/rsar/hd_rsar.htm (accessed November 26, 2008).

"Endymion sarcophagus [Roman] (47.100.4)." In *Heilbrunn Timeline of Art History*. New York: The Metropolitan Museum of Art, 2000–. http://www.metmuseum.org/toah/hd/rsar/ho_47.100.4.htm (accessed November 30, 2008).

Matz, Friedrich. "An Endymion Sarcophagus Rediscovered." *The Metropolitan Museum Art Bulletin*, n.s. 15, no. 5 (January 1957): 123-128.

McCann, Anna Marguerite. *Roman Sarcophagi in the Metropolitan Museum of Art*. New York: Metropolitan Museum of Art, 1978.

Morford, Mark P. O. and Robert J. Lenardon. *Classical Mythology*. 6th ed. New York: Oxford University Press, 1999.

Richter, Gisela. "A Roman Sarcophagus." *The Metropolitan Museum of Art Bulletin* 20, no. 3 (March 1925): 77-80.

Sorabella, Jean. "A Roman Sarcophagus and Its Patron." *Metropolitan Museum Journal*, 36 (2001): 67-81.

CPSIA information can be obtained
at www.ICGtesting.com
Printed in the USA
LVOW04s1044031215

464816LV00017B/75/P